THE ART OF DUNCAN GRANT

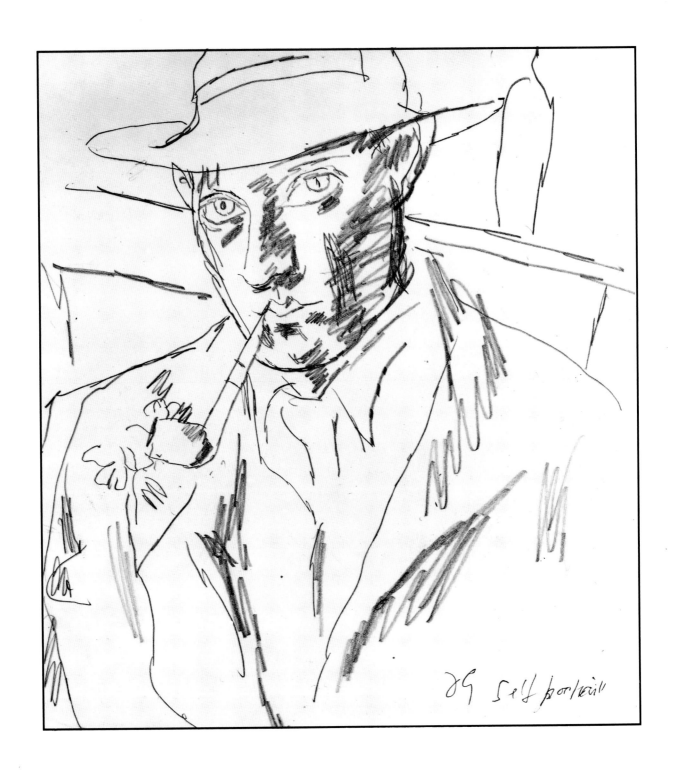

dg self portrait

THE ART OF

Duncan Grant

SIMON WATNEY

John Murray

TO QUENTIN BELL

Frontispiece: *Self-portrait c.* 1916, pencil,
10½ × 9¼″ (26.2 × 23.1 cm), Anthony d'Offay

© Text: Simon Watney 1990
© This edition: Berkswell Publishing Co Ltd 1990

First published in 1990
First reissued in paperback in 1999
by John Murray (Publishers) Ltd
50 Albemarle Street, London W1X 4BD

A catalogue record for this book is available from the British Library

ISBN 0–7195–5782–8

Edited by John Stidolph
Designed by Paul Watkins
Typeset by Footnote Graphics, Warminster
Printed in China. Phoenix Offset & The Hanway Press Ltd

Contents

INTRODUCTION

6

CHAPTER ONE

Formative Years

16

CHAPTER TWO

Post Impressionism

29

CHAPTER THREE

Maturity

49

CHAPTER FOUR

Isolation and Rediscovery

65

CONCLUSION

77

APPENDIX A

Professor Quentin Bell in Conversation with Duncan Grant

81

APPENDIX B

The Lincoln Murals: Duncan Grant's Notes

88

NOTES

89

BIBLIOGRAPHY

96

ACKNOWLEDGEMENTS

98

COLOUR PLATES

99

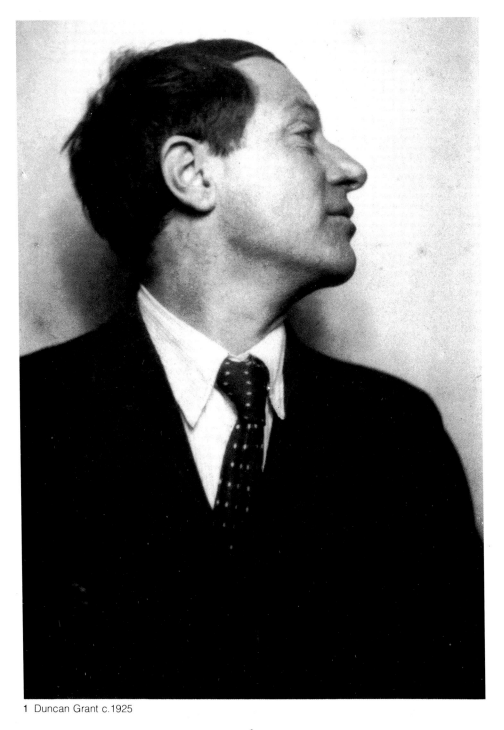

1 Duncan Grant c.1925

Introduction

When Duncan Grant died in 1978 at the age of 93, he was the sole surviving member, not only of the original Bloomsbury Group, but also of that generation of British artists whose work had profited deeply from direct experience of the Parisian avant-garde before the outbreak of the First World War. Grant did not simply serve to introduce modernist painting from the outside to a reluctant Britain; he was himself a significant early modernist, whose work deserves to be considered in its wider international context, as well as in relation to his local British background.

This book is not concerned with Grant as a member of the Bloomsbury Group, save in so far as some aspects of his art are intimately bound up with the beliefs and values of his closest friends. Throughout his long life, Grant quietly but deliberately followed a path of his own making, and as a painter he always stood at something of a tangent to his more literary colleagues. Indeed, it may be argued that his work would be far better known and appreciated had he been less closely associated with Bloomsbury, to whose changing critical fortunes his own reputation has been closely linked. Certainly, interest in few major twentieth-century British artists has been subject to more violent swings of critical esteem.

Grant's early years provided him with an extra-ordinarily wide knowledge of European art. As a teenager he copied the works of Masaccio and Piero della Francesca in Italy. He spent a year in Paris studying with Jacques Emile Blanche, and met the Steins, Picasso, Matisse and Derain. In his twenties he was bowled over by the experience of seeing the mosaics at Constantinople and Ravenna, and by the impact of the French Romanesque. In London he participated in the adventure of Roger Fry's Post Impressionist exhibitions, and the formation of the Omega Workshops. By 1920 he was already a highly regarded and successful young artist, whose work was widely recognised as possessing an elegance and decorative fluency that distinguished him sharply from his British contemporaries. Throughout the twenties and thirties his work was immensely influential. However, the relative weakness of British art criticism

in comparison to literary criticism contributed to the unfortunate later tendency to dismiss him as no more than Bloomsbury's semi-official court painter, with the result that his actual career and achievements remain largely unexamined and under-valued.

Yet Grant was a painter of considerable sophistication, complexity, and authority. The most recent British book about his career was published as long ago as 1944, and more than forty years later its author, Raymond Mortimer, looked back over Grant's long career on the occasion of his ninetieth birthday, and a small exhibition of his work that the Tate Gallery had organised in his honour:

In 1914 when his friendliness, charm, good looks and original talk endeared him even to those who found his work incomprehensibly modern, the jealous D. H. Lawrence described him as a black beetle. Never since then have I heard of anyone who disliked him. He remains delightful, and modest also. Good critics singled out the youthful Grant as the most gifted of the artists here who had been influenced by the Paris Post Impressionists. Later, when our other painters were growing less realistic, he became more so, swimming against the current to the vexation of most critics. Today he wins increasing applause from young painters who work in a contrasting tradition. Having admired him and his work for over fifty years, I know that, though a keen enjoyer, he has never been distracted by alcohol, smart society, indolence, the demands of dealers or the other temptations that have enfeebled so many of the most promising painters. Regardless of fashion, he has always obeyed his own eyes and his own imagination. [1]

There are many reasons why the name of Duncan Grant tends to be more familiar than his work. The first, and most important, has to do with the availability and visibility of his best work. With the exceptions of Charleston, the Sussex farmhouse in which he lived for more than half a century, and the rooms that he decorated with Vanessa Bell for Maynard Keynes at King's College Cambridge in the early 1920's, all of his early decorated interiors have perished, mainly as the result of war damage. 'Open air where we sat so many nights, gave so many parties', as Virginia Woolf confided to her diary after viewing the heap of ruins that

37

Numbers in text refer to Notes, ps. 89–96. Numbers in the margin refer to colour plates.

had been her home in Tavistock Square, decorated like many others by Duncan and Vanessa in the inter-war period, with their murals, carpets, painted furniture, hand-painted tiled fireplace surrounds, screens, pots and fabrics. [2] Nor has there been a major exhibition of his work in a leading public gallery since the Tate Gallery's 1959 Retrospective, with the selection of which he was personally unhappy. *The Times'* con-temporary reviewer noted, 'a lack of any special weight on the side of the decorative qualities in Mr. Grant's work', and missed a sense of continuity within the show. [3] Writing in the *Manchester Guardian*, Eric Newton concluded that, 'One is tempted to speak of Duncan Grant in the past tense, though he is in every sense, very much alive.' [4]

With the exception of a magnificent exhibition at Wildenstein's in 1964, subsequent shows of his work have been sporadic and limited, and have not attracted much critical attention. It should also be noted that whilst Grant exhibited regularly throughout his work-ing life, large areas of his decorative work were very rarely shown in galleries, and have only recently become accessible with the opening of Charleston to the public in June 1986.

The 1959 complaint that Grant's work lacks 'con-tinuity' reveals far more about critics' expectations concerning the ideal shape and sequence of an artist's career, than it does about the work itself. Duncan Grant was an artist of great natural facility and fluency, and he worked in a variety of manners, whilst return-ing constantly to a number of personal subjects and technical problems to which he was drawn. He also worked in a wide range of different fields, including fabric design, ceramics, book illustration, theatre work, ballet, interior decoration, and print-making, besides oil painting and his work in other media, principally gouache, pastel and watercolour, in all of which he excelled. Grant was also one of the most prodigiously gifted British draftsmen of this century. Unfortunately this Protean range has often been re-garded as a problem in itself, rather than a fundamental aspect of his identity as an artist. Ironically it would seem that the very qualities that make his work so

distinct and challenging have sometimes been used to disqualify him from serious consideration as an artist.

This factor has been complicated by attitudes towards his fifty year working collaboration with Vanessa Bell, which raises difficulties for critics and art historians who prefer an artist to subscribe obediently to a less complicated career structure, to display more total autonomy, and to embody a more traditional sense of development and progression.

To understand the work of Duncan Grant it is especially important to be able to consider all its many phases and component parts, since he so frequently transferred ideas from one medium into another. It is also important because Grant himself seems to have needed to work simultaneously in different media and with different styles at various stages throughout his career. Thus his work gears together into a complex whole, as if experimentation in one area needed to be balanced by slower revision in another. In this respect, Grant's working practice as an artist was unusual, and possibly threatening to commentators who have required artists to reveal a more clearcut sense of chronological 'progress' in their work – the sense of a beginning, a middle, and an end. Although there are clear periods in Grant's career, his work is better understood in relation to the way in which he de-veloped themes and ideas constantly, in different media, throughout his life, returning, for example, in his eighties to the themes and techniques of his youth.

Virginia Woolf's housemaid Maud was once heard to comment, possibly in despair, 'That Mr. Grant gets in everywhere!' [5] However, it is precisely the mercurial and exuberant diversity of his work that should most engage and please us, for modern Britain can boast few artists whose work is so beguilingly rich and varied, in subject as in technique. Again, it is possible that some critics have been offended by the frank hedon-ism and languorous eroticism of much of his imagery and brush-work. He will always appear frivolous or 'merely decorative' to those who expect art to be morally uplifting and improving. Thus, although he was championed by Roger Fry and Clive Bell in the Twenties and Thirties, his work has generally lacked

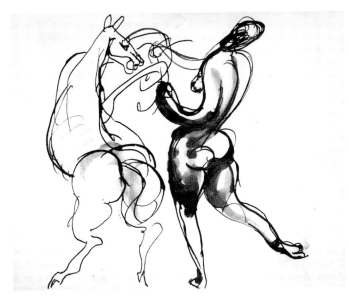

2 *Woman Dancing with a Horse* c.1913, ink and wash on paper, 7 × 8¾″
(17.5 × 22.4 cms.), private collection

critical support in recent times. He never illustrated theories, and was very much an instinctive artist, rather than an intellectual. Furthermore, British twentieth-century criticism has tended to evaluate all aspects of design in the inter-war period against the aesthetic criteria of either the Bauhaus or the Dutch De Stijl group. This has led to the serious neglect of most non-functionalist design work between the wars, and especially the work of Vanessa Bell and Duncan Grant.

Together with the effects of the general lack of institutional support for early twentieth-century British modernist art at the time, it is also important to recognise the profound influence of the First World War on British culture, and the strong swing away, in the 1920's, from what then seemed the intolerable levity of pre-war modernism, with its endless feuds and factions. As a character observes in a 1923 novel by Carl Van Vechten;

Everything one called modern a year or two ago is old-fashioned: Freud, Mary Garden, Einstein, Wyndham Lewis, Dada, glands, the Six, vers libre, Sem Benelli, Clive Bell, radio, the Ziegfeld Follies, cubism, Sacha Guitry, Ezra Pound, The Little Review, vorticism, Marcel Proust, The Dial, uranians, Gordon Craig, prohibition, the young intellectuals, Sherwood Anderson, normalcy, Guillaume Apollinaire, Charlie Chaplin, screens in stage d-d-d-d-decorations, Aleister Crowley, the Russian Ballet, fireless cookers, The Chauve Souris, Margot Asquith, ectoplasm, Eugène Goossens, the tango, Jacques Copeau, Negro dancing.[6]

The elegance and innovations of Post Impressionism seemed as inappropriate and out-dated to those who had seen trench warfare, as the psychedelia of the 1960s seemed in the more sober 1970's and 1980's. Moreover, by 1920 Grant was in his own mid thirties, and although his work continued to be exhibited and admired, his reputation was to some extent affected by his record of war-time pacifism, and his association with the Bloomsbury anti-war lobby. This hardly enhanced his career in the narrow, xenophobic climate of the inter-war years, in which the younger avant-garde was increasingly involved, developing a more frankly political culture in response to the rise of fascism.[7] His reputation also suffered as the result of a widespread prejudice against all things to do with Bloomsbury in the Forties and Fifties. Nor has it been enhanced by the many pedestrian landscapes that have passed through the auction houses since his death.

It was not until the late 1960's that his work began to be looked at seriously once more, in a period far more receptive to both decorative art and representational painting. The gradual revival of interest in the Bloomsbury Group also ensured that at least some attention would be paid to one of the Group's leading figures, though the emphasis on the writers of Bloomsbury continues to eclipse its artists.

Above all it has been the restoration, after his death, of the artist's home, Charleston, and its recent opening to the public that has made Grant's work accessible to a wide audience for the first time. At Charleston one may see his pictures, fabrics, pottery and design work in the type of environment for which they were envisaged, as elements of an overall aesthetic involving the artist in every aspect of an interior. Writing of Charleston, the artist Angelica Garnett has described how her parents, Vanessa Bell and Duncan Grant;

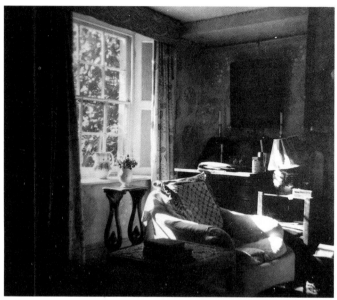

3 Charleston, The Sitting Room, early 1960's

did not affect the sustained brilliance displayed by their friends and relations. They flourished in a more relaxed atmosphere, where they could give full rein to a natural sensuality, indifferent to the ordinary conventions of social intercourse, free to dream about such abstract notions as light, space and colour. Imposed by circumstances and discovered by luck, Charleston was exactly what they needed.[8]

As she explains;

The fascination of Charleston lies in its contradictions. The very simplicity of the house left Duncan and Vanessa free to rediscover impressions that had accumulated from things seen abroad before the 1914 war, things which may have derived an added potency from their temporary inaccessibility. The Italian Quattrocento and Romanesque wall painting can be seen behind the form and colour of Post Impressionism, but the most far reaching influence was that which came from Italian fresco via Piero della Francesca, Giotto and Veronese. It was this that enabled them to make the imaginative leap from seeing walls, doors and fireplaces as a potentially tasteful background, to treating them – like canvases – as an opportunity to make a statement of a very personal nature. Such a change of perspective left William Morris and the English decorative tradition far behind and

one is justifiably astonished as well as impressed by the success with which they imposed so foreign a vision on the walls of a Sussex farmhouse.[9]

At long last, it seems likely that Duncan Grant will be increasingly widely regarded and admired in his own right, and on his own artistic terms, and that invidious and misleading comparisons between the artists of Bloomsbury and the Arts and Crafts movement will be less frequently made. Although his taste was evidently informed from a very early age by the decorative abstraction of the late Pre-Raphaelites and the Aesthetic Movement, it is difficult to think of two more different outlooks and approaches to design than those of William Morris and Duncan Grant. Nothing could be further from the spontaneity and rich cultural associations of Grant's work than the fussy, mechanical repeats of a William Morris wallpaper, or his timid use of colour. If we seek precedents to the spirited sense of touch, and subtle abstraction that characterises so much of Grant's work as a designer, we should look to more radical designers such as E. W. Godwin, Lewis F. Day, and Walter Crane, artists who prepared many of Grant's generation for the reception of Post Impressionism.

At a time when influential yet ill-informed critics can still claim that the lives of Bloomsbury's artists are of more interest than their work, it is helpful to consider Grant's career rather than his personal life, although the separation is to some extent artificial, since his life so constantly emerges through and in his work. He was educated as an artist in a tradition of emulation, within which painters were trained to understand and honour the history of the artistic conventions in which they were formed. The viewer was similarly expected to be able to pick up and identify references to the work of other painters. Grant's work is replete with such references, and his career consisted of long and intimate dialogues with those artists he most admired – Bonnard, Giotto, Piero, Titian, Poussin, Chardin, Zurburan, Rembrandt, Watteau, Delacroix, Cézanne, Matisse, Derain, and, above all, Picasso.

As the perceptive American art historian Christopher Reed has pointed out, the artists of Bloomsbury appear of special interest today;

as an alternative to the precious materials and machined sleekness of the 'heroic' modernism exemplified in the designs of Le Corbusier.[10]

Following the work of Witold Rybczynski, Reed criticises the ideal of the Corbusian house;

or, in the architect's words, 'machine for living', one much like another, with its tiny, inconvenient kitchen, the absence of privacy in its flow-through spaces, and its inability to accommodate the clutter of daily life, all glossed over with an aesthetic of high-tech efficiency.[11]

As Reed concludes, the growing disenchantment with functionalist modernism encourages a greater sensitivity to the diversity of modernist aesthetics, and their relations to many different social circumstances:

In this age – often termed 'Post-modern' in recognition of its self-conscious abandonment of modernist authority – such historical alternatives to the evolution of modernism as Bloomsbury take on a new currency. Even the term 'Post-modernism', with its echo of the Bloomsbury-coined 'Post-Impressionism', suggests Bloomsbury's relevance to contemporary culture. Indeed, many of Bloomsbury's basic aesthetics and social attitudes – hitherto condemned as failures to live up to, or wilful deviance from modernist norms – seem to anticipate the principles of the Post-modern.[12]

From this perspective, Grant's work becomes important and of interest by virtue of his refusal to abide by many of the fundamental conventions of early and mid twentieth-century aesthetics. For example, his career can be considered as a series of temporary resolutions of the orthodox modernist division between fine art and design, a division that is never resolved, but which is itself addressed in the work. Sadly, a widespread and fashionable view of Bloomsbury as a group of harmless eccentrics, neatly obscures much of the radical thrust of Grant's career, and in particular the relation in his life and his artistic practice between the studio and the home. Perhaps only Bonnard has more obsessively sought to domesticate aesthetics in

the twentieth century, and I can think of no British artist, except Vanessa Bell, who has so assiduously made the home, and the related spheres of holidays, pleasure, sensuality and domesticity the central focus of his or her career.[23]

Without wishing to regard Grant's work as a mere 'reflection' of his social ambience, it should be recognised as part of the wider cultural project of Bloomsbury, which insisted on regarding Britain as a part of the larger pattern of European culture some sixty years before the United Kingdom formally joined the European Community. His outlook and values were always hostile to nationalism, and moralism of all kinds, especially in matters of sexuality. It is no coincidence that one of his earliest successes was a poster for the Women's Suffrage movement.[13]

Duncan Grant dreaded 'good taste', and agreed with Roger Fry that it is usually a social rather than an aesthetic value, founded upon snobbery.[14] Such attitudes were axiomatic within the Bloomsbury Group, and Grant upheld them all his life. Nor should we under-estimate the extent of hostility in Edwardian England to atheism, or the faintest whiff of republicanism. In spite of their many differences – and Bloomsbury was by no means invariably homogeneous in its beliefs – most of the Group's original members would have enthusiastically supported Leonard Woolf's later definition of the objective of a civilised society as the construction of, 'a society in which the free development of each is the condition of the free development of all and in which the existence of every individual was widened, enriched, and promoted'.[15]

Such beliefs had clear corollaries in Bloomsbury aesthetics, and its actual artistic practice. Firstly, it encouraged the Bloomsbury critics to think, as Christopher Reed puts it, that, 'their purpose was to encourage the sensitivity to aesthetic pleasure, inborn – like musical pitch, to a greater or lesser extent – in everyone'.[16] Secondly, it encouraged the Bloomsbury artists to bring their social and their artistic lives closely together. It also encouraged them to some extent to cut themselves off from the rest of society, which could at times lead to a failure of critical

judgement, and over-production. Angelica Garnett has said that all Vanessa and Duncan talked about was painting, but in a narrow and uncritical sense. Vanessa might suggest minor pictorial changes to Duncan, 'a line to be moved an inch or so', but 'never questioned the conception or value of pictures'.[17] None the less, their collaboration stimulated all their best work, as he gently led the way, and she generally followed.

It is difficult to assess Grant's view of himself as an artist, since, apart from asides in letters, he left only fragmentary writings. In this respect the influence of Bloomsbury was less constructive. Writing from Charleston in March 1917, he cautioned his old friend Virginia Woolf to,

Remember please I cannot express myself with pen and ink and feel terrifyingly empty and confounded when I try to.[18]

Ten years later he wrote to her from Cassis in the south of France, praising her recent novel *To The Lighthouse*:

I think by the way that the dinner party is an absolute chef d'oeuvre. If I were writing a review I should say I know "nothing like it in English literature". However unfortunately you know the little I know of English literature.[19]

He seems to have subscribed cheerfully to the prevailing Bloomsbury opinion that, by their nature, visual artists cannot write, or writers paint. Yet he was also a highly literate and well-read man. For example, a note in a sketch-book lists books that he had read at Charleston in the summer of 1924, including Didier's *L'Art Français de 19me. Siècle*, Baudelaire, *The Mutiny on The Bounty*, Radiguet's *La Bal du Compte Orgel*, and Macaulay's essays on Milton, Frederick the Great, and Madame D'Arblay. Another note records that in the following summer he read Gray's poems, the memoirs of Hector Berlioz, *The Story of Genji*, Delaborde's life of Ingres, Mrs Gaskell's life of Charlotte Bronte, and Frazer's *The Golden Bough*.[20] Like many artists who live and work in predominantly literary cultures, he assumed a convenient persona, allowing him to be accepted and taken seriously, at the same time protecting him from being swamped by literary criticism and theory, by which he and Vanessa Bell both felt

constantly threatened. This to some extent explains the nature of their everyday working lives at Charleston.

Charleston was undoubtedly the *sine qua non* of both their lives. As Angelica Garnett has written, here Vanessa at last discovered 'somewhere to live which suited her gift for balancing between the demands of a family and artistic creation: the perfect canvas on which to let herself go'.[21] For Duncan it was a safe haven, in which he could uninterruptedly pursue his chief pleasure – painting. At the same time, however, they both maintained studios in London until the end of their respective lives. In this manner Duncan always managed to be a central figure in the social and professional life of the London art world, whilst not entirely of it. He was able to sustain friendships with artists of his own generation, including Sir Matthew Smith, Dunoyer de Segonzac, and John Nash, as well as younger painters such as Keith Baynes, William Coldstream, Claude Rogers and Robert Medley. London also protected him from his tendency to be completely reliant on Vanessa, 'converting her into an oracle whose judgement was final and who was therefore placed outside and above ordinary human relationships'.[22]

At Charleston, Duncan Grant perfected one of the most distinguished decorative styles produced within the modern movement, a style which none the less fits somewhat uneasily with the canonical taste and values of orthodox design history. Hence the need to look at his work for what it is, and to resist any temptation to try to judge it against the criteria of functionalism. For amongst other things, his work helps us the better to understand the wider latitude of modernism, and I would argue that an appreciation of the real achievements both of the artists of Bloomsbury and of European functionalist design is enhanced by an awareness of the full range of options that opened out from Parisian modernism in the early years of the century.

This point may perhaps be clarified by way of anecdote. When I was an undergraduate at the University of Sussex in the late 1960's, I came across a book written by Dorothy Todd and Raymond Mortimer entitled *The New Interior Decoration*.[23] First published

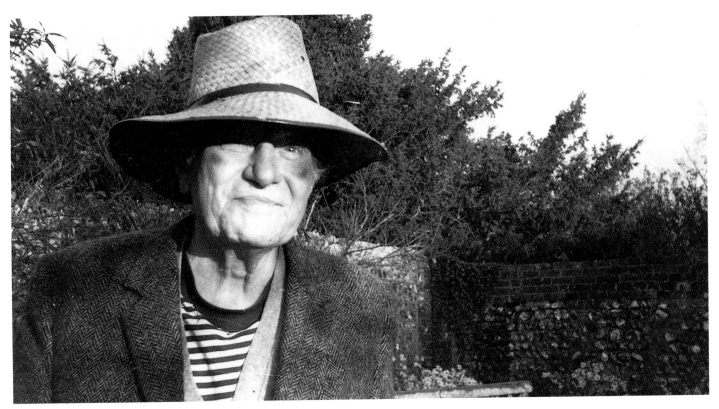

4 Duncan Grant 1969, photograph by Simon Watney

in 1929, it was copiously illustrated, and set the contemporary work of Le Corbusier, Gropius and Mallet Stevens alongside that of Vanessa Bell and Duncan Grant, together with a few of their younger followers including John Banting. At the time this struck me as more than a little absurd, but the years have increased my respect for the authors' intentions, and their argument that,

'As life becomes more uniform and is increasingly dominated by machines, we may wish in our homes to escape from this impersonality. We need fantasy, imagination, wit in our houses. We want to relax, to enjoy intimacy, to feel, as well as actually to be, comfortable. The Corbusier style of decoration is as formal as the old French salon which had hard-backed chairs at regular intervals all round it. We require our homes to be quieter, more informal, more personal.'[24]

Duncan Grant may never have had the opportunity that he might have liked, to design the rooms and buildings that he decorated. Yet in the event, he created a style that is indeed instinct with fantasy, imagination, wit, and a strong sense of physical comfort, qualities in short supply in modern Britain, where all too often it may fairly be concluded that whimsy is all, whimsy and 'good taste'.

I had the good fortune to know Duncan Grant for the last decade of his life. We were first introduced at a dinner-party in Brighton in 1968. He was wearing a pair of extremely baggy black-and-white checkered trousers, and had evidently made some effort to dress for the occasion, sporting a rose from the garden at Charleston on the lapel of his flapping black jacket. Entering the dining-room, he peered round amiably from beneath his inevitable straw hat with the con-

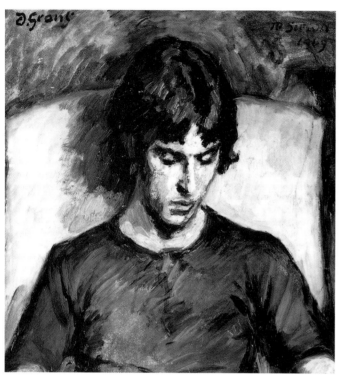

5 *Portrait of Simon Watney* 1969, oil on board, 15¼ × 142″ (38.5 × 36.7 cms.), private collection

modelling was the fate of most regular visitors to Charleston, whether friends or family. Our friendship prospered, I think, precisely because I offered him some access to a social world from which he was, for a variety of reasons, somewhat cut off. It was certainly not as an undergraduate art historian that Duncan saw me, but as someone actively involved in the contemporary social life of the still swinging Sixties. He was ever eager to hear of one's amours, keen to meet friends and lovers, especially if they could be pressed into service as sitters. In this way there was no interruption to the central business of his life – his art. Charleston ran in those days like an ancient and infinitely beautiful clock, and it is not I hope unfair to the memory of either Grace or Walter Higgens, who worked for Duncan as house-keeper and gardener, to compare them to the figures on some ornate campanile (I think of Venice), striding out from the body of the mechanism to sound the hand-bell in the hall around which the life of the household revolved. What I quickly came to love and respect in Duncan was his absolute refusal to moralise, or to judge other peoples' lives according to excessively abstract theories. All he wanted to do was observe and, on the basis of observation, to inhabit a world largely of his own making, in the defence of which he was quietly and unobtrusively ruthless. As Angelica Garnett shrewdly notes,

he never wore the harrassed look of those who hang their cares like an invisible chain of office round their shoulders, and this was in part the secret of his attraction, particularly for the young. He possessed the instinctive wisdom of an animal, never undertaking responsibilities that belonged to others, never promising more than he could perform. He bobbed on the surface, gently irrepressible, impervious as a duck to water, elusive as a leaf on a pond. If this appears to be egotism then Duncan was a consummate egotist, with a clarity of vision that is rare, doing neither more nor less than he wanted.[25]

fident humility of a Confucian sage. None the less, his shirt-tail refused to stay in its allotted place, and hung down between the back of his jacket and the inside of his knees, accidentally but splendidly enhancing the curious oriental effect. I was lucky enough to be invited back to Charleston the following week, for tea, and thus began a friendship that was to last until his death. I visited him at Charleston almost weekly for tea or dinner in the following years, as often as not staying overnight in Clive Bell's old bedroom, which overlooks the pond at the front of the house, where the leathery leaves of a mighty magnolia grandiflora scratched amicably against the window-panes, admitting a subterranean green light to the pale grey, green and ochre interior of what had originally been Vanessa's studio when she took the house in 1917.

I sat for various figures in his later paintings, for

Duncan never, I believe, sought worldly success or material riches. Instead, he preferred to reduce discomfort to a minimum, surrounding himself as far as possible with variously amusing, attractive and preferably intelligent people, and the pleasures that he liked to

14

take for granted. Those included good claret, Harvey's bottled Nutbrown ale, French coffee (which arrived weekly from the Algerian Coffee Stores in Soho), and oranges. These latter he would cut into quarters at breakfast, as his porridge arrived from its battered bain-marie, sucking the juice somewhat messily from the rind on the virtuous precedent, as he explained, of the 'Good Queen', meaning Victoria, for whom he always maintained a great show of affection. That at any rate is how he struck a gauche teenager.

It is beyond my brief and my means to provide more than this hint of Duncan's character – his extraordinary dignity (on which he never stood), his rare and delighted sense of the absurd, his alchemical capacity to strain a sometimes sordid world of all that is unpleasant, and to represent a style of life devoid of ostentation or conceit, endlessly brimming over with his own astonishingly fertile sense of fantasy. Duncan taught me, and many others, to respect the *work* of painting, to understand something of what it means to be a serious artist. In his life that involved the courage continually to take his most peripheral, fragile and uncertain perceptions, and to trust them to be the centre of his very existence. He intensely disliked teaching, yet his entire life was a model of instruction to other, less formed spirits. He was the most complete and thorough professional, and as Quentin Bell notes,

he was more serious in the studio than anywhere else in the world I think, and he was capable of being very much alone in a kind of private universe where there was just him and the thing he was painting, and yet capable of coping agreeably, sensibly, with the world outside all the time . . . I think he was instinctively, and perhaps shall we say in a kind of involuntary way, against *terribilità* . . . I think on the whole his was a very happy life, although no doubt there were chaps who made it miserable at times. Simply because he could get an enormous amount from very simple things; simply from finding a sunny place in which to sit down and contemplate the world, and of course, more intense pleasure when he was able to do that with brush or pencil handy.[26]

Duncan Grant was a highly prolific artist. He worked every day that he could, to a strict routine. He was also an uneven artist, though there is work of the highest quality from all periods of his career. Much of his best work remains in private hands, and much undoubtedly remains unknown. In my choice of illustrations I have tried to give some impression of his range, both in differing media, and across the entire length of his working life. Since it has hitherto been extremely difficult to obtain any direct awareness of the range of Grant's work, I have provided an overview of his entire career, concentrating on his basic themes and techniques. More detailed art historical analysis is required to clarify the full record of his contributions to exhibitions, and to a large number of British art institutions, from the founding of the Arts Council, in which he was closely involved as an advisor, to the Society of Industrial Artists and Designers. Nor have I dealt with Grant's work for the theatre in anything like the detail it deserves. Yet I hope that readers will come away from this book with an increased understanding of Grant's considerable artistic gifts, and hence with an enlarged and enhanced appreciation of British twentieth-century art as a whole.

The rediscovery of the quality of the art of Duncan Grant is part of the constantly changing process by which cultures find images and ideas that help them further understand themselves in the present. It would certainly seem that our renewed interest in the artists of Bloomsbury is connected to other contemporary re-evaluations, the change in taste that makes us newly aware of the greatness of De Chirico's later work, or the German Neue Sachlichkeit painters, or the American Synchronists, or Picabia.

Writing of such changes and re-evaluation in previous centuries, Francis Haskell insists that;

To conclude that variations in taste in the arts are, like pagan Gods, so wholly arbitrary and capricious that they can merely be observed – is to abdicate responsibility at too early a stage.[27]

In reconsidering the art of Duncan Grant, we might pause for a moment to reflect on the changing face of Britain, and of aesthetics, that make so much of his work seem so transparently and unquestionably life-enhancing and brilliant today.

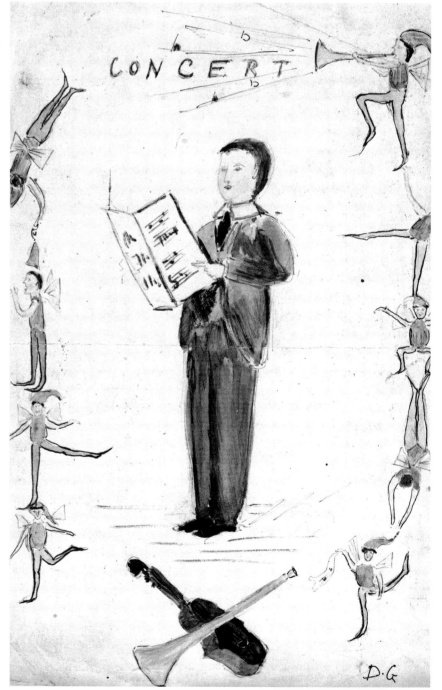

6 (above) Duncan Grant c.1888, Charleston Trust.
7 (below left) *Self Portrait* c.1892, pencil and watercolour on card, 3½ × 1¾" (9 × 4.7 cms.), private collection.
8 (below right) Duncan Grant c.1897.
9 (right) *Concert Programme from Hillbrow School* 1897, pencil, ink and watercolour on paper, 8¼ × 5¼" (21 × 13.2 cms.), private collection

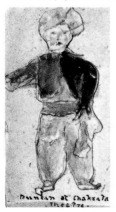

Formative Years

Duncan James Corrowr Grant was born of a distinguished and ancient Scottish Highland family, on 21 January, 1885, at his father's family home, The Doune, in Rothiemurchus, Inverness. As is well known, he was the only child of the love-match between Major Bartle Grant and Ethel McNeil, whom Bloomsbury folklore, and possibly history, would have as a penniless beauty. Whilst photographs testify to Ethel's beauty, her son's life thus began on a wholly appropriate note of legend and improbable romance. Duncan's parents had returned to Britain for his birth, as was standard practice for military families serving overseas. Of his immediate origins, I can do no better than quote from his close friend David Garnett's eloquent memoirs. Duncan Grant was,

a first cousin of the Stracheys – Lady Strachey having been a daughter of Sir John Peter Grant, 11th Laird of Rothiemurchus. Duncan's father, Major Bartle Grant, was a younger son who, after enlisting in an expensive and fashionable regiment, improvidently married the most beautiful young woman, a portionless Scottish girl called Ethel McNeil, whom he met in India ... His father, who was by gifts and inclination a musician, a botanist and a cook learned in the history of gastronomy, was left a poor man after his father's death. He exchanged into a line regiment, but the army bored him; he could not earn a living by writing accompaniments to Victorian drawing-room songs, or by his knowledge of Burmese orchids.

Mrs Grant was about forty-five when I first met her and one of the most lovely women I have ever known ... She was not in the least intellectual, but had that rich warmth which comes to women who have created the world they wanted around them, in face of all sorts of difficulties ... Duncan inherited his mother's beauty and more than his father's intelligence and aesthetic tastes.[1]

His childhood was spent in Burma and in India, returning every two years to Britain, as again was standard practice for army families. Looking back some seventy years later, he recalled,

quite well when I was six years old at Chakrata I think in the Himalayas being dressed for a party I suppose in black satin knee breeches, lace ruffs & white wig, and sitting dangling a silver-handled cane. A strong feeling overcame me which I can only described as an aristocratic feeling, suggested I

suppose by my get up. But I distinctly remember the certain satisfaction of the feeling of power and direction with which I was filled. At this time of course, no sense of poverty had entered my life. We had many native servants. I had an English nurse. I was devoted to my mother and liked the company of the army officers, friends of my father. With this sense of security & background, it was easy to loll and to dream of power, and to believe that to observe life was the way to live.[2]

It is extremely fortunate that an unusually substantial quantity of juvenilia survives from these childhood years, a likely indication that the talent for drawing that derived from his taste for observing was recognised from a very early age. His mother collected her son's work in a bound album. Dating from as early as 1892, it includes many drawings of ships, copies from Christmas cards, and vignettes from everyday life – a kitchen cupboard with its doors open to disclose pots and plates, a canary in a wooden cage, and still lifes. Many of these have carefully designed decorative borders around them, prefiguring Grant's lifelong interest in patterning. An 1893 interior of St. Paul's Cathedral, presumably copied from a postcard, is all but overwhelmed by a brilliant decorated mount, with flowers and wriggling streamers of red and yellow. Another, larger watercolour, dated February 1893, shows a horse-drawn rickshaw with its driver, with the white horse left unpainted as negative space. There is even a tiny self-portrait in Indian costume, complete with turban, at about the age of six.

Many of the drawings and paintings are dedicated to his nurse, Alice Bates, from whom he was separated when he was sent back to England to attend school in 1894. She was an important figure in his childhood, and encouraged his drawing, thinking that he would eventually become an architect.[3] Many years later he placed an advertisement in *The Times* and eventually tracked her down to Billingshurst in Sussex, though this was not without its complications since, as he informed Vanessa in a letter, he also heard from, 'a sham Alice Bates' who wrote back to him from Liverpool, 'in a slightly offended tone I thought. I shall have to write to her too.'[4]

work revealing acute observation, and that employing his great gift for colour and abstract design, before he was ten years old. That division, in different ways, continued to inform his entire career as an artist, and becomes increasingly apparent in the few works surviving from his time at Hillbrow Preparatory School, Rugby, which he attended from 1894 until 1899. For example, from early in his years at Rugby he sent Alice a careful drawing, which is inscribed in his words on the reverse, showing, 'The cottage at Rugby where Tom Brown enjoyed sausages and roast potatoes after a football match.' Yet at the same time he designed the cover of a programme for a school concert, with the figure of a standing schoolboy in uniform, singing from a score that he holds up in front of him. The singer however is surrounded by an astonishing decorative border of tiny winged figures, dressed in natty red and green outfits, one of whom blows on a trumpet which announces the one word, 'Concert'. Equally astonishing is the small decorative motif at the bottom of the programme cover, which shows two crossed musical instruments, a trumpet and a violin, an image that would again reappear repeatedly throughout his life.

In the juvenilia one may also detect a strong feeling for textures and shapes: an imaginary bird is painted on a piece of cut cardboard, and its wings and tail have then been painted with glue, onto which glitter has been carefully poured. This all reinforces the impression of a remarkably gifted child, already extremely confident in his abilities. It is therefore understandable that his art teachers at Rugby, and then at St. Paul's, should have taken a special interest in him. He later described his teacher at Rugby as,

a genuine painter and a pleasant man who made me understand that he thought I had some talent and gave our class delightful things to do such as copying Japanese prints. Then there was the headmaster's wife ... who on Sundays read scenes from Dickens and lent me a large volume of reproductions of the work of Burne-Jones. This was a revelation to me, I suppose of a purely aesthetic nature. I had always hitherto pored over the yearly books of the Academicians, but Burne-Jones was different. I couldn't

10 *Tea* 1899, ink on paper, 6 × 7″ (15.2 × 17.8 cms.), private collection

One of the very finest of these early pictures shows, in profile, a woman with long brown hair, holding a green fan seated before a goldfish bowl set on a table. In the background there is an amazing decorative frieze, painted in brilliant blues, reds and yellows, which is almost unnervingly like a later design from the Omega Workshops. There are also many images of angels and other winged figures that continue to appear in his work for the rest of his life. And perhaps most remarkable of all, there is a tiny painting, also from *c.* 1893, showing an oblong box, decorated with blue, yellow, red, green, and brown stripes, which clearly anticipates a lifetime of painting on any and every surface available to him.

Already one may clearly discern a division between

explain this to myself, but for years I would ask God on my knees at prayers to allow me to become as good a painter as he. I am still very doubtful if God answered my prayers.[5]

He summarised the impact of Burne-Jones as,

a new, utterly unknown experience for me, to see something which was done from the aesthetic point of view, and not just a story, or something in the Academy pictures, which were wildly exciting – battle pieces and things of that sort – which I thought were the best thing going, until I saw Burne-Jones.[6]

In the first year of his holidays from school he would stay with his grandmother, Lady Grant, then living at Hogarth House in Chiswick, and was afterwards aware of having benefited from her society.

Totally without self-consciousness she would talk about her pictures, and experiences in Italy. She was a beautiful old lady, directly a relic of the Byronic age. She possessed a slender foot painted on a piece of marble, and another of a lustrous eye.[7]

By the time he left Hillbrow in 1899 he was determined to become a painter.[8] At Hillbrow he had been a friend of his older cousin, James Strachey, and had visited his aunt and uncle's family on several occasions. In London, he attended St. Paul's School for the first two terms as a boarder, and then became a dayboy, living with the Stracheys at Lancaster Gate. A drawing from this time shows him more impressed by Beardsley than Burne-Jones, especially in the dotted rendering of the pig-tailed page, the woman's sleeves, and the man's cravat. In *Tea*, the contrast between the large abstract forms of the overall design, and the detailed texturing of trees, hair and fabrics, also seems to anticipate some aspects of his later approach to Post Impressionism. With this in mind, one may legitimately begin to find traces of Beardsley in many later paintings, such as *The Queen of Sheba* from 1912. Another drawing from this period shows a shepherd boy with sheep, and is much closer to Burne-Jones, and Walter Crane. It was framed between two illustrated initial letters, and already suggests an interest in the relation of images that he would later explore in his many decorated screens. There was also at Charleston,

and perhaps still is, from around the year 1900, a framed group of three watercolour studies of chickens running and scratching, very closely observed. Other watercolours also survive, with figures in elaborate eighteenth-century costume, and pierrots, prancing in the toy-town style of Walter Crane and his many followers.

We have already seen that Grant was well aware of himself as an artist from an early age, and it is not entirely surprising that he did not learn to read until he was nine years old.[9] It would seem likely that the extremely literary emphasis of the Strachey household would have further reinforced his own distinctly different identity as an artist.

Although he won at least one prize for art at St. Paul's, it is significant that by 1900 he was also attending private art classes under Louise Jopling, whom Richard Shone notes had been a friend and model to both Millais and Whistler, a combination of influences that must have been somewhat confusing for her.[10] Many years later Grant helped organise a celebratory dinner party at the Café Royal for two of the art masters at St. Paul's who had taught him, and younger pupils including Claude Rogers.[11] Many years later he commented that they 'were very intelligent, but not as good as the one at Hillbrow'.[12]

He was not happy at St. Paul's, partly since the poverty of his parents seemed set to doom him either to the army, or a career in the rice trade, though he conceded that, 'My mother, I think, was rather uncertain as to how much I wished to become a rice merchant'.[13] The artist Peggy Angus recalled a conversation on the subject of education between Duncan and Clive Bell at Charleston, in the course of which Duncan stated his objection to sending children away to boarding schools on the grounds that they can only talk to one another, and lack any access to 'conversation', as he had been fortunate enough to experience at the Strachey household in Lancaster Gate, to which he returned daily after school.[14] Quite what all the conversation meant to him is less clear. Looking back in 1917 he wrote to Virginia Woolf of James Strachey, that he,

11 *Shepherd*
c.1900,
ink on paper,
4½ × 4¼"
(11.4×11 cms.),
private
collection

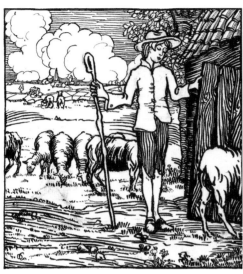

12 *Lead Garden
Statue* c.1902,
illustration in The
Tate Gallery
Archives,
London

has a lot of good points but I have seldom met a person who was less creative in the head. After all what have any of them done but sit like cats in the sun spitting? You mustn't think I don't value these qualities, but it has suddenly come over me – their unproductiveness . . . this view of intellect as an end in itself (which I sometimes feel to be held by some of them), exasperates me.[15]

It may also have been difficult for him to accept his position as a poor relation, and this perhaps explains something about the role and importance of fantasy in his early work, and in his early life, expressed in the often elaborate persona which he adopted in these years, to protect him. Hence the aptness of David Garnett's comparison of him as a young man, to Dostoevsky's Prince Myshkin, 'taken for an idiot by narrowly conventional people'.[16] This was certainly a role that he took some trouble to cultivate. On one occasion he dressed up as an old lady and called upon his aunt, Lady Strachey, giving a German name, and,

was ushered into the drawing-room and announced by the housemaid. . . . he explained in guttural accents that he was a friend of a certain Fraulein Grüner, a formidable and high-brow school-mistress acquaintance of Lady Strachey's. He then entered into a lively conversation with the visitors round the tea-table and eventually got up and took his departure without his aunt having the slightest suspicion that her visitor might not be what she seemed.[17]

In the 1910's he would sometimes don a false beard and moustache, before setting out to observe people in the streets of London, whilst his many performances at Bloomsbury parties, and his fondness for fancy dress, is well known. Fortunately he was a great favourite with Lady Strachey, who eventually took his mother to one side and suggested that since Duncan was not doing well at St. Paul's, and only wanted to draw and paint, it would be better for him to go to an art school. Privately she confided to her son Lytton, 'The great excitement is about Duncan who appears likely to turn out to be a genius of an artist . . . but what to do with him is the difficulty.'[18] According to David Garnett, Duncan deliberately played the dunce with her, in order to get taken away from school, where he had at first been placed in the army class, and in 1902 he

entered the Westminster School of Art, which he attended for the next three years.[19]

Long since closed, the Westminster School of Art was then housed 'in a curious ramshackle building near Westminster Abbey'.[20] Sickert taught there after 1908 for some ten years, but in Grant's day his Professor, a Mr. Loudan, was, 'a successful Scotch painter of children's portraits . . . of no importance whatever'.[21] However, amongst his fellow students he reported, 'The conversation about painting was certainly more intelligent and less puritanical than much I have listened to since.'[22] Whistler and Degas appear to have been the most highly regarded artists by Grant's contemporaries, and they, 'despised much of the contemporary painting in England. It was not a provincial atmosphere at all.'[23]

He was also extremely fortunate in the arrival into the Strachey ménage of the French artist Simon Bussy. Recently arrived from Paris, Bussy had been a pupil of Gustave Moreau at the Académie des Beaux Arts, where he also struck up a lifelong friendship with another of Moreau's students, Henri Matisse, Bussy's work belonging far more to the direct legacy of French Symbolism.

Bussy set Grant to work copying the works of the Old Masters in the National Gallery, not always leaving the choice of picture to his pupil, who recalled that he, 'told me to work every day and not to rely on inspiration'.[24] He also remarked on the use of the word 'clou' in both Bussy and Matisse's artistic vocabulary; 'every picture must have its clou. This was I suppose some point of the utmost importance in the composition of a picture or the colour harmonies, without which all would collapse.'[25] He did not sound terribly convinced about this, but the habit of working every day stayed with him, together with the practice of copying and adapting other, earlier artists' pictures. A small landscape done on a visit to the Hebrides reveals the influence of Bussy very clearly, in the dry, finely graded tone, and the generalised flatness of the composition. Though dated 1902 on the canvas, it was undoubtedly painted in the summer of 1903. His grasp of dates was ever elusive.

In a rare review, published in *The Spectator*, Grant praised Bussy's pastels in terms that tell us much about the older artist's influence on both his painting and his way of thinking:

The spectator will find it impossible to say: 'I like that tree and that hill; but I do not like the sky'. He will find that they exist in the picture only for the sake of their relationship to one another, and that only that portion of the aspect of an object is chosen which plays its part with other forms, tones, and colours to complete a whole, and reproduce the deliberate impressions of the painter. It is this deliberation, this intentional suppression of certain natural details in order to convey a sustained and essential impression, that will perhaps cause some people to exclaim: 'Well, I never saw anything look like that!' But that is hardly the point, which is rather: 'Are we not glad that M. Bussy has?'.[26]

Grant also did graphic work for a publication entitled *The Country Gentleman*, which his mother preserved in an album, together with press cuttings of reviews and illustrations of her son's work, now lodged in the archives of the Tate Gallery. It includes an illustration of the design for two lead figures in picturesque and fanciful rural costumes of the eighteenth century, a flower maiden and a bowing man, intended to stand facing one another on adjoining balustrades.[27] There is also a careful line illustration of a supposedly Saxon dovecot at Streatley-on-Thames, where he spent part of the summer of 1902. An illustration of a cart-horse was published in April 1904. At Streatley he painted *The Kitchen*, a small picture showing a luminous interior, which reveals a wholly contemporary and intelligent interest in Whistler, together with French naturalism.

It was also at Streatley that he had, 'a sort of visionary experience', which he described in a later memoir of his studies in Paris. According to his own account, he heard a voice from outside of himself, telling him:

You must go out into the world . . . to learn all there is to know and be seen in the world of painting. The Impressionists you must see and learn from and then there are other things going on at this very moment of which you know nothing.[28]

The visionary command was fulfilled soon enough, perhaps as the result of its repetition to his family as may have been intended, for in the autumn of 1904 he travelled with his mother to Florence for the winter, following in the footsteps of his hero, Burne-Jones, who had visited Italy in 1859. However, it was not contemporary Italian art that engaged his attention. On the contrary, it was to the Quattrocento that he turned, and to the Florentine tradition at its purest. He copied from Masaccio's celebrated frescoes in the Brancacci Chapel of the Carmine Church, which Michelangelo himself had copied as a student. Grant also copied Piero della Francesca's portrait in the Uffizi of the warrior Duke of Urbino, Federico da Monte-feltro. His very exact version hung at Charleston until his death, and although in some respects it was a strange choice of picture to inspire a young painter, the curious wounded profile of Federico's face has a powerful effect in relation to the simplified forms of his hat and dress. Grant also visited Siena and Arezzo, where he saw the great fresco series of scenes from the legend of the Holy Cross, by Piero della Francesca, in the church of San Francesco. This proved to be one of the most decisive sources of artistic inspiration in his life, and was in all probability recommended to him by Simon Bussy. The mystic voice seems also to have impressed his Aunt Elinor, Lady Colvile, who arranged for the sum of £100 to be made available to him on his twenty-first birthday.

Returning to England in 1905, he left the Westminster School of Art, and for a short time rented a studio on Upper Baker Street, whilst living with his parents who had returned to Britain for good, and were now settled in Belsize Park. It was at this time that he first met Vanessa Stephen (later Bell), at the Friday Club, a group of painters and others, which she had brought together the previous autumn. He visited France and Wales that summer, and returned to Paris within weeks of his twenty-first birthday, in January 1906, armed with a letter of introduction from Simon Bussy to M. Jacques-Emile Blanche, a well-known society painter who had recently opened his own teaching académie, La Palette.

Grant found Blanche sympathetic as a teacher:

he always allowed his pupils to go along their own lines rather than paint as he painted. [29]

Classes took place in the morning at La Palette, leaving the afternoons for copying in the Louvre, though he was amused by Blanche's

passion for the rather second-rate collection of English Eighteenth Century portraits which the Louvre possesses. Standing in front of a not very good Hoppner he excitedly pointed out that the white dress was the most brilliant patch in the whole of the Louvre. I saw it as a patch of the purest Flake White and found it difficult to give it any great aesthetic significance. [30]

13 *The Kitchen* 1902, oil, 16 × 20″ (40.7 × 50.8 cms.), The Tate Gallery London

This already implies a certain independence of mind, which is reflected in his observation in his Memoir of Paris that,

it would be a fascinating study to follow the meaning of words technically used by painters. In my early days one heard much of tones and values. I do not know exactly what they mean now. I hear people talking of 'les valeurs' and they seem to be talking of pure colour: Le Ton also seems to include much more colour than when I first heard the word used, implying the relative relations of blacks, whites and greys. 'Values' in English I never understood and do not to this day.[31]

This speaks directly from a British art education founded on the then fashionable revival of Velasquez,

and Whistler. Both Vuillard and Bonnard were listed as official 'visitors' to La Palette, but never visited the school whilst Grant was a student, perhaps as a result of an initial rivalry with the more famous Académie Julien, with which they were also associated. Instruction thus fell largely to Blanche, and a few assistants. Blanche was a dandy and a tremendous Anglophile, of whom Grant wrote shrewdly but with affection in retrospect as,

not a great painter though possibly now an undervalued one. That is to say if once again marks are given for adroitness, savoir faire, a gift for getting a likeness and placing the subjects of his portraits in exactly the mileu that best suited their characters . . . He turned a rather nasty and savage eye on his own generation. He could be disgustingly bitter and unfair to Matisse, Derain, Picasso etc.[32]

He was sufficiently sensitive to remark on the pathos of Blanche's total inability to find the correct milieu for his portrait of Thomas Hardy.

At first, Duncan was especially struck by Chardin, whom he copied in the Louvre, and Poussin, for whose drawings he developed a passion, according to a letter he wrote to Lytton Strachey:

I really think they suggest everything that's heavenly in this world. And they are so grand and splendid and at the same time so intimate in some curious way.[33]

In June 1906 he returned to Florence, and stayed with a friend of his family at the Castello in Certaldo, whence he walked to San Gimignano, with which he was enchanted. He also visited the annual Palio horse-race around the streets and Campo Santo of Siena, arriving back in Paris in October, where he remained until the autumn of 1907. His correspondence shows him reading Racine and Molière, as well as the fables of La Fontaine, Shakespeare, Darwin's *The Origin of Species*, and Blake. In February 1907 he was copying in watercolour from Rubens,

a superb youth with wings flying through the air with a portrait of that gross Marie de Medici to show to Henry IV. It sounds bizarre, but there are a great many other characters in the sky and on the earth which carry it beyond all criticism.[34]

14 *Street Scene* c.1906, ink on paper, 8½ × 3¾″ (21.3 × 6.5 cms.), private collection

Although he visited the Caillebotte bequest of Impressionist pictures at the Luxembourg, he seems not to have visited either the great Gauguin retrospective at the Salon d'Automne of 1906, or the equally important Cézanne retrospective which was part of the Salon d'Automne in 1907. Nor does he appear to have been aware of the Fauves, in spite of the furore caused by their exhibition at the first Salon d'Automne in 1905. This may be partly explained by his close associations with the British art community in Paris. His particular friends included the young Birmingham artist, Constance Lloyd, who had been a pupil of Simon Bussy at his Kensington classes a few years earlier, and her circle of acquaintances, including Henry Lamb, who also studied at La Palette, and Gwen John, whom Grant thought a much better artist than her brother, Augustus. He described her, 'in the background, living with her cats on the fortifications'.

Yet it would be wrong to dwell on what Grant did *not* see during his time in Paris, for his copying in the National Gallery and the Louvre prepared him to place Post Impressionism and Cubism in a far wider historical context than was available to many of his contemporaries. Indeed, it is one of the defining characteristics of Bloomsbury modernism that it contained no sense of an avant-gardist rupture with the past. This should not be attributed to the influence of the theoretical writings of Roger Fry and Clive Bell, since it was independently fundamental to the outlook of both Duncan Grant and Vanessa Bell.

Grant was visited in Paris by Clive and Vanessa Bell, her brother Adrian, and her sister Virginia at Easter in 1907, and as a result of this visit he met the Irish ex-patriot artist Roderick O'Conor, who had known Gauguin at Pont-Aven. He also met the Canadian artist James Wilson Morrice, who had moved to Europe in 1890, studying at the Académie Julien, as a follower of Whistler. Little survives of Grant's work in Paris. There was at Charleston in the early 1970's a very academic oil sketch of a male nude, on wood, painted from the life at La Palette, but its present whereabouts are unknown. Some drawings however show a lively interest in the model, together with the

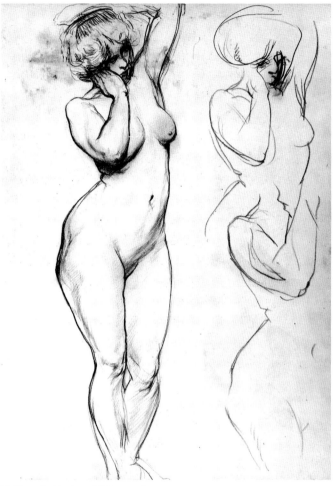

15 *Female Nude* c.1906, pencil on paper, 12¼ × 9½" (31.3 × 24.2 cms.), private collection

In March he was working on a copy of Rembrandt's portrait of a youth with a black cap, which he described as, 'nearly divine', and went to see a collection of Impressionist paintings prior to auction at Durand-Ruel's. He singled out the Renoirs for praise, but remarked that,

Degas sometimes almost oppresses me by his gigantic scholarship but there was a picture of his which ought to have (been) bought by the National Gallery ... It was like a novel by Maupassant.[35]

strong feeling for design which was already well developed.

Returning to England in July 1907, he was commissioned to paint a portrait of his cousin, John Peter Grant, the Laird of Rothiemurchus, drawing on Manet and Degas. He registered at the Slade School of Art in the autumn of 1907 and again in 1908, but there was little that he could learn there, after La Palette. Drawing was at the centre of the Slade's curriculum, and was strictly supervised by Henry Tonks, notorious for reducing his female students to tears. Grant recalled saying to himself during a life class under Tonks,

'I know exactly what I must do to win approval here', and I executed a drawing perfectly in the manner of Tonks. Sure enough, he took the bait. When he came round to me he held up my drawing as an example of what a good drawing should be. I felt rather mean, and also disillusioned.[36]

Without any other means of support he turned to portrait painting, though this cannot have been without a certain sense of irony, since he was well aware that Simon Bussy had come to London to make his name as a portraitist, and had failed, in spite of producing a number of outstanding pictures, including many of the Strachey family and the remarkable portrait of Lady Ottoline Morrell, in the collection of the National Portrait Gallery. Grant's portraits in the years 1908 and 1909 are all eminently serious and literal paintings, relieved only by the arabesques of such fabrics and details of wall-papers as he could fit in. The influence of Simon Bussy is everywhere apparent, and it is a French translation of Dostoevsky, by way of Degas, that we see in *Crime and Punishment*, painted on the back of his *Portrait of Lytton Strachey*, suggesting a shortage of artist's materials, which reveals much about his financial circumstances at this time. However, in 1908 he began what was to prove a most important relationship with John Maynard Keynes, who was then teaching economics at Cambridge. The affair was a serious one, though Grant was less committed from the outset. However, Keynes' company was extremely stimulating, and seems to have given Grant a new confidence in himself. In the summer of

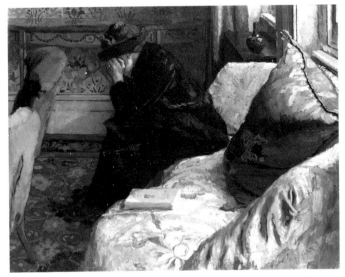

16 *Crime and Punishment* (Marjorie Strachey) 1909, oil on panel, 21 × 26″ (52.5 × 65 cms.), The Tate Gallery, London

1909 Keynes moved into rooms above the gatehouse that leads from King's Lane to Webb's Court, and Grant was a frequent visitor, and made many new friends. In 1910 he designed costumes for an undergraduate production of Aristophanes' *The Birds*, from which there survive some rather spidery drawings in a manner he then frequently employed, possibly based on some Greek vases at the Fitzwilliam Museum, with which he was very struck. There are also several self-portrait drawings and paintings from the years 1909–1910, done in the careful naturalistic manner that he had mastered at La Palette. In several of these he sports fantastical turban-like headgear, probably relating to his participation in the notorious Dreadnought Hoax, when he, together with Adrian and Virginia Stephen, were persuaded by Horace Cole to pass themselves off as Abyssinian princes, on a supposedly 'official' visit to His Majesty's navy at Weymouth. The fancy-dress element also suggests an element of homage to Rembrandt, and also expresses his lifelong fascination with dressing up, and extraordinary hats.

There is from about 1909, a tiny but ravishing still life of *Maynard Keynes' Hat, Shoes and Pipe*, which

hung in the artist's studio at Charleston until his death. More than any other painting from these years, this demonstrates Grant's increasing engagement with the work of Cézanne, as if recognising that he had reached a dead-end of sorts in his portrait style. The flattening of volume by the careful adjustment of marks and colour tones across the entire surface begins a fascination with still life painting that runs through his entire life, and it is worth remarking that the meaning of his best still lifes is always closely connected to the personal and social connotations of the objects depicted. In this instance we are effectively offered a humorous 'portrait' of Keynes, depicted in his absence by his fastidiously chosen hat, gloves and pipe. There is also the implication of intimacy, associated with any scene of clothing lying on the floor.

It was also in 1909 that he visited Matisse at his studio home on the outskirts of Paris, with another letter of introduction from Simon Bussy:

He was very kind to me but it was impossible for me at that age to think of anything to say on seeing his pictures which were in another idiom to anything I'd ever seen before. However he let me sit in the corner of his studio whilst he prepared an enormous canvas in the middle of it, on which I think that afterwards *La Ronde* was painted.[37]

Grant is presumably referring here to *La Dance*, the first version of which was painted in March 1909 at the Boulevard des Invalides, whilst the second version was indeed painted at Issy-les-Moulineaux, in 1910, as a commission from the great Russian collector, Sergei Shchukin in Moscow, where it remains. The picture's famous motif of a circle of dancers against a starkly arbitrary ground and sky was widely admired and imitated throughout the early modernist movement.[38]

It was in all probability at this same time that Grant first visited Leo and Gertrude Stein for several of their Saturday evening 'at homes' in her house on the Rue de Fleurus, which was hung with their unrivalled collection of pictures by Matisse, Picasso, Cézanne, Bonnard, and many others.[39] In 1908 Virginia Woolf had commented to Clive Bell in a letter that she found Duncan Grant, 'difficult, but charming ... I think he has too many ideas, and no way to get rid of them'.[40]

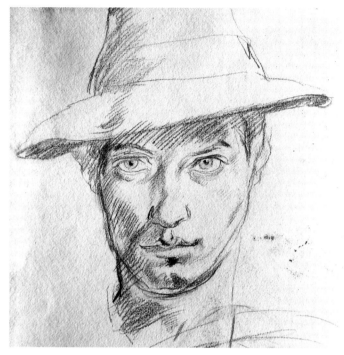

17 *Self Portrait* c.1909, pencil on paper, 8 × 8″ (20 × 20 cms.), collection Stephen Keynes

The experience of the Rue de Fleurus removed any such problem, and in a characteristic manner Grant described his introduction to Cubism as, 'not very gradual'.[41] He recalled Gertrude Stein explaining that the head of the great Picasso *Nude with Drapery* of 1907 derived from the Dresden *Venus* of Giorgione – the original of which was the only painting that had ever moved him spontaneously to tears, not, he added, that that was necessarily, 'any guarantee of anything'.[42]

Grant also remembered Picasso discussing the physical fragility of *Les Demoiselles d'Avignon* with the critic André Salmon, though this suggests a much later date, since Salmon did not exhibit the painting until 1916. Furthermore, the anecdotes concerning the Gertrude Stein salon frequently refer to events that can only have taken place following the development of collage as a pictorial technique after 1912. For example, Grant described how he had found some rolls of old Victorian wallpaper stored away in a cupboard in his

Paris hotel, and took some round to Gertrude Stein's to give to Picasso, who was apparently delighted, but shocked at the thought that they might have been stolen. Grant concluded,

It did seem to me really rather ridiculous to think that I should ever have been found out ... I was very much surprised.[43]

It is safe to assume that Grant first visited the Steins in around 1909, by which time they were in possession of the *Nude with Drapery*, and several preparatory studies.[44] There are two known preliminary studies which show the Nude in a horizontal rather than vertical position, bearing out Grant's statement concerning its relation to the Dresden *Venus*.[45] It would also seem that he was a regular visitor in subsequent years, as is borne out by his descriptions of meeting Léger and others there. The *Nude With Drapery* itself was sold to Shchukin in 1913. Its influence is felt throughout Grant's work in the years from 1910 to 1912 and it would appear to have had a much greater impact on him than the *Demoiselles d'Avignon*, that he also reported seeing in Picasso's studio, though when, or at which of Picasso's studios, is unclear.

In 1909, Grant and Keynes were living together in Belgrave Road, and moved at the end of 1910 to 21 Fitzroy Square, where Duncan set up a studio on the first floor. Adrian and Virginia Stephen were neighbours in the same square, whilst Clive and Vanessa Bell were living nearby in Gordon Square. Grant was by now an accepted member of the circle of friends that became known as the Bloomsbury Group. In June 1910 he exhibited at the first public exhibition organised by Vanessa's Friday Club, and showed work at the Winter Exhibition of the New English Art Club for the second year in succession, and at the age of twenty-five his name was becoming known.

Earlier in 1910 Clive and Vanessa Bell had met Roger Fry by chance at Cambridge railway station, where they were all stuck waiting for a late train. Vanessa renewed her previous very casual acquaintance, and they quickly became firm friends. Fry addressed the Friday Club on 21 February.[46] It was

therefore only a matter of time before Fry and Grant met, though the latter had little or no involvement in the planning or organisation of Fry's First Post Impressionist Exhibition, which opened at the Grafton Galleries, with what must have been careful timing, on 5 November.

Grant's *Portrait of Adrian Stephen* which was painted at this time immediately shows the new confidence he felt. He was especially impressed by the Cézannes at the First Post Impressionist Exhibition, and it should be pointed out that although Grant was deeply versed in the history of European painting, he was hardly in a position to have been familiar with the complex lineage that underpinned the advanced contemporary works by Matisse and Picasso at Gertrude Stein's house. Whereas the French Fauves had the advantage of having been able to follow the complex sequence of French exhibitions of Gauguin, Cézanne, Van Gogh and the pointillistes, the British were faced by them collectively, as one, for the first time. It is important to understand that the work of Cézanne was thus seen as if it were contemporary with that of Matisse. This was to have profound consequences for young British painters, as it did in other countries such as the United States which faced a very similar situation when the Armory Show opened in New York in 1913, modelled by Alfred Stieglitz on Fry's Second Post Impressionist Exhibition.

Yet Grant did not become a fully fledged modernist overnight. Paintings from this time such as *The Lemon Gatherers* and *The Dancers*, both of which exist in two finished versions, show a careful attempt to assimilate something of his recent experience to what he had learned from other sources, including Maurice Denis, and Piero della Francesca. The tall basket-like hats worn by the lemon gatherers are closely related to the remarkable hats worn by many of the figures in Piero's San Francesco frescoes. Furthermore, the evenness of light which defines the forms of the figures evidently derives from Piero, just as the postures of the three standing women derive from the standing angels in Piero's *Baptism of Christ*, in the National Gallery, which Grant had copied under Simon Bussy's supervision.

The principle difference between the two versions of *The Lemon Gatherers* is in the handling of the tree, which in the second version becomes a stunning object constructed by arbitrary brush marks with little or no descriptive function.

It would be difficult to exaggerate the importance of Piero's work to Grant at this time, for it demonstrated the possibility of modelling with light and colour, rather than in the layered chiaroscuro technique that he had learned from the French classical tradition. He described Piero's frescoes as, 'an eye-opener' on his first visit to Florence in 1904, adding that,

I never varied or altered my opinion of him . . . what struck me first of all was the art of fresco painters. It had such a different quality to oil painting. . . .[47]

Grant's *The Dancers* of 1910 combines many different sources and styles of painting. Its figures are stately and three-dimensional, and quite unlike the sprightly women in both versions of Matisse's *La Dance*. Their complex, interlocking arm movements relate as much to the ring of dancing women in Ambrogio Lorenzetti's fourteenth-century frescoes in the Palazzo Pubblico, Siena, as to Matisse, who himself had visited both Siena and Arezzo in the summer of 1907, while staying at the Stein's villa in Fiesole. Nor should one forget the grand circle of scantily clad dancers in Botticelli's *Primavera*, to which Grant's composition also looks, like the many groups of dancing maidens painted by Burne-Jones, which he would also have known.[48] Grant's use of colour, though dramatic, is less radical than that of Matisse, and seems to relate to the type of 'fancy picture' produced by Augustus John and his many followers at this time. In the place of John's exoticised gypsies, Grant offers Italian lemon gatherers and statuesque dancers who suggest an imaginary Arcadia of their own. Nor should one overlook the ground on which *The Dancers* tread, for its wriggling brush-strokes are amongst the first registration of Grant's other great lesson from Italian fresco painting, namely the decorative potential of the false marbling that takes up so much of the lowest level of wall painting at San Francesco, as in so many other fresco

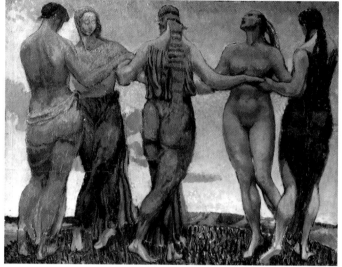

18 *The Dancers*, oil on panel, 21 × 26″ (53.4 × 66 cms.), The Tate Gallery, London

sequences of the Quattrocento. This interest becomes increasingly marked in Grant's later work.

A painting of *The Adoration of the Magi* which was at Charleston in the early 1970's shows a statuesque naked Madonna and child, seated in profile on a simple throne, with the three Magi variously kneeling, stooping and leaning towards them. Yet between the two groups there is a landscape with a river and a bridge that derives directly from the Cézanne of the 1880's. The picture is unresolved and unfinished, but it shows something of the seriousness with which Grant was wrestling to incorporate new influences to his work. But he was not yet ready to assimilate the lessons of Picasso's *Nude with Drapery*, although that time was not far off. He had grown up under the long cultural shadow of the Whistler-versus-Ruskin libel trial of 1878, which hinged around the artist's claim to produce pictures that should not be judged against the crude criterion of likeness to nature. The rest of his long career would take place in the light of Post Impressionism, and the influence of a generation of European artists who took Whistler's audacity for granted, and pushed his claim to extremes that he could neither have imagined nor licensed.

Post Impressionism

In 1934 Vanessa Bell looked back to consider the state of English painting in 1910:

The world of painting – how can one possibly describe the effect of that first Post Impressionist exhibition on English painters at that time? ... Sickert and the Camden Town Group were producing work that was sympathetic but for the most part rather timid – Sickert's own work of course always had life and character as well as exquisite taste and colour, but his followers too often seemed to have only taste. John was the rising genius and at one moment seemed to promise something strangely new and exciting. But that did not last – London knew little of Paris, incredibly little it seems now ... To those who had 'lost their way', and I think many had or might soon have done so, here was a sudden pointing to a possible path, a sudden liberation and encouragement to feel for oneself which were absolutely overwhelming. Perhaps no-one but a painter can understand it and perhaps no-one but a painter of a certain age. But it was as if one might say things one had always felt instead of trying to say things that other people told one to feel (. . .).[1]

She was however scathing in her criticism of those who thought that they could,

paint like Gauguin or van Gogh by the simple process of putting a black line round everything or like Cézanne by putting a blue one.[2]

In many respects the public response to the First Post Impressionist Exhibition formed the basis of Bloomsbury's founding myth of itself, together with the scandal of the Dreadnought Hoax, which took place only weeks after the exhibition closed. These events established Bloomsbury in its own eyes as shocking and daring, surrounded on all sides by outraged hordes of English philistines. And indeed there was some truth to the myth, though it is probable that the Bloomsbury painters were closer to their contemporary British artists in 1910 than at any subsequent time. Furthermore it would be wrong to imagine, as I have argued elsewhere, that the impact of the French painters gathered together by Fry could have aroused any response other than outright rejection from young British painters had they not felt able to apply these new ideas in a meaningful way to their own experience.[3] This was especially the case for artists such as Grant, who were already in sympathy with the degree of formal abstraction that had characterised so much of British art nouveau design in the 1890's. Indeed, as early as 1927 the poet Richard Le Gallienne had pointed out that: 'Those last ten years of the nineteenth century properly belong to the twentieth century, and, far from being "decadent", except in certain limited manifestations, they were years of an immense and multifarious renaissance.'[4] It was above all the use of colour by Gauguin, Van Gogh and Cézanne for which few British artists could have been prepared.

Certainly Duncan Grant was not one of those content to proclaim conversion to the cause of Post Impressionism by the simple expedient of painting a black or a blue line around everything he painted. At Easter 1911 he accompanied Maynard Keynes on a holiday to Tunisia and Sicily, where they visited the great Norman cathedral of S. Maria la Nuova in Monreale, with its famous twelfth-century mosaics, and a cloister which has some of the finest Romanesque stone carving in Italy, with much use of dogtooth, circle motifs, and gigantic vertical zigzags on the supporting columns. Visiting the holy Muslim city of Kairouan in Tunisia, Grant stopped long enough to decorate two locally made vases, which he somehow managed to transport back to Britain unharmed. These provide clear early evidence of his response to what he had seen in the collection of Gertrude Stein, and in particular a ceramic vase around the body of which Matisse had painted three buxom maidens, c. 1907.[5]

Grant's 1911 vases are both objects of considerable importance, and are still housed at Charleston in his studio. The smaller one relates more closely to the Matisse, with a motif of two standing women with their arms raised, in the place of Matisse's three dancing figures with their arms raised. It also has a criss-cross frieze under the neck and stripes down the side, all in dark brown against the creamy brown glazed earthenware ground. The larger pot is more ambitious, using the entire body, with its much longer neck, to house another two women, whose faces relate unmistakeably to the hatched style of Picasso's *Nude*

early evidence of what Vanessa Bell dubbed Grant's 'leopard manner', which he employed frequently in the next two years. It is also apparent in *The Red Sea – Decoration* of 1911–1912, and *The Queen of Sheba*, 1912, which was painted for Newnham College, Cambridge, though it was never installed. There are also several portraits of Grant's friend George Mallory painted in the 'leopard manner' in 1913. The largest extant work in this style is *On the Roof: 38 Brunswick Square*, of 1912. This shows Virginia Stephen and her brother Adrian, with whom Grant had recently had a serious relationship, together with Leonard Woolf, whom Virginia was shortly to marry. It was painted on the roof of the house to which Duncan and Maynard Keynes had moved in November 1911, and which they shared with Virginia and Adrian. Grant seems to have liked the roughness of this technique, leaving large areas of white primed ground showing, in order to emphasise individual brush marks and colours. Pushed to an extreme, as in *Group at Asheham:* 10

19 *Figure with Arms Crossed* 1910, ink on buff paper, 3½ × 2″ (8.5 × 4.8 cms.), private collection. (Drawn on front cover of *The Burlington Magazine*, Vol. XVI, No. LXXXII, January 1910)

with Drapery (*Daix*, 95). On one side the woman's body is drawn in a curvilinear manner, whilst the other is more geometric. Neither is exactly like the style of either Matisse or Picasso, and they cover the entire surface of the vase in a single, complex linear pattern that only fully emerges in movement, when it is rotated. The larger vase also introduces the idea of an image that moves, which was to preoccupy Grant a few years later. Together they presage a lifetime of decorating pots.

A large portrait of his mother in profile from 1911 also begins to explore the possibilities of the very loose divisionist style that Matisse had employed in his 1899 *Sideboard and Table* from the Stein collection, and is

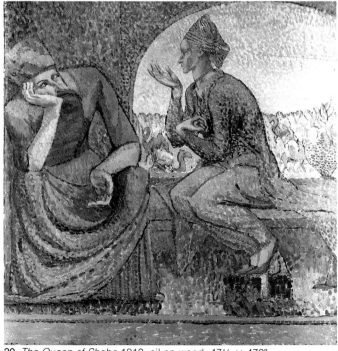

20 *The Queen of Sheba* 1912, oil on wood, 47¼ × 47½″ (120 × 120 cms.), The Tate Gallery, London

Adrian Stephen, Virginia Woolf, Vanessa Bell, and Henri Doucet, 1913, the 'leopard manner' approaches total abstraction, and as in *On the Roof*, the forms of individual figures are recovered by the use of line. The attention that these pictures draw to the qualities and texture of the paint itself, suggests that Grant had also at some point been very impressed by the work of Vuillard from the mid to late 1890's, [6] and also the recent work of Modigliani, to whom both Grant's and Vanessa Bell's many contemporary caryatid figures seem especially indebted.

In the summer of 1911 Grant worked on two large mural panels that were to decorate the students' dining room at the Borough Polytechnic in London. Roger Fry had brought together a small group of artists to undertake the commission, with an overall theme of 'London on Holiday'. Grant chose the subjects of *Football* and *Bathing*. The entire series was later bought by the Tate Gallery in 1931. In April 1911 Grant wrote to Keynes from Rome that he had spent many hours in the Sistine Chapel. Michelangelo had long been one of his favourite artists, and both of Grant's panels reveal his interest in Michelangelo's heavily muscled male bodies. *Bathing* depicts seven male nudes, diving from a plinth, swimming towards, and clambering into, a boat which rides out of the water as two of the figures climb aboard. But it can also be read as the continuous movement of a single figure, which is what he had originally intended.[7] The boy throwing his right leg up into the boat derives directly from the male figure on the extreme left of Michelangelo's cartoon for the *Battle of Cascina*, whilst the heavily stylised depictions of the bodies in both Grant's panels carry strong memories of Michelangelo's ink studies, which he much admired.

It was the manner in which Michelangelo constructed almost impossible ideal bodies from a fixed convention of drawing with its own integrity that seems to have excited Grant's imagination. In a similar manner, the undulating bands of greens and purples through which his bathers swim sustain a familiar convention for representing the sea in Byzantine and Romanesque frescoes and especially mosaics, as at

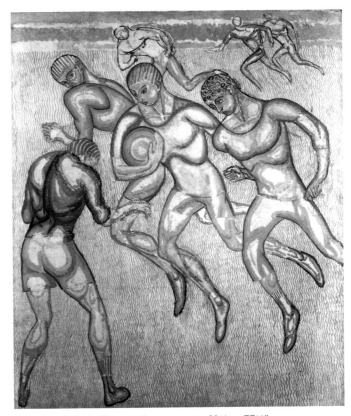

21 *Football* 1911, oil on asein on canvas, 89½ × 77½"
(228 × 197 cms.), The Tate Gallery, London

Monreale for example, and St. Mark's in Venice. Grant was drawn to such conventions of representation, and much of his best Post Impressionist work involves, amongst other things, the playful alignment of different artistic conventions.

He had visited Istanbul in April 1911, where he had ample opportunity to visit the finest mosaics, and on his visit to Tunis earlier in the year he had visited the Bardo Museum, which contains a magnificent and extensive collection of late Roman mosaics, some of which are highly suggestive of the strongly linear style of his own work at the Borough Polytechnic.[8] The ground on which his *Footballers* play is dramatically flattened down to a field of regular, narrow wavy lines, whilst the painting of the actual players owes

22 *Sculpted Capitol, St. Benoît-sur-Loire* 1911, pencil, on paper,
7½ × 5¼″ (19 × 13.3 cms.), private collection

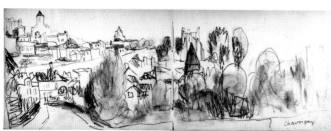

23 *Landscape, Chauvigny* 1911, pencil on paper, 15 × 5¼″
(38 × 13.3 cms.), private collection

much to the convention of damp-fold drapery in Romanesque art, which represents clothing as if it were wet and clinging to the underlying forms of the body, revealed as it were from within. Many of his drawings and paintings from 1911 to *c.* 1920 continue to explore and develop the extreme simplification of facial and other physical features. The motif of boys swimming, often accompanied by huge, cheerful fish, evidently caught his imagination. It re-appears in many different forms, on decorated boxes, and in the gouache design for the inside of a chest lid which Maynard Keynes' younger brother Geoffrey commissioned from him in 1913.

In the autumn of 1911 Grant undertook a tour of French Romanesque churches, bicycling with Roger Fry, whilst Clive Bell went by train.[9] They visited the remarkable, isolated church of St. Benoît-sur-Loire, near Orleans, where Grant drew a copy of heads from one of the sculpted capitols beneath the free-standing bell-tower that fronts the church. Like the sculpture at Autun, these heads had also inspired Derain a few years earlier, as Fry was probably well aware; and the conventions of Romanesque sculpture lie behind the device Grant and Bell specially favoured at this time for representing the human face, drawing the eyebrows down to a point for the nose, as in the faces he had painted on the vases from Kairouan. Grant also made several topographical scroll-like drawings on this visit which explore the abstract qualities of line and tone as much as the actual landscape before him.

They also visited the church of St. Pierre at Le Dorat, and the famous frescoes in the crypt and nave at Saint-Savin. In later years Grant frequently referred to the experience of Saint-Savin as having been highly important to him, and the dry, deep blue and russet hues of the backgrounds to many of the scenes would appear to have informed something of the overall decorative scheme at Charleston and elsewhere.

The use of colour at Saint-Savin is very subtle, with much use of earth colours, terracotta, terra verte, emerald green and maroon. He made colour notes of the banded decorations on one of the columns. However, it may simply have been the scale of

wall-painting that so impressed him, especially since earlier in the year he had been struggling somewhat in the first decorations for Keynes' rooms in Cambridge. These are now covered up by later work, but early photographs show a ring of male and female dancers, looking rather dwarfed and, very unusually for Grant, out of proportion to the four panels on which they are painted. They seem more like paintings to hang on a wall, than a mural, and the direct experience of Saint-Savin may have reinforced Grant's growing dissatisfaction with overly pictorial murals.[10]

What so distinguished Grant's work from that of his contemporaries was his determination to be as free to draw upon Sienese Trecento painting, or Byzantine mosaics, or Romanesque frescoes, as he was free to interpret the work of Poussin or Michelangelo, or Cézanne, according to his immediate intuitive needs. Returning to London he painted a ravishing still life with parrot tulips for the Second Camden Town Exhibition at the Carfax Gallery, though he had no real working relations with the members of the Camden Town Group, and Sickert's attempt to annexe him away from Bloomsbury at this time came to nothing. *Tulips* in Southampton City Art Gallery combines the brilliant colours of Post Impressionism with the rich earth hues he had seen at Saint-Savin earlier in the year. This was characteristic of his entire approach to art: he could apply lessons from his paintings into his murals or ceramics, as easily as the murals could suggest easel paintings.

Grant never aspired to a single, coherent stylistic manner, to be consistently recognised across the different media in which he worked, or even within any one of these. Throughout his life he remained a '*bricoleur*', selecting his subject and manner according to the job in hand. His work is always intensely personal, and usually unmistakeable, but its unity as an oeuvre does not reside in any simple linear development. What was required for the decoration of rooms at 38 Brunswick Square in 1910–1911 bore no necessary relation to what he felt appropriate for the dining hall of the Borough Polytechnic, let alone the Camden

Town Group. Thus for example *Tulips* already shows evidence of his liking of strong vertical and horizontal elements in his still lifes and portraits, which seems to have derived from his experience as a designer.

His interest in fabric design also reflected his wish to be able to introduce his own work into his immediate social environment, and thence into his paintings, whether in still-lifes, or as part of the general mise-en-scène of his portraits and interiors. From 1912 onwards he increasingly depicted pictures or murals within other pictures, thus permitting complex visual dialogues between different levels of representation, as his own pots, fabrics, decorations and paintings became part of the subject matter of subsequent pictures. [20] Furthermore, this allowed him to revisit and develop details from earlier work, as it were, outside their original context.

Thus the corner of a painted canvas, propped up on a decorated mantelpiece, may typically become a central element in a later still life. Such details take on a highly abstract quality, like enlargements of photographs whose original subject matter is no longer clear, leading to increasingly complex images that are as materially constructed as contemporary cubist paintings, but by very different means. The self-conscious emphasis on the process of painting itself that was involved in such pictures relates to his great admiration for the work of Chardin, and especially the still lifes of Zurburan. Such paintings about painting constitute one of Grant's most significant contributions to the modernist movement. [16]

In September 1912 Grant wrote to Virginia Woolf to say that he was,

trying to finish some dozen of pictures for this blessed Grafton Show. I almost believe Uncle Trevor was right and that I shall end my days in the Royal Bethlem Hospital surrounded by hundreds of unfinished works.[11]

He was referring to Roger Fry's Second Post Impressionist Exhibition, which ran from 5 October until 21 December, and which was held, like Manet and the Post Impressionists, at the Grafton Gallery. Grant showed six works, including *The Dancers* and *The*

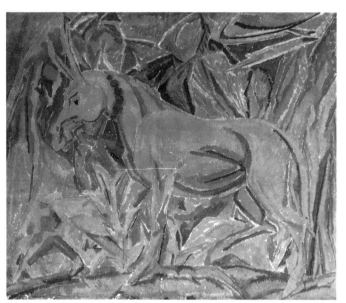

24 *The Ass* 1914, oil on canvas, 48 × 59½" (121.9 × 150.5 cms.), Ferens Art Gallery, Kingston upon Hull

Queen of Sheba, both of which he had exhibited earlier in the year at the Galerie Barbazanges in Paris, together with four other paintings. He also designed the exhibition's poster for Fry, working with his colleague Frederick Etchells, with whom he had collaborated in his Brunswick Square murals. Matisse was especially well represented in the Second Post Impressionist Exhibition. *La Dance 1* was accorded a special place of honour, flanked by two of Matisse's bronzes. Also included were *The Young Sailor 2* of 1906, *Le Luxe 2* of 1907–1908, and *The Red Studio* of 1911. Matisse's practice of developing a painting in a pair of versions seems to have impressed Grant, many of whose most important pictures underwent a similar process of change through duplication. The second version of *The Young Sailor* had a particular impact on Grant, with its highly decorative pink background, and massive design. There were also thirteen works by Picasso in the show, including the heavily faceted *Head of A Woman* of 1909 (*Daix*, 266), a 1911 cubist figure *Buffalo Bill* (*Daix*, 396), and a fine 1912 still life, *Bouillon Cube* (*Daix*, 454).

It is significant that Grant's work in the following year remained far closer in spirit to Picasso's hatched style of the *Nude with Drapery*, and to Matisse's work *c*. 1906, than to either artist's later work. Judith Collins has noted the close resemblance between a 1913 *Design for a Bedhead*, and one of the horizontal studies for Picasso's *Nude with Drapery*.[12] For example, both versions of Grant's *The Ass* progressively subject the motif of a Persian miniature to Picasso's violent flattening of space. There are several paintings from 1913 which share this same stark hatching technique, including the figures of a standing male nude and female nude inside the doors of a small cupboard at Charleston, and *Slops*, also now at Charleston, which shows a woman throwing water onto a garden from a shallow bowl.

More dramatic still is *The Tub*, which is usually thought to be 1912 but which may have been completed in the following year. The brilliant red hatching down the right hand side of the picture, and the red and black hatching underneath the shallow bowl in which the central figure stands, seem to relate closely to a detail of a peacock in S. Vitale in Ravenna, which Grant did not visit until 1913, though he may well have known the detail in reproduction. The strong similarity between the composition of *The Tub* and the image of the peacock implies a direct relation between the two.

Ravenna provided Grant and Vanessa Bell with the most dramatic examples of fully integrated interior decorations, using strong colours and simple yet highly sophisticated forms that they both found profoundly inspiring. Thus spheres, hanging drapes, and gushing fountains all found their way directly into Grant's decorative work at the Omega, and subsequently throughout his life. Indeed, the generalised white bell-like flowers that feature so strongly in his late 1920's design for an embroidery panel, now at Charleston, are closely related to the flowers that sprout along the bottom level of the apse mosaics at S. Apollinare in Classe. The *Head of Eve* from 1913 also relates closely to the same motif of the peacock with its feathers outstretched in a halo of black and red hatching, which

further suggests a date of 1913 for *The Tub*. The *Head of Eve* is a study for a large painting of *Adam and Eve*, commissioned by Clive Bell for the Contemporary Art Society, and tragically destroyed after flood damage at the Tate Gallery in 1928. Its destruction was one of the most grievous losses in twentieth-century British painting, since a surviving photograph reveals that it was at least as major a work as *Bathing* from 1911.

In the meantime Grant had seen the great Bernheim Jeune exhibition of Matisse's recent Moroccan paintings in April 1913, which encouraged him to experiment with the use of thinner paint in his portraits and still-lifes. It would, however, appear that the motif of palm trees behind Adam and Eve derived from Matisse's earlier *Blue Nude* of 1906, a subject that Grant would interpret in his own terms in 1914. The extraordinary image of a scrawny Adam standing naked on his hands, beside a vast Cycladic Eve, was all his own. The *Head of Eve* corresponds to a facial type to which he often returned in his Post Impressionist work, with large staring eyes, and small, round 'Clara Bow' lips.[13] Eve was already, to some extent, imagined as Vanessa Bell, and it is clearly possible to read *Adam and Eve* as a picture of the two artists, imagined as the originating parents of a new Edenic world of Post Impressionist art in England. This was entirely in keeping with

the wider contemporary European spirit of cultural atavism, that had found its first expression in Matisse's *Bonheur de Vivre* of 1905–1906, and Picasso's *Demoiselles d'Avignon*, as well as Derain's *La Dance* of 1906, which also contains the type of Romanesque facial features used by Grant and Bell in their Post Impressionist work.

Throughout this period Grant was a frequent visitor to the performances given in London by Diaghilev's Ballet Russe, which he had seen during its first London season in 1909, at the invitation of Lady Ottoline Morrell. Fokine's celebrated 1911 production of *Petrushka* received its first London performance at the 1913 Covent Garden season, with Benois' memorable Scene Two set, which included a painted screen with figures, against two starkly simple stage-flats, painted a deep Prussian blue for the sky, with a crescent moon and a sprinkling of yellow stars. Like most of his contemporaries, Grant was tremendously smitten by the Russian Ballet, but its impact on him has perhaps been exaggerated and misunderstood. There was little that Grant could have learned technically as a painter from the productions, since he was already so largely in sympathy with the general aesthetic that lay behind the work of Benois and Bakst as stage and costume designers. It was the revelation of the potential of the theatre for modern design that inspired him, like so many others.

The most important aspect of the Ballet Russe for Grant was probably rather more prosaic. It made a certain kind of decorative art suddenly and intensely fashionable, together with a dramatic yet lyrical atavism which found its perfect expression in ballets such as *The Rite of Spring, The Firebird, Petrushka*, and a little later, *Les Noces*. It was this sense of the relevance of the art of the past that works such as *The Tub* and the *Head of Eve* shared with the Russian Ballet. Yet Grant was never a serious archaeological 'primitivist', although one critic had compared his work at the Borough Polytechnic to the work of the nineteenth-century German Nazarene painters.[14] The generalised North Africa that appears in the backgrounds of the *Queen of Sheba* and *Adam and Eve* was a largely

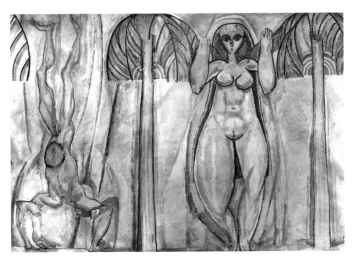

25 *Adam and Eve* (destroyed) 1913, c. 7 × 11 feet

imaginary domain of social and erotic fantasy, as it had been for many artists since at least the time of Delacroix. In Grant's case this was to some extent qualified by his homosexuality, as was his relation to the Mediterranean. This is only to note that Grant had grown up under the long cultural shadow of the trials of Oscar Wilde in 1895, a shadow that may still be felt across British society to this day. Yet as Angelica Garnett has pointed out, she never heard him say anything 'in any way that made me think that his homosexuality had ever been a real problem to him . . . it always seemed he's known about it from the word go, and just accepted it'.[15]

Ten years later he painted a screen on which Maynard Keynes and his wife Lydia Lopokhova, who had been a première danseuse for Diaghilev, appear as Harlequin and Columbine dancing under a crescent moon remembered from *Petrushka*, watched over by three somewhat stocky matrons, modelled by Angus and Douglas Davidson. On the right-hand panel stands

a tall musician in a white clown's costume, very much in the manner of Piero's Arezzo frescoes. The Russian Ballet offered a vision of erotic and aesthetic pleasures to Edwardian London that proved irresistible. It seemed to represent, in the public domain, many of the values that Bloomsbury held most dear – a pan-European model of sexual and cultural radicalism. This, after all, is what Post Impressionism signified to Fry and his friends, a challenge to nostalgic, backwards-looking puritanism, in the sense described so memorably by H. L. Mencken as, 'the haunting fear that someone, somewhere, might be happy'. This is, I think, what Grant meant when he described the great dancer Nijinsky as 'a revelation'.[16]

In the early months of 1913 Roger Fry had spent much time and effort trying to raise funds to finance his project for a showroom in central London that could market Post Impressionism to the general public. As Quentin Bell remarked in 1964;

I do not think it is generally realized nowadays how difficult it then was to be an advanced painter if you had no money . . . Fry's calculation was that people who would not buy Fauve pictures would buy Fauve lamp-shades, and in this he was right. This may sound a rather cynical transaction, but there was also a missionary side to it. One needs to remember what the world was like fifty years ago and, more important still, how it appeared to a painter like Roger Fry or Duncan Grant . . . It was a world of fussy little decorations, desperate, dingy, cheap gentilities, a world of lace curtains and lincusta . . . to the Post Impressionists these feeble trimmings appeared horrible.[17]

It was in this crusading spirit that Fry launched his Omega Workshops, which opened their doors at 33 Fitzroy Square in July 1913. His aim was twofold: to provide a regular income for sympathetic but impoverished artists, and to effect a revolution in British taste. However, as Professor Bell has perceptively oberved;

People think of the Omega Workshops as a kind of twentieth-century version of Morris, Faulkner, and Co. They judge it and condemn it by the standards of the craftsman. But Morris was not a painter and his interests were not a painter's but a craftsman's interests.[18]

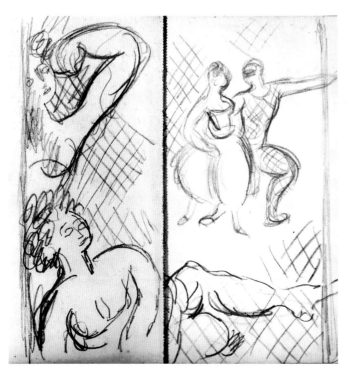

26 *Design for 'Harlequin and Columbine' Screen* 1924, pencil on paper, 8 × 8″ (20.3 × 20.3 cms.), private collection

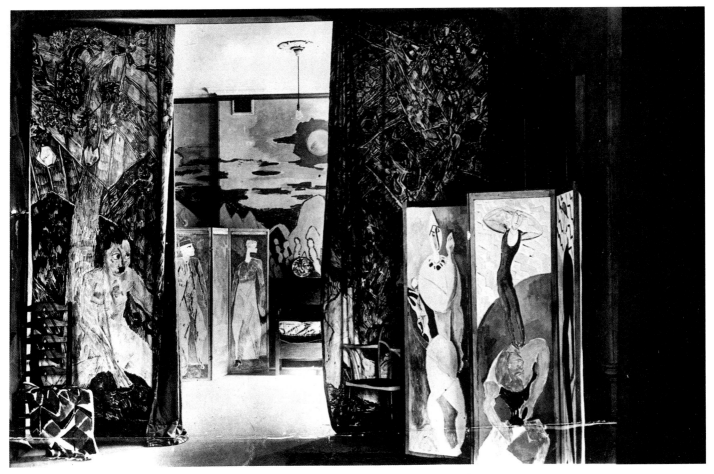

27 The Upstairs Showroom of The Omega Workshops, August 1913. The screen in the foreground
 is by Wyndham Lewis, that in the background by Duncan Grant

Spurious analogies between William Morris's firm and the Omega Workshops obscure everything that is most significant about the latter, and in particular its refusal to accept the validity of the distinction between the fine and applied arts which had been sustained throughout the Arts and Crafts movement.[19] For Fry and his colleagues at the Omega, design was a term that might equally apply to the manufacture of pottery, or stuffs, or household furniture, as to book illustration, murals, or easel painting.

At the same time the Omega has suffered from equally invidious comparisons with the Bauhaus, and the De Stijl movement, as if modernist design were a uniform tendency, to be assessed in all its variant forms against a single set of criteria. The Omega however reveals that modernist aesthetics did not necessarily lead to the worship of abstract geometry that found its final and most complete expression in the dismal tower-block housing projects of the 1960's, which may very well look beautiful against an evening sky, but in which few people would ever choose to live. In such circumstances one needs to ask who is accusing whom of aestheticism. Fry was sympathetic to the machine-age aesthetics of Simpson's department

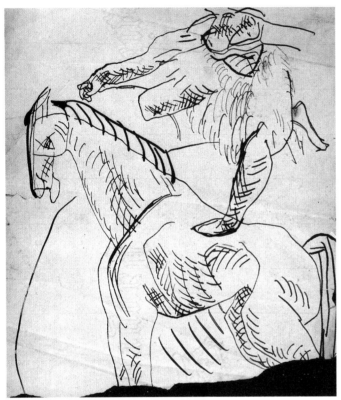

28 *Dancer on Horseback, Omega Workshop Design* c.1913, ink on paper, 8¾ × 8″ (irregular) (22.5 × 20.1 cms.), private collection

the original idea was a place where you could go and work if you were hard up . . . There were no rules otherwise at all. It was to help painters make a little money for themselves to paint. But it was very inspiring to be given special jobs to do, for definite purposes, and all sorts of ideas I think came out of doing decorative things I think if one didn't have the opportunity of doing otherwise.[23]

This reflects his earlier sense of admiration for the work of Quattrocento artists who painted for specific situations, with specific light conditions, and a specific audience. Much has been made, quite correctly, of the general tendency of Bloomsbury painting to be concerned with the world of domestic interiors and domestic, private life. However, the Omega was a fully fledged attempt to produce saleable art, for public consumption, whilst celebrating individual taste and creativity. It was one of Bloomsbury's few successful excursions into the public domain of cultural production, with the notable exception of publishing.

Grant's design work for the Omega is of exceptional interest and importance, for it demonstrates in the liveliest fashion how much in the vanguard of the international modernist movement he was at this time. His Omega work is also extraordinarily playful and witty, as well as aesthetically daring. There can be little doubt that had such work been produced in France or the Soviet Union it would be as internationally well known as the designs of Rodchenko and Alexandra Exter, or the Delaunays in Paris. Moreover, there is no parallel for the manner in which Grant would frequently transfer an idea from one medium to another, for example, developing a painting of a lily-pond into a highly sophisticated design for screens and table-tops. Indeed, his *Lily-Pond* furniture combined for the first time his love of marbling with a modernist sensibility.

Sometimes designs would work their way into paintings, and it is significant that the entirely non-figurative paintings of 1914–1915 all derive in one way or another from Grant's experience of working at the Omega. These abstract paintings are distinguished by the fact that they were not produced in relation to any metaphysical theory such as informed the non-figurative work of artists such as Kandinsky, or

store in Piccadilly, and to John Burnet's starkly modernist Kodak House of 1911 on Kingsway, but he did not commit the vulgar error of supposing that the same aesthetic criteria should be applied to a steel-frame building as to a teapot.[20]

Work at the Omega was produced anonymously, yet most of the designs and products that survive may readily be attributed to individuals. This is not to overlook the significance of the overall concept of collective work that informed the spirit of the Workshops, even if they in practice sustained a fairly traditional division of labour between men and women, the former being predominantly designers, the latter predominantly skilled workers.[21] For Duncan Grant 'working at the Omega helped to generate ideas'.[22] As he explained,

Robert Delaunay, or Malevich. His was a much more material-based approach to abstract painting, which was largely experimental and was never regarded as an alternative to figuration in any absolute sense. This did not prevent his producing some of the most impressive British abstract painting of the period, or his executing one of the great masterpieces of the early modernist movement, his 1914 *Abstract Kinetic Collage Painting With Sound,* henceforth described as *The Scroll.*

19 *The Scroll* was made with the intention that it should be viewed through a rectangular aperture as it was slowly unwound, like a roll of film passing between the two spools of a camera, to the accompaniment of music. A contemporary drawing shows a device whose measurements exactly fit that of *The Scroll*, a device moreover that closely resembles a rice, the standard machine for winding yarn in craft weaving to this day. This in turn implies that *The Scroll* was meant to be seen moving vertically rather than horizontally, as in the Tate Gallery's filmed reconstruction.[24] Another drawing that relates closely to *The Scroll* decorates a copy of Apollinaire's *Les Soirées de Paris* of 15 March, 1914, which contains an article by the artist Gabrielle

Buffet, the wife of Francis Picabia, who described the possibility of projecting literary texts onto a screen simultaneously with music. She concluded with the speculation:

Perhaps this might be the point of departure for a completely new form of art which would no longer have any resemblance to what we have up to now called music and musical composition ... We should be able to see painting abandon objective representation in order to break free into the domain of pure speculation.[25]

Grant may also have seen an article in *The Times* of 20 March, entitled 'Music as Colour' which also provided a theoretical armature for a new form of experimental art based upon the synaesthetic combination of different human faculties. Its author, A. Wallace Rimington had published a book on this subject in 1911.[26] In July 1914, Apollinaire himself had written of the paintings of Survage that they fulfilled his earlier prediction of an art,

that would be to painting what music is to literature ... coloured rhythm may be compared to music, but the similarities between them are superficial; we are dealing rather, with an autonomous art having an infinite variety of resources that are peculiar to it alone ... independent both of static painting and cinematographic representation ... an art that ... will have an infinite appeal to those who are sensitive to the movement of colours, their interpretation, their sudden and slow transformations, their juxtapositions or their separation.[27]

In 1916 the American artist Morgan Russell designed a *Kinetic Light Machine* that would appear to have been closely modelled on Grant's *The Scroll*, but Russell's project was unrealised.[28] There is no other European work of art in this period that so imaginatively fulfills Apollinaire's Orphist dream of a modernist art that aspires to the condition of music. *The Scroll* 18 is eleven inches wide and some fifteen feet long. It consists of seventeen configurations of six basic coloured rectangles which tumble down its length in the manner of an oriental scroll painting, one of Fry's many enthusiasms. The first seven groupings are entirely collaged onto their paper support, and the final four groupings are entirely painted onto the support–

29 *Lilypond Screen*, c.1913, oil on canvas, each panel 86¾ × 24½" (217 × 61 cms.), Roger Fry Collection, The Courtauld Institute

30 *Study for Vertical Armature for the 'Abstract Kinetic Scroll'* 1914, ink on paper, 7 × 4½" (irregular) (17.7 × 11.3 cms.), private collection

31 *Study for 'Abstract Kinetic Scroll'* 1914, ink on paper, 7 × 9" (17.7 × 22.7 cms.), private collection

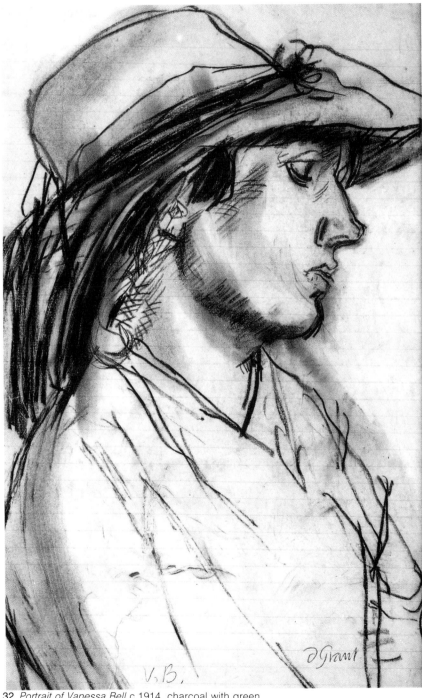

32 *Portrait of Vanessa Bell* c.1914, charcoal with green chalk on paper, 15 × 6½" (38 × 24 cms.), private collection

40

ing paper. The others combine collage with painting.

The movement of these elements is not in the least mechanical, nor is the sequence of colours constant throughout *The Scroll*. The ground itself is marbled in blue and white for some of its length, but opens out for the greater part into an elegant and complex calligraphy of individual, snaking brush-marks, closely resembling the dado decoration in a room decorated by Grant for the Omega the previous year.[29] The edges of many of the coloured elements have been stippled with black dots, in yet another range of techniques, ranging from tiny points to loose blobs and thinly hatched lines. Such markings evidently relate to Picasso's Cubist work at this time, serving a similarly ambiguous purpose, suggesting volume without defining it. They also increase the sense of a sequence of movements whilst tentatively establishing a relationship between the ground and the clusters of coloured elements that travel along it. It is possible that Grant had heard Picasso discussing the possibility of moving pictures, but this should not obscure the fact that *The Scroll* examines movement within a single, if extended, pictorial space.[30] *The Scroll* does prefigure some aspects of the early abstract films of Hans Richter and Léger in the early 1920's, but this is only to note that all three were working within a shared range of cultural references and practices within the European modernist movement as a whole. *The Scroll* may also be seen to develop some aspects of the formal experimentation evident in his French landscape drawings of 1911.

It is entirely typical of Grant that *The Scroll* should thus combine elements of the most advanced contemporary French art theory in 1914 with Fry's British advocacy of an art based on purely formal values, in the context of a work of art that unites the scroll form of ancient Chinese art with some aspects of Picasso's Synthetic Cubism. Furthermore, it attests to Grant's well-known love of music and dancing, and his fascination with describing the continuous process of movement that he had previously explored most fully in his *Bathing* of 1911, and in his frequent practice of serial painting, returning to a motif repeatedly in different ways. Grant often produced two or more

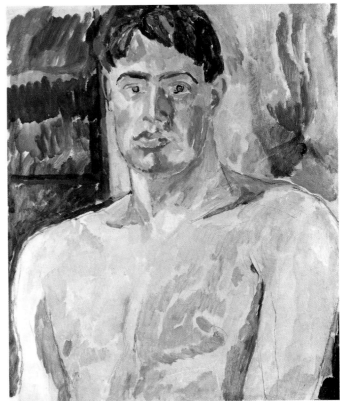

33 *Portrait of David Garnett* 1916, oil on canvas, 24 × 21″ (60 × 52.5 cms.), private collection

consecutive versions of the same painting throughout his career, generally developing after-thoughts in a looser, and more experimental manner. Thus a series of portraits of Vanessa Bell was painted between 1914 and 1916 showing her wearing a long, red, densely patterned dress that she may well have designed and made herself. At least one of these paintings introduces pieces of cut and pasted painted paper, imitating the fabric of the dress, whilst another has actual pieces of the fabric itself, cut out and incorporated into the picture surface.

Several still lifes from this period were painted in two versions, one painted directly from the subject, the other executed entirely in collage. Vanessa Bell's *Portrait of Molly McCarthy* was made in this manner,

as she cut out and matched paper in front of her sitter. Grant also worked directly from the motif with paper, paste and scissors, in a similar manner to Picasso's frequent reworking of the same motif in different media in 1912.[31] Many of Grant's portraits in these years were painted in the company of Roger Fry and Vanessa Bell, from the same subject, seen from slightly different angles. These were often painted in a single sitting, very thinly, almost in imitation of water-colour, with the white ground serving to reinforce the overall effect of bright washes, combined with highly personal brush work, as in the 1913 *Portrait of Lytton*
15 *Strachey*, and his magnificent portraits of David Garnett and Mary St. John Hutchinson. Yet at the same time he could also work in a brighter version of his earlier 'leopard manner', as in the *Blue Nude with*
21, 22 *Flute*, a portrait of Marjorie Strachey, which again exists in two versions. This is Grant in his most sensuous and fluent Post Impressionist manner.

In 1913 Grant was invited to design the sets and costumes for a production of Shakespeare's *Twelfth Night*, directed by the eminent and innovative French director, Jacques Copeau, at his Paris theatre, the Vieux-Colombier. The scenery consisted of little more than simple architectural forms, against which Grant's fantastical costumes must have appeared all the more tellingly, for the production was a great success. As Michel Saint-Denis recalled,

The comedians seemed to be inflated by air ... – creatures of the imagination; they had neither the hair, hats, nor swords of ordinary historical reality, and their acting had a peculiar, floating lightness.[31]

Copeau himself concluded;

It seemed to me that this was a moment of perfection ... It was a very brief moment, and so perfect a one ... that all who participated in it were fructified by it for the rest of their lives.[32]

In 1917 *Twelfth Night* was transferred briefly for a season in New York, and Grant added a pair of painted screens, as well as costumes for a new production of Maeterlinck's *Pélleas et Mélisande*. Grant found Copeau easy to work with;

But the theatre was tiny, and the clothes were the only thing that mattered really. There was this little empty stage with a few painted screens about the place, but no decor.[33]

Although Grant designed numerous ballets in subsequent decades, he never again enjoyed such critical esteem for his work in the theatre, and this was a source of some disappointment to him. Grant's theatre work was very much of a piece with his work for the Omega Workshops, and his few abstract paintings. However, the growing carnage of the First World War was inexorably effecting a more sober cultural mood throughout British society, and as a character in a 1916 novel by the young Rose Macaulay reflected, 'Painting and war don't go together.'[34] Another character continues, 'this war is beastlier than any other ... The first-rate people, both the combatants and non-combatants, are too much disgusted, too upset, to do first-rate work.'[35]

Grant's old school friend Rupert Brooke died on 23 April, 1915, only a month after his younger brother Alfred, whom Grant had also known and liked, was killed in action. Grant responded privately with a memorial painting of considerable gravity, which adapted the convention of the Greek funeral style to contemporary purposes. *In Memoriam: Rupert Brooke* is a severely geometric picture, which achieves a strong personal sense through its handling, and the conflicting movement between a cluster of vertical rectangles, counteracted by the sharp point of the motif closely resembling the form of an ancient Greek funeral monument, or style, with its cultural associations of the Eastern Mediterranean, where Rupert Brooke had died. Grant also collaged a piece of reflective foil near the base of the picture, possibly inspired by Juan Gris' addition of a piece of mirror glass to a still life in 1912.[36] For Grant this can only have been a distorting mirror, or perhaps more likely, a source of continual reflected light, almost like a votive candle, within the picture itself.

Gris' use of pieces of marbled paper may also have 17 impressed Grant at this time, and he continued to produce paintings in duplicate, one entirely painted,

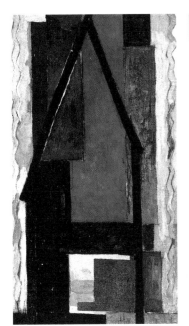

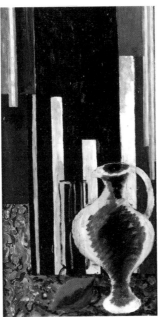

34 *In Memoriam, Rupert Brooke* 1915, oil and collage on wood, 21¾ × 12″ (54.4 × 30 cms.), Yale Center for British Art, New Haven, USA

35 *The White Jug* c.1915 (reworked c.1917), oil on canvas, 41 × 16½″ (102.5 × 41.2 cms.), private collection

the other collaged. These include *Still Life with Paper Hats*, and *Interior, Gordon Square*. This latter he described many years later as, 'an imaginary view based on a real view, in which the various visual components were re-arranged by the artist to make a satisfying picture'.[37]

This confirms the impression that Grant's figurative and non-figurative work at this time were both intuitive and, as it were, constructed. The Interior also suggests his interest in Picasso's 1913 *Man with a Guitar* (*Daix*, 616), which was in the collection of Gertrude Stein and which he must have seen on one of his several visits to Paris in 1913 and 1914. Hence we may tentatively consider the appearance of the work Grant contributed to the First Vorticist Exhibition in June 1915, of which the art critic of the *Glasgow Herald* commented contemptuously that, 'It is intended that we take seriously Mr. Grant's two "paintings" composed of pieces of firewood stuck on the canvas and

left uncoloured together with smears of paint upright in shape.'[38] It is at least possible that *The White Jug* from 1915 originally sported three-dimensional elements. In any event, Grant became dissatisfied with the picture's appearance, and at some later date (*c.*1917/1918) he added a lemon and a white jug to what had previously been an entirely non-figurative painting.

These additions have some considerable iconographic significance. Clive Bell had purchased a 1907 still life by Picasso of *Jars with Lemon* (*Daix*, 65), which had greatly inspired some of Grant's most adventurous Omega designs, including a number of fire-screens. The lemon thus stands in some sense for figuration, however minimal, and it is worth noting that *Jars with Lemon* is technically one of Picasso's least obviously representational paintings prior to the radical fragmentation of his Horta del Ebro paintings from the summer of 1909. The motif of a white jug or clear glass with a stem and a wide foot, had been used by Grant in an emblematic fashion as a form of autograph or personal presence in a large number of works since *c.*1912. This motif may also relate to the *Bouillon Cube* still life by Picasso (*Daix*, 454) which was shown in the Second Post Impressionist Exhibition, and includes a white jug. In one *Decorative Panel* from *c.*1917 a white glass contains yellow flowers, very much like the paper flowers, seen in several 1914–1915 still lifes, which were hand-made at the Omega. This motif also contains within it the germ of a favourite Omega design, featuring large circular forms, favoured by both Grant and Vanessa Bell. The motif becomes as it were a modern Post Impressionist version of the disc shapes that were so frequently used by Robert Adam in his decorative work, and later throughout the Aesthetic Movement, often in the form of sunflowers.

It should also be noted that Grant had a particular affection for embroidery and wool-working, and many of his best designs were worked by his mother and aunts, as well as friends, including Vanessa Bell and Virginia Woolf. Their skills to some extent reflect the general revival of embroidery in the 1890's, and the possibility for developing a close working relation between designer and maker.[39] Thus once more the

Omega may be seen to be building on the larger heritage of the Aesthetic Movement and the specialised skills of the Arts and Crafts movement, translated into modernist terms. Embroidery permitted Grant yet another opportunity to play off different techniques against one another, and to employ his favourite motifs in different media. For example, in 1919 Grant designed an embroidered chair-back based on the image of a white vase.

Throughout 1915 Grant seems to have been working his way into ever more complex and dense paint-work, as if tired of his use of thin Post Impressionist paint. He was still working for the Omega, but the Workshops were already suffering as a result of under-capitalisation and their low pricing policy. In the meantime Grant's still lifes become increasingly densely painted, with a solidity of handling that clearly demonstrates his re-newed enthusiasm for Cézanne together with a liking of subjects that are spacially ambiguous. Thus *The Coffee Pot* shows its still life elements against a charac-teristic background of canvases, apparently stacked against a painted wall. Such pictures often contain pictures within pictures, allowing him to juxtapose a section of complex marbling against singing colours, whilst the overall design depends upon the subtlest variations of flat planes at an angle to the picture plane.

The surviving decorative embroidery panels designed by Grant speak eloquently of a comfortable, domestic modernism that is specific to Bloomsbury. They summon up a social world before the introduction of television, in which bags of brightly coloured wools rested by chairs: a world in which the inhabitants of a house contributed materially to its appearance, in-volved in a mode of cultural production that could be combined with the day to day life of the household. They also speak of a love for the materials themselves, rich in effect but not in cost, the very reverse of that 'conspicuous austerity' that Witold Rybczynski has described as the hallmark of fashionable modern décor.[40]

In the meantime Grant's situation as a conscientious objector to military service obliged him to move out of London, in order to fulfil his legal obligation to work

36 *Study for 'The Kitchen'* (self portrait c.1916, pencil on paper, size and present whereabouts unknown). Reproduced in Roger Fry, 'Line as a means of expression in modern art', *The Burlington Magazine*, December 1918

37 *The Tub* 1919, woodcut on paper, 4¼ × 7¼″ (10.8 × 18.4 cms.), private collection

on the land. Thus in the spring of 1916 he and Vanessa Bell moved to Wissett Lodge, near Halesworth in Suffolk, together with the writer David Garnett, who was a frequent model for them both in those years. In the autumn they moved to Charleston, an old farmhouse near Lewes in Sussex, that had more recently been used as a guest-house. Here Vanessa established a base from which she could paint and raise her young family, without being separated from Grant, whilst he continued as a farm worker. Earlier in the year he had written to Roger Fry, explaining that he had been busy digging, and only thinking about paintings, with no time to execute them;

I think I shall paint less and less from life and more and more from drawings. I want more and more to make pictures like objects in some way, and yet believe it is useless to invent. I want to paint unrealistic realistic works.[41]

Making a virtue of necessity he concluded, prophetically enough;

Anyhow I'm never going to live in town again. I can't think why anyone does.[42]

This can hardly have been comforting news to Fry.

Given the exhausting nature of his farm work, it is hardly surprising that Grant produced relatively few pictures in the years 1916–1918, though he collaborated with Vanessa Bell on murals for Mary Hutchinson's Sussex home in 1917, and for Maynard Keynes' apartment at 46 Gordon Square the following year. He did however return to one of his most remarkable Post Impressionist works of 1914, *The Kitchen*, adding a self-portrait standing naked with his back to the viewer, looking round over his left shoulder. *The Kitchen* shows a scene of three women, one of whom cradles a child. It is painted in his most excited Post Impressionist manner, whilst the self-portrait inhabits an altogether different style of painting, tightly modelled in secondary colour, straying as if guiltily into a fantasy of his own creation. Although more psychologically complex, this is a similar strategy to his own contemporary additions to *The White Jug*. In 1918 he also painted a *Self-Portrait* in an oval mirror, in which, as Duncan Thomas has observed,

he sees himself without too many preconceptions as to what a self-portrait is, what function it should have. He is interested in the effects of patches of strong colour placed next to one another. He records the way in which disassociated shapes are trapped in the distorting bevelled edge of the mirror, a pictorial incident that ... other painters would have shown no interest in. And especially he is interested in the ambiguities of this mirror, the fact that his subject is both a reflective surface which happens to hold his reversed image and himself. He paints the whole thing – the distortion, the cause of the distortion (the mirror) and what is left of himself.[43]

This perceptive summary draws attention to Grant's highly sophisticated manipulation both of paint itself, and of the levels of information in his paintings. Such pictures also exemplify his thoughts concerning his wish to make pictures, 'like objects', as he had written to Roger Fry. These paintings thus relate to the general Parisian concept of the painting as an autonomous and self-sufficient object, the objet-tableau, which had informed much of his non-figurative work. But here it is reconsidered in relation to figurative painting.

In 1918 Grant also produced two woodcuts for a collection published by the Omega that year. These were *The Hat Shop*, and *The Tub*. Both are witty and imaginative designs, the latter reworking the subject of a now lost 1917 painting of Vanessa Bell bathing, also

38 *'Morpheus' Bedhead* c.1916, oil on wood, with wood applique, 12 × 37½″ (30 × 94 cms.), The Charleston Trust

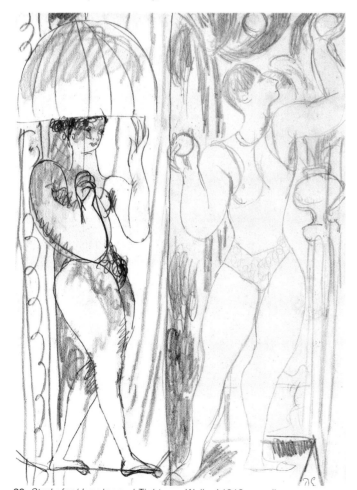

39 *Study for 'Juggler and Tightrope Walker'* 1918, pencil on paper, 12¾ × 9″ (31.9 × 22.5 cms.), collection Sandra Lummis

called *The Tub*, which was once in the collection of Roger Fry. There is a later copy of the original from *c.*1940 in a private collection.[44]

Grant was released from his agricultural labours some time after the Armistice in November 1918. At Charleston he had prepared an ideal working environment in which he could live and work and recover his equilibrium as a peace-time artist. During his temporary stay in Suffolk in the spring of 1916 Grant had painted the Wissett chickens blue, outraging his neighbours, possibly on aesthetic grounds alone. Whilst he and Vanessa painted some wall decorations at Wissett, it was not until they settled at Charleston that the task of home making began in earnest. Given the rigours of war-time England, it is hardly surprising that they should have been determined to cheer up their surroundings. This was not restricted to painting. In March 1917 Grant wrote to Virginia Woolf;

We are rather excited about flamingos. Nessa found a letter from an old gentleman in *The Field* who wrote to say his flamingos had weathered the severe winter without shelter, and were admirable birds to keep in England on small ponds. So she wrote saying she had long wanted to keep a 'couple of these beautiful birds' and would the writer tell us where we could get some. I am longing for the reply . . . Anyhow if only we could get them going on the pond I feel Charleston would be more than a match for Garsington with all its peacocks.[45]

He also noted that Vanessa Bell ('Nessa') was knitting a pair of stockings;

(a thing she has never done before) and reading at the same time *Framley Parsonage* through a pair of horn spectacles.[46]

Later the same year he reported to Vanessa Bell from Charleston that he felt he had been doing

no good to the picture on the door today but hope to improve it.[47]

Work at Charleston proceeded in a steady way. One of the first things Grant decorated was a bed for Vanessa, with a dramatic head of Morpheus, the God of sleep, presiding over the head-board. Morpheus' head is flanked by simplified wings that open out across a background that divides into two halves, one

painted in tones of pink to Burgundy red, the other frantic with red, black and grey marbling – 'mobbling' as he and Vanessa referred to it. On the back of the head-board are her initials in yellow, filling a roundel of scumbled blue against white, with swags. Most remarkable, however, are the two pieces of plain, unpainted wood that Grant attached to Morpheus' head – one describing a hat of sorts, or hair, and the other forming a nose that runs up into the right eyebrow, in the manner of the Romanesque capital he had copied at St. Benoit-sur-Loire in 1911. He also painted and collaged the shaped ends of a rough wooden settle with the kneeling figures of angels in profile, their wings folded behind them and their hands raised in prayer.[48] Still at Charleston is a *Log-Box* painted *c.* 1917, with dancers on two sides, and angelic musicians on the two remaining panels. These are amongst Grant's finest Post Impressionist decorations, and combine the elegance of the figures he had designed for the inside of the window shutters at 38 Brunswick Square in 1913, with his newfound confidence in the most subtle modulations of colour. They also brought to Charleston a spirit of casual, languorous eroticism, and the international civilization of the Russian Ballet. In June 1919 he wrote, in a mood of exhilaration, to Vanessa Bell from London of Derain's new sets for Diaghilev's production of *La Boutique Fantasque*:

It's so extraordinary to see the scenes and dresses done by a painter. I have never done so before. It's quite a different thing and adds to the triumph of modern art much to the discomforture of the upper and cultural classes. Met Derain and Picasso last night they both very friendly indeed ... According to Clive (who of course is very suspect) they don't really admire Roger's painting. Derain said that with my gifts I ought to attack 'des grandes problémes' but I don't really understand what that means.[49]

Grant also saw Picasso's production of *The Three Cornered Hat* at the same season. It is characteristic of him that he should report, almost in the same breath, going to see a Poussin at the Sackville Gallery, some Sienese primitive paintings just arrived from France, and rumours of a forthcoming exhibition at Heal's

Mansard Gallery including work by Matisse, Picasso and Roger de la Fresnaye. His attitudes are also revealed in a letter written to Vanessa in the autumn of 1919 from his parents' temporary home near Dartford in Kent, describing a visit to the circus;

It was great fun and extremely beautiful. I don't think that I had ever been to a real one before ... It was all enchantingly traditional with clowns and exquisite horses and jugglers. The audience was perfect and one felt hundreds of miles from the world of culture.[50]

Charleston was intended to be equally far from the despised 'world of culture', with all its snobbery and well-informed philistinism. Sadly, Grant's most experimental Post Impressionist work, such as *The Scroll*, had not been well received by Roger Fry or others, and had been abused to his face by D. H. Lawrence.[51] In 1919 he set out on a rather different series of experiments, making pictures as objects entirely from his imagination and from drawings, including *Venus and Adonis, Juggler and Tightrope Walker*, and numerous still lifes of which *Still Life with Plaster Bust* is perhaps the most important.[52]

Venus and Adonis seems to have developed from a related drawing of a huge woman, curled up on a sofa, with curtains pulled to both sides, in the manner of an open stage. As completed, it shows a tiny Adonis in the background, stared at intently by a vast Cycladic Venus, who sprawls on cushions across the entire foreground, with the familiar device of a white jug in front of her.

In March 1917 Grant had written to Vanessa Bell complaining;

I have been working hard at that red Venus and constantly wonder whether it will be good enough to bother.[53]

This also suggests a slow genesis for this painting, though its overall disposition brings to mind Poussin's *Echo and Narcissus* from the Louvre, whilst the hanging curtain on the left adapts a familiar motif from the High Renaissance convention of the reclining Venus, familiar from the Dresden *Venus* by Giorgione and Titian, and many of Titian's other reclining nudes. Yet this is also a most ravishing experiment in painting in

the hottest hues of pink and red, whilst Venus's body is wildly anti-naturalistic and inventive.

The *Juggler and Tightrope Walker* similarly combines a wealth of sources, from the background landscape behind the juggler, with its references to Piero's *Baptism of Christ*, to the familiar fresco-derived 'mobbling' of his costume. The figures are also highly anti-naturalistic, and belong very much to the types who populated Grant's imagination increasingly in the 1920's, especially in his decorative work. They are divided from one another by an astonishing, arbitrary stripe of entirely non-representational painting, employing a similar strategy to the use of a vertical dividing motif in *The Kitchen*. However, whilst *The Kitchen* is divided by a recognisable panel, copied closely from two Italian painted fairground columns, brought back from Venice in 1913, the centre of the *Juggler and Tightrope Walker* appears to have no descriptive function whatsoever, and provides a purely abstract, scroll-like vertical montage of brush strokes that contains all the colours used in the painting, almost like a catalogue, flush with the picture plane. It is an extraordinary piece of bravura painting, and demonstrates how daringly he was prepared to interpret the notion of peinture pure.

30 The *Still Life with Plaster Torso* provides yet more evidence of Grant's increasing fascination with the quality of thicker paint, which was already clearly discernible in *By the Fire*, from 1916, which shows Vanessa Bell huddled over an open fire wrapped in a blue robe with a green turban on her head, dwarfed by the contingency of a section of round table top, flush to the surface of the picture, with a still life of figs on a plate, a caraffe and glass. The *Still Life with Plaster Torso* reassembles many of the individual elements that Grant had used in his 1918 panel decorations for Maynard Keynes' Gordon Square apartment, but whereas in his panel of Italy we see the beefy legs of a voluptuous Venus from the waist down, in the still life we see literally a plaster torso from the knees up, and headless. The torso is framed by the arches of a colonnade, through which we are looking, with a curtain draping down to the left. It also contains the familiar autograph device of a white glass, which

echoes the forms of the colonnade, together with a fig, and a pair of books, recalling details from several of his early portraits. In effect the picture is almost like an Italian renaissance interpretation of the Dutch seventeenth-century convention of the frame within-a-frame, from which the subject of a portrait leans forward, with a curtain behind in the corner. Grant was endlessly fascinated by such conventions, and he repeatedly returned to them in this way, just as in *The Scroll* he had narrated different kinds of representational painting in a sequence. This aspect of Grant's work is especially in need of further consideration. The row of books beside the bust has stepped directly from Grant's 1909 *Portrait of Lytton Strachey*, which in turn relates closely to the books in Simon Bussy's portrait of *Sir Richard Strachey*.[54] Books and torso are placed on a gorgeous red and black fabric, which provides the pretext for more sumptuous painting, as does the highly abstract curl of fabric in the foreground, with its attendant fig and white glass. The plaster torso itself seems almost lit from within in its sombre setting, and is quite as uncanny as a contemporary Di Chirico, and perhaps not dissimilar in conception.

Like the *Head of Eve, The Scroll, The Kitchen*, and 13, *The Tub* of 1916, these are paintings of an extraordinary 23 intensity, both of technique and the imagination. In them, Grant made the underlying conventions of Western art the subject of his painting, and was content to play fantastic games with them, always drawing attention to the process of painting itself and its basic means, colour. He was never a modernist in the spirit of Robert Delaunay's paintings of the Eiffel Tower or Bleriot's monoplane, or Spencer Gore's paintings of Letchworth Station, or flying at Hendon. His modernity consisted in this sensuous play with the fundamental materials of painting, and its history.

In November 1919 he exhibited for the first time with The London Group, the principal grouping of contemporary British artists. The following year he took over Sickert's old studio at 8 Fitzroy Street, which had been used by Whistler, and Frith before him, and also had his first one-man exhibition, at the Carfax Gallery in London. He had established himself.

Maturity

Charleston is a singularly private house that is discovered suddenly, hidden behind a screen of trees, at the end of a long, narrow, winding Sussex lane, which remained rutty and potholed until it was eventually metalled in the early 1970's. It stands, as Quentin Bell describes,

near the foot of Firle Beacon – the noblest of the South Downs – and in a very beautiful stretch of country ... The rooms, although well proportioned were but slightly furnished and seemed large and bare. At bedtime one's candle seemed only to hint at the extremities of the room and, in the morning, one might find that a basin of water left overnight in the bath room was thinly but firmly glazed with ice, while the tap from a tank which demanded half an hour's energetic pumping every day, would not even yield that modicum of cold water which was all that it would promise.[1]

Radiators, hot baths, and electric light did not arrive until the late 1930's, and with them the telephone. It was, as Professor Bell recalls, 'a bit rough'.[2]

For Vanessa Bell Charleston provided an environment in which she could exercise control over a household according to her own lights, without any concern for contemporary middle class values and habits. At Charleston she was able to combine the tasks of child-raising and of painting. She was perhaps not unlike the character of Lucy Honeychurch in E. M. Forster's novel, *A Room With A View*, who came to recognise that;

men were not Gods after all, but as human and clumsy as girls; even men might suffer from unexplained desires, and need help. To one of her upbringing ... the weakness of men was a truth unfamiliar.[3]

To understand Grant's career after the First World War it is necessary to establish something of his relationship with Vanessa Bell, with whom he worked so frequently, and with whom his name is so closely linked.

Some artists are sparked off by close contact with one another. The intimate partnership between Picasso and Braque in the years 1906–1916 provides one such example; Van Gogh and Gauguin another. However, such working relationships are rare, and generally short term. It would seem that Vanessa Bell tended increasingly to over-value Grant's opinion of her work, and that her inspiration was to some large extent dependent upon his proximity, both as a person and as an artist. This was not entirely the case for Duncan Grant.

Far more than Vanessa Bell, he had found himself increasingly at the centre of a European avant-garde focussed on Paris in the years immediately prior to and during the First World War. His skills had been tested against innovatory art of great complexity and sophistication. There is a sense in which Grant had worked in London, without being entirely of it. It was to France that he looked for encouragement, and it was to French taste that he and Vanessa turned in the 1920's.

Keeping a studio in London whilst spending most of his time in Sussex, Grant was able to ignore those aspects of London 'society' that Aldous Huxley caricatured so remorselessly in his novels of the period. At the same time it is important to note that he and Vanessa Bell were bound by a deep mutual love and respect, and sustained their personal relationship over more than half a century. They were by far the least conventional 'couple' in Bloomsbury's inner orbit, and that is frequently overlooked.[4] Their isolation drew them together, as did their work. Charleston was their environment, and both cherished it fiercely, as they cherished one another.

David Garnett has described Grant's Fitzroy Street studio in the early Twenties as,

a large, oblong room, with a big skylight on the East, and incredibly dirty. Duncan had a most peculiar little folding-bed which, when unoccupied, rose vertically in the air and concealed itself inside a piece of furniture not much larger than a very wide grandfather clock.[5]

In 1920 Grant was working in two distinct manners. The first involved a radical toning down of the brilliant colours that had been so typical of his Post Impressionist work. Brown became, temporarily, his preferred colour, and a number of almost monochromatic still lifes testify to his pleasure in returning to a close toned, densely textured style of painting, in flat, even light

conditions. *Still Life with Jug, Pear, Bottle and Lamp* is typical of many pictures *c.*1920 in which he seems deliberately to have set himself the task of extending his technical skills, with a new emphasis on volume, and the special wetness of fresh oil paint. Landscapes in this manner are equally likely to depict scenes in which the light is even, and individual brush strokes retain a powerful degree of autonomy independently of what they happen to describe. It is often as if a small area of Post Impressionist marbling has been drastically enlarged, in such a way that it almost unexpectedly opens out into a recognisable and even familiar scene, like the pond at Charleston, a favourite subject.[6]

Pushed to an extreme, this could lead to the stark sobriety of his 1920 portrait of a model, *Polly,* whose sensuality is transferred almost entirely from the field of colour to that of handling. This acknowledges something of Picasso's contemporary neo-classicism, but in an entirely different idiom. The deeper debt remains to Picasso's earlier work *c.* 1908, especially the closely toned still lifes such as *Vase of Flowers, Wineglass, and Spoon* (*Daix*, 196). This had probably also partly inspired Grant's several Omega Workshop period still lifes with paper flowers, which is how he imaginatively interpreted the influence of Le Douanier Rousseau on the Picasso, firstly making paper flowers that resembled those in the *Vase of Flowers*, and then recreating them in his own paintings.[7]

Grant's other chosen manner at this time was far lighter, though largely confined to his use of watercolour, which refused to thicken or lose its innate transparency. In place of the rigorous, intense naturalism of his oil paintings, his watercolours from the early 1920's, and subsequently, conjure up a wholly delightful fantasy world, largely drawn from a generalised vision of Arcadia, peopled by ample nymphs and shepherds, far removed from Picasso's stern gods and goddesses. Roger Fry once noted that;

It is generally in small works thrown off by the way that an artist reveals the underlying trend of his nature, precisely because such works are less moulded by deliberate and conscious purpose.[8]

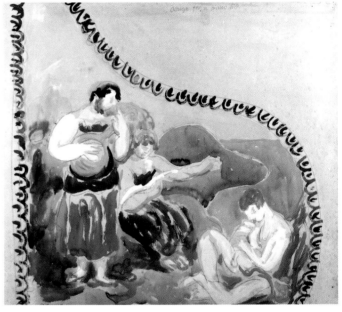

40 *Design for a Piano Lid* c.1925, red crayon, watercolour and gouache, 18½ × 21″ (47 × 53.5 cms.), private collection

If one is to describe Grant's classical imagery as Theocritan, this must include an awareness of the passion and the transience of sexual pleasure, as well as its delights. Thus he was drawn to themes such as *Cupid and Psyche, Venus and Adonis*, or *Apollo and Daphne*, with their darker implications of impossible desire, and loss. There is a deep psychological realism to these works, which suggest a resignation to the fact that one is subject to one's fate in certain areas, that one does not choose to fall in love, or to be attracted to certain types of people, that desire will likely lead to pain as well as pleasure, and that the goal of pleasure is thus all the more precious. It was entirely in character that Grant should even have invented his own myths when necessary, as in *Venus and the Duck*, of which several versions exist.

Bruno Bettelheim's sensitive analysis of the story of Cupid and Psyche from Apuleius' *The Golden Ass* provides a helpful model for the further analysis of Grant's frequent use of mythological themes. As he concludes of Psyche's fate;

Once woman has overcome her view of sex as something beastly, she is not satisfied with being kept merely as a sex object or relegated to a life of leisure and relative ignorance. For the happiness of both partners they must have a full life in the world, and with each other as equals.[9]

A *Design for a Piano Lid*, from this time, simply shows a near naked boy sitting, playing a flute, accompanied by two women, with a guitar and a mandolin. The image is utterly delightful, Grant at his most unashamedly ravishing. Yet the theme of watching and being watched, of wanting and being wanted, seem not unconnected to his own inner life, and circumstances. The decision to stay with Vanessa was in all probability not made consciously, or at any one moment, but it was none the less the most decisive decision of his life.

In the spring of 1920 they visited Italy, in the company of Maynard Keynes, renting a studio in Rome, and travelling out into the Campagna. Returning via Paris, they dined with Derain and his wife, with the Braques, Satie, and Dunoyer de Segonzac, and attended a private view of Picasso's recent works.[10]

Restored to Charleston they both continued their work on panels for Maynard Keynes' rooms in Cambridge, which were to occupy them off and on until 1922. The imagery of muses male and female remained very much in their Post Impressionist manner, though more densely handled, with statuesque, Piero-like figures, posed against richly marbled backdrops, with strong echoes of the series of life-size heroes and heroines painted as decorations by Andrea del Castagno for the villa of the Carducci family at Soffiano near Florence, which had in their own day profoundly influenced Piero della Francesca himself. Yet life was not without its stresses. Duncan wrote miserably to Vanessa in July from his parents' home:

I really think it is necessary to leave this hellish climate. After being given a glimpse of how heavenly summer might have been last evening it is now pouring with rain again and no sign of hope and I dare say 30 million people wet disappointed and miserable. I began a little picture yesterday but of course today am ruined. I do seriously think one

ought to go and live in Italy. Why should one waste the best year's of one's life in this place if one is a painter? One always says this but I think it is weak not to go. What do you think? . . . I see no reason to suppose that England has not entered into another black period like 1400 or whenever it was when it apparently rained incessantly for 40 years on end and everything caved in.[11]

The stylistic separation between oil painting and interior decoration became increasingly pronounced during the Twenties and Thirties. Life at Charleston encouraged painting as a routine, daily practice, as Simon Bussy had prescribed long before, when he recommended Grant to paint every day, with or without inspiration. At the same time both Vanessa Bell and Duncan Grant also worked on lighter decorative schemes throughout the Twenties, producing elaborate interiors for their London friends living in and around Bloomsbury. Robert Medley has recalled the scene at 51 Gordon Square, when he was invited to join them in the

formidable task of redecorating the entrance hall and five-flight staircase – in a complicated mixture of powder colours, whitening and size prescribed by Duncan and resembling 'French grey'.[12]

He also helped out with the production of Lytton Strachey's play, *The Son of Heaven* in 1925. Although it had been written in 1912;

the fact that Lytton had written it and that the decor and costumes were by Duncan Grant was considered enough to guarantee sufficient response . . . The designs were strikingly fresh and original, a characteristic chinoiserie fantasy. Clear ochres and greys set off pinks, oranges and emerald greens. The costumes, some of them elaborately decorated, were hand painted by Duncan and Vanessa with a confident boldness that astonished me, but to which all their experience of the Omega Workshop days obviously contributed.[13]

On the upper panel of the door to Clive Bell's library at 50 Gordon Square Grant painted a vertical landscape of the walled pond in front of Charleston, as seen from the writing room, and later library, in which Bell worked when he was visiting. The door to that room was similarly decorated in 1918 with a view across the farmyard which would be visible were the

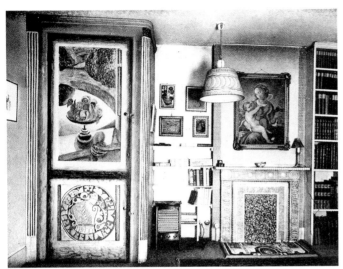

41 Clive Bell's Library, 50 Gordon Square, London, decorated by
Duncan Grant and Vanessa Bell

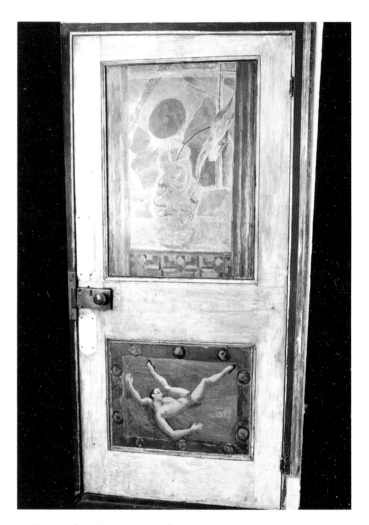

42 Door to Clive Bell's Library, Charleston, c.1917

remainder of the house behind the door invisible. It is
in this sense that one may begin to appreciate a level of
unity within Grant's decorative work, that is intensely
autobiographical, however oblique the means. It
should also be noted that the elaborate trompe l'oeil
rectangle of a complex geometric motif on the 1918
door panel at Charleston, represents a printed paper
that had originally been used in the room to which the
door opens. It is thus possible to begin to draw an
analogy between the way in which Grant had pre-
viously liked to explore the possibilities generated by
combining different conventions of representation in
a single picture space, and the increased blurring of
the distinction between 'inside' and 'outside' in the
44 decorations at Charleston, and many of his paintings.

Nobody has written of this aspect of Grant's work
with greater sympathy or sensitivity than Sir Stephen
Spender, who has observed;

when one speaks of Duncan Grant as being decorative one
really means more than the word implies. One means that
he paints in a style which alters subject matter and material.
One of his paintings hung on a wall, might leave the wall,
cover tables, chairs, rugs and curtains with its curves and
hatchings and colours. Ideally, it would be put in a room

where there are patterns responsive to it. ... There is
something about such paintings which is like mirrors
reflecting interiors, and one another. Duncan Grant paints a
landscape, a still life, a nude, a Leda and the Swan. But he
also – really or implicitly – paints the wall on which he
hangs these, and then the woodwork of the doors and
windows and panelling. Moreover, he and Vanessa Bell
design the rugs and also the pottery that are in the room ...
Then they paint other pictures which are of interiors of the
room and its contents, nudes of people standing on rugs
they have woven, views from these windows, even pictures

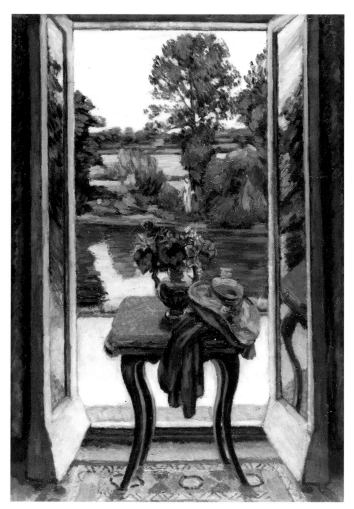

43 *The French Window* 1953, oil on canvas, 43 × 30¼"
(107.5 × 75.6 cms.), the Reader's Digest Collection, USA

and canvases which are themselves pictures of the room
and its goings on. It is a world which brings everything
outside indoors, including not only the immediate things
I have mentioned, but also places to which a group of
friends have journeyed – Provence and Venice – and also
the influences of Matisse, Derain, Masaccio, Piero della
Francesca, etc.[14]

Indeed, it cannot be sufficiently emphasised that Grant
inhabited a house which he and Vanessa Bell constructed
as carefully as any of their paintings. Charleston was

lived in very much as an ongoing process of represen-
tation. Both seem to have been quietly but keenly
aware of this. For example, in the early 1930's Vanessa
Bell worked on a large and extremely important
picture, *The Other Room*, which combines various
elements and motifs from different rooms at Charleston
into a single, imaginary interior, with three women,
one lying down, one burying her head in her hands,
and one staring out of a window. It is a picture of great
psychological complexity, dealing with relations
between women that increasingly occupied her
imagination in later years. In a not dissimilar manner
Grant painted *The French Window, Charleston* in the
1950's, which literally opens the garden doors of the
downstairs sitting room at Charleston onto a view of
the pond that is in fact seen from another side of the
house. Both he and Vanessa were free to reinvent
Charleston as they liked in their pictures, since they
had invented it in the first place, and their joint
authorship is evident throughout the house. In *The
French Window, Charleston*, Vanessa's hat and cape lie
draped across the corner of a table inside the room,
alongside just the type of blowsy, baroque flower
arrangement at which she excelled. Grant and Bell are
thus constantly within one another's pictures, as their
pottery and fabrics and pictures and decorations are
recombined in an infinite range of compositional per-
mutations.

At times it seems almost as if Grant were living
inside a picture that he was painting, of himself
painting the picture in which he was living. Much of
his best work subtly addresses such vertiginous possi-
bilities. In other words, there is a conceptual depth and
complexity to Grant's still lifes and decorations that
has scarcely been noticed.

When an artist chooses to represent objects and
scenes that he himself has already painted with other
representations, and in other styles, a complex series
of overlapping dialogues becomes possible between
different periods in the artist's work, and work in
different media and manners, as well as between
objects that co-exist in the same picture space but at
different levels of representation. Grant's best still lifes

between the two world wars return repeatedly to the construction of such subtle and visually dense sets of references. For example, *The Italian Handkerchief* of *c*. 1935 shows Grant's self-emblematic white bowl, on a richly decorated piece of brown fabric, reminiscent of his own decorative work in the 1930's, draped over an upright brown box or cabinet which is loosely marbled in his familiar pre-war Post Impressionist manner. All of this has been carefully set up in front of a section of the huge decorative panels on which he was working for the interior of Cunard's liner, the *Queen Mary*. The abstract, sweeping orange forms in the decorative panel escape to repeat themselves in the variations of the fall of the handkerchief over the edge of the box, whilst the colour itself moves forward into the marigolds that rest in the white bowl. The overall play of greens and reds, ochres and browns, purple and black, are inimitable, and possess a grandeur of scale and an exuberance that is not to be equalled in twentieth-century British painting. Nor has any British artist been more instinctively aware of the possibilities of still life as a genre in which such richly layered meanings may be constructed and finely controlled.

This close attention to detail extended throughout life at Charleston, from the choice of old picture frames to the annual ritual of consulting the latest seed and bulb catalogues, that in turn would dictate the look of the year's pictures. As Grant explained enthusiastically to Vanessa Bell in the Spring of 1924, Mr Stevens, the gardener,

is going to give us some stocks and marigolds later but says it is too late to plant roses this year, so we shall have to put other things in the terrace beds. I am very much tempted to spend a pound or two on lily bulbs. I have a catalogue of autumn flowering lilies which sound too lovely for words. What do you think? In any case I am going to buy a collection of late flowering gladiolus which sound lovely and are quite cheap and very easy to grow – one can have clumps of them. Also I am going to buy some sunflowers.[15]

Plants were selected with as much care as furniture or fabrics: seen from the house, they became part of the house. In a memorable phrase, Grant described his work as a decorator as, 'another part of one at work',[16]

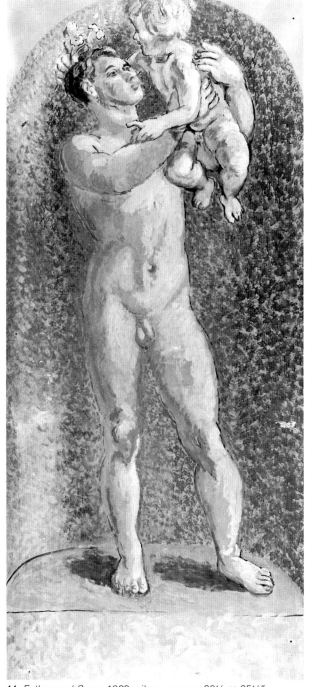

44 *Father and Son* c.1929, oil on canvas, 80½ × 35½″ (201.3 × 88.9 cms.), Southampton City Art Gallery

and spoke of the relief of decorative work after the concentration of painting;

if I go to a house of a friend who hasn't anything, I think of myself almost unconsciously decorating the space over the fireplace, or something like that.[17]

Yet neither he nor Vanessa Bell made much effort to work in the commercial world of interior design, though throughout the Thirties they produced designs for fabrics and ceramics of great beauty. It is however significant that such work was generally done for small companies, rather than major industrial firms in the mass market. An offer from the John Lewis partnership in the Twenties was not taken up, and it must have been more than a little galling to work for designers like Clarice Cliffe whose work was such a feeble, if commercially successful, derivative of the type of design they had pioneered before the First World War at the Omega.

None the less, Grant's *Corner Cupboard* from the mid Twenties exemplifies his work as a decorator at its best. Besides, neither Duncan Grant nor Vanessa Bell were temperamentally well suited to the more rigorous demands of industrial production. They much preferred the immediate creative patronage of friends, who were appreciative of the direct painterly quality of their decorative work. It is perhaps not surprising that their 1932 exhibition of a complete interior for a music room at the Lefevre Gallery was not a success. Few clients could have been expected to order such an extravagant interior 'off the peg' as it were, whilst Grant and Bell could never have arbitrarily applied their talents to order, unless they knew and trusted their patrons socially and aesthetically. It is thus particularly unfortunate that the interior that they created in 1930 for Lady Dorothy Wellesley at her home, Penns-in-the-Rocks, is no longer extant as an ensemble, though individual panels and other objects do survive.[18] (*see opposite*).

Although he exhibited frequently throughout the Twenties and Thirties, he seems to have had little interest in public exhibition per se. That is not to assume he was unaware of the financial aspects of exhibiting and selling his work, since he had no other direct source of income. He wrote to Vanessa Bell from Paris in 1923 after his Recent Paintings and Drawings show at the Independent Gallery, noting that he was,

rather alarmed at the sales in my exhibition. What does it mean do you think? That I am a very bad painter? I expect Roger will come to this conclusion. But on the other hand it is about 3 years or more work. £200 a year is a not unreasonable amount to make out of people do you think?[19]

By comparison, Maynard Keynes' income from his writings and investments had risen to £5,156 in the financial year 1919–1920.[20] Income tax began at £160 per annum, and the average industrial wage just after the First World War was about £75 a year.

Grant's comments concerning Roger Fry's attitudes to his work are very revealing. Neither he nor Vanessa Bell had much regard for his work as an artist, yet revered his opinion as a writer. To them, Fry was a man who had fatally confused the functions of artist and writer, which, as good members of Bloomsbury they held to be mutually exclusive. When Fry visited Charleston or their London studios they would hide their recent paintings, yet hang on his words. It is difficult to estimate Fry's influence on Duncan Grant, but a note in a drawing book from 1939 concerning a recent Cézanne exhibition at Wildenstein's suggests something of the respect in which his opinions were held, especially in the years after his premature death in 1934:

The more I study his (Cézanne's) production the more I feel that Roger's analysis of his work is the best I have read,

though he noted that Fry had less opportunity to know the later work, which left Grant,

almost in the state of mind as one was in seeing C.'s painting for the first time, i.e. intense excitement and awareness of something really great.[21]

Grant went on to compare Cézanne's *Chateau Noir*, and his portraits of *The Gardener* from the first half of the 1890's to the late string quartets of Beethoven,

which was as high as his praise could go.[22] Fry's own book on Cézanne offers the best opportunity to consider how Grant might have responded at the most personal level, since it concentrates so much on the question of still life painting, concerning which he had learned much from Jacques Emile Blanche. Blanche's own still lifes however stand firmly within the tradition of Fantin-Latour and Manet, building up a central pictorial motif which is firmly distinguished from its surroundings, working from dark tones to light, with much dependence on the use of white highlights on crockery, bottles, the handles of water-filled glass vases, brass, pearls spilling from velvet boxes, silverware, and so on. It had after all been Chardin whom Grant had copied most assiduously in the Louvre in his student days, and there were few more powerful sources on his later art than Chardin's *Remains of a Lunch*, a copy of which remained at Charleston until his death.

Fry had frequently proclaimed his own love of still life painting. Writing in the early 1920's he explained that;

Those critics who like to speculate and generalize must often regret that the genre of still-life has been so rarely cultivated throughout the course of European art ... Because it is in still-life that we frequently catch the purest self-revelation of the artist. In any other subject humanity intervenes ... In still-life the ideas and emotions are, for the most part, so utterly commonplace and insignificant that neither artist nor spectator need consider them.[23]

For Fry, Cézanne's still lifes were, 'dramas deprived of all dramatic incident', and he speculated,

whether painting has ever aroused graver, more powerful, more massive emotions than those to which we are compelled by some of Cézanne's masterpieces in this genre.[24]

In his *Reflections on British Painting* of 1934, Fry concluded that,

the power to see and feel plastic form is almost a measure of an artist's power to free himself from the interests of ordinary life and attain to an attitude of detachment in which the spiritual significance of formal relations becomes apparent.[25]

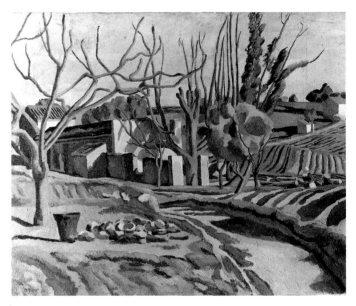

45 *Landscape near St. Tropez* 1922, oil on canvas, 25½ × 31¾″ (63.7 × 79.4 cms.), The Tate Gallery, London

Yet such a firm distinction between the aesthetic and 'ordinary life'[26] does not easily explain the strengths of Grant's still lifes, which at their best were replete with immediate personal and social significance. Perhaps this is why Grant suspected Fry's judgement of his work, with some reason. It was in his landscape painting that Grant more closely approximated to Fry's austere vision of artistic excellence, although Lawrence Gowing comes nearer to the significance of Grant's out of doors work in his observation that, 'A sketch that is evidently made with oil paint at a certain moment in an actual place registers the experience against our sense of an irrefutably physical stuff, hurriedly handled with inevitable self-revelation'.[27] Yet from the Twenties onwards Grant's landscapes frequently tend towards the routine and the formulaic, and constitute the most uneven area of his work.

Grant's finest landscapes were generally painted either near Charleston, or else during the painting trips to Europe that he and Vanessa Bell made annually from the late 1920's onwards, to Venice, and to the small farmhouse of La Bergère at Cassis, near Marseilles,

46 Duncan Grant, 1931 (with portrait of Harry Daley)

to which they returned every year between 1927 and 1938. Recalling Grant's horror of the British climate, it should be remarked that the very sight of a painted Mediterranean landscape or still life possessed its own iconographic significance in the inter-war period. Hence we may appreciate Margaret Drabble's insight concerning the look of such scenes a full quarter of a century later:

Ripe tomatoes, red, green and yellow peppers, artichokes, olives, courgettes. These vegetables were not then, in the 1950's, part of the staple British diet. They were symbols, glowing, of plenty . . . regardless of the rigours of a north-ern European climate and a war-crippled economy.[28]

One should consider how much more such images meant in the Britain of the 1930's. Travel also provided Grant with regular contact with European painting. He would report back eagerly to Vanessa Bell from his frequent trips abroad, as in 1921, when he visited the Salon des Indépendents with his old friend Constance Lloyd;

The principal points of interest are the Cubist room and the room which contains Segonzac . . . Marie Blanchard and a new man called Bossingault (who did the drawings I rather liked in *L'Amour de l'Art* of people dancing). De Segonzac's big picture is extraordinarily fine, 2 nudes sleeping out of doors only enormous. . . .[29]

He also reported that Vanessa Bell's work in the exhibition, 'looks very well'. He found time to visit Jacques Emile Blanche a few days later, but

the awful thing was that I could hardly get a look at his Renoirs and Corots and Manets which are simply extra-ordinary because he wanted to know what one thought of his beastly great portraits. But I had a peep at the Renoir (the big bathers) which I must tell you about it is so extraordinary.[30]

The following year he informed Vanessa Bell, who had just left Paris, that,

I think less and less of Dufy who is evidently all the go now. He is really nothing more than pretty and amusing.[31]

He also admired a 'fish piece' by Matisse, and new work by Derain, together with Delacroix's *Death of Sardanapalus* in the Louvre. But he was never uncritical of what he saw, remarking of Derain's portrait of Kisling that,

the chief thing that struck me was its extraordinary likeness and character. It is extraordinarily solid and beautifully drawn but almost unpleasantly rigid in its paint quality at first sight.[32]

Visiting the Salon des Indépendents in 1922 he noted ironically,

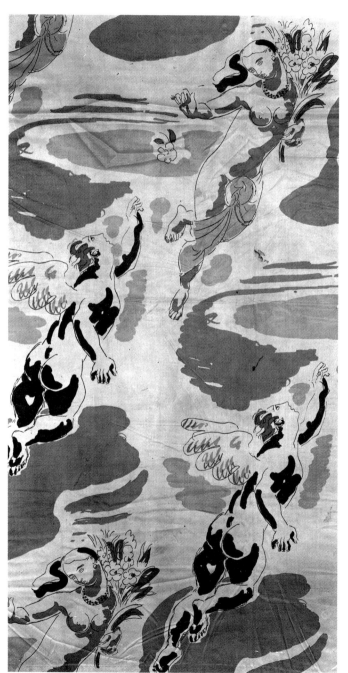

47 *'Apollo and Daphne' Fabric* Allan Walton Textiles, 1932/33, private collection

I was very much struck by Roger's things – so you can judge as you like of the quality of the show . . . I very much wonder what you will think of the general level of the painting here. I am rather appalled – by the extraordinary quantity of very high talent, and also by a certain lack of distinction in the effort. [33]

He was however charmed by Dufy's fabrics,

woven at Lyons by machine. They really are lovely things. I cannot think who can buy them – they cost about £3 a yard. They are wonderful colours and charming designs but I think one might invent a rather newer sort of treatment – they are very much in the Tradition . . . I think the best plan is to accept the repeat very thoroughly. [34]

This was certainly the way in which he approached the fabrics he himself designed for manufacture by Allan Walton Textiles in the 1930's. *Clouds*, the most complex of these, contains no less than eight colours, and solidifies the nebulous cloud motif into a virtual index of his favoured decorative devices at the time, with cross-hatching, stippled dots, and full, fat curves. *Flowers and Leaves* provides a similar sampler of his general decorative style in the 1930's, with strings of irregular circles and highly simplified flowers amid swirling leaf forms. The figures which soar across *The West Wind* and *Apollo and Daphne* similarly embody his love of generous, well-rounded bodies – the type he had stationed on either side of his studio fireplace as caryatids, warmed by the stove between them, like the undressed maidens who squat on their haunches on the mantlepiece over the sitting room fireplace, from *c.* 1928. Such fabrics are noticeable looser in their manner, and more daring, than the work of contemporaries such as Marion Dorn or Eileen Hunter.

He and Vanessa Bell shared a profound knowledge and direct acquaintance of European art, and tended to support one another's opinions. Writing to her from Berlin in 1924 of contemporary German art he explained,

It struck me their painting is either too artistic – feeble with a sort of sensitiveness, which is the best – or utterly vulgar . . . There was a Matisse among them – a most lovely view of the Seine in Paris – which looked so quiet and almost grey among them. [35]

However, the Kaiser Friedrich Museum was another matter;

It really is a marvellous gallery more comparable to the National Gallery than the Louvre. I mean there are more primitives and it is an all round collection. I practically looked at everything for 3 hours so only have a very general view. But what I most remember are the Masaccios + Giotto + superb Signorellis. But the Italians are wonderful + they have one of the best Rembrandts in the world I should think, Hendrickje looking out of a window. You know the reproduction. It is simply amazing . . . Everything is shown with the most correct taste, beautiful frames etc. . . . But *à la fin* one does feel very profoundly that making a museum is a very different affair from making even the most minor work of art. In fact it was a relief to find a Japanese copying a Botticelli.[36]

He also confided how a friend of his

thought it would amuse me to be taken to some of the homosexual cafés that are so famous here. It was interesting to see but as you might imagine extremely proper + rather slow + not unlike a Cambridge party at a rather shabby undergraduate's rooms. The only thing that was a little bolder was that the pictures on the walls were sometimes photos of nude young men with horses – very teutonic.[37]

In another letter he added,

I forgot to tell you I saw the Raphael you are copying. It is evidently I should say not finished + taken up by someone else . . . Your colour brings out the beauty of the design much more than the original colour does . . . There are 3 or 4 other Raphaels of incredible perfection.[38]

This is very much painters' studio talk, and he commented that,

it is no good going into raptures over pictures you have never seen. One has always to use the same words – like the critics + they mean nothing.[39]

At the Kaiser Friedrich Museum he copied in water-colour from a landscape by Annibale Carraci, a Rubens landscape, and the central section of a Masaccio, presumably one of the predella panels now in the Staatliche Museum, West Berlin. He also attended a performance of Mozart's *Seraglio* which he considered,

much better done than Beecham or the French . . . I think the Germans are a kindly hard working honest race with a great many good qualities + extraordinarily open minded. I dare say it is very unimportant that they dress so badly + paint so badly.[40]

It was Dresden which most roused his enthusiasm, and he wrote to Vanessa Bell in great excitement to tell her,

I have seen the *Sistine Madonna*.[41] I couldn't help thinking it might be one of the greatest aesthetic thrills as I dashed round the gallery – really rather nervous of finding it. I didn't know what I might not feel . . . There is no doubt it is one of the very great collections in the world + housed in a very sympathetic palace it is more like the Uffizi than anything else I've seen. It is nearly all masters of the High Renaissance + quantities of really lovely Dutch pictures. I suddenly came across the *Sistine Madonna* . . . It is in a room all by itself + I could only see a crowd of rapt onlookers, peasants and all sorts – it's being Sunday. My first impression was utterly different from the photographs, somehow it nearly all seemed space + the figures comparatively unimportant. All very quiet + the most beautiful rather subdued colour not unlike the quality of the *Madonna della Perla* in Madrid. I must say I was very much impressed – tho a good deal I suspect at first was the extraordinary prestige the picture has. But I sat and looked at it for some time + I thought it extraordinary fine + so much more perfect than I had ever expected but it really was very thrilling – I had never known quite what to make of it before. What I cannot make out is why a picture that depends I should say so entirely on its purely formal beauty, should impress such masses of people who seem uninterested in pictures as a rule.[42]

This is perhaps the most detailed extant description by Grant of his most personal response to a single work of art, and it is very telling. For the *Sistine Madonna* had been one of the most esteemed Italian renaissance paintings in the nineteenth century, and hence one of the most reproduced. Its popularity undoubtedly rested on the contrast between the vastly aloof figure of the Madonna, distancing herself and her baby from her attendant saints, and the two putti, who lean out from the bottom of the picture, with respectively ribald and wistful expressions. It is typical of

Grant that he should consciously see none of this, and be drawn so totally to the negative space surrounding the figures, and the device of the hanging curtains that he himself had so frequently employed in works such 32 as *Venus and Adonis*.[43]

His next business, he continued,

was to find the Giorgione + I was very nervous before I found it. Suddenly I came across it + it simply staggered me by its beauty. I don't think I have every been quite overcome by a picture in the same way. In fact I am rather ashamed to own it brought tears to my eyes ... I cannot describe to you the extraordinary effect the balancing of the spaces has on one. It is simply uncanny + I should be very interested if the Science of Picture making could explain it ... Besides there are 4 or 5 of the greatest Correggios, masses of Rembrandt, Rubens, all the late Italians, + 2 very important Vermeers. The Giorgione I think certainly one of the greatest pictures in the world, + one so seldom gets his particular thrill. Lord if he had lived what wonderful things we should have.[44]

In this respect it is fascinating to compare two drawings done from Giorgione's *Fête Champêtre* in the Louvre by Grant and Bell at some time in the early 1920's. Vanessa Bell draws back from the social and amorous aspects of the painting, emphasising the isolation of the woman standing on the left, who is made to shrink away from her three companions. Although the Grant is not perhaps such a fine drawing, it shows him on the contrary moving into the scene, tying all four figures together in a wonderful sweeping design which emphasises the central position of the mandolin that Vanessa Bell had all but obliterated in her version. There is a certain pathos however in Grant's correspondence from Paris over the years, and especially in the evidence of his seeming need to maintain the esteem of artists such as Dunoyer de Segonzac, whom he must have realised was a far slighter painter than either he or Vanessa Bell. He was also only too well aware of Vanessa Bell's dependency on Segonzac's good opinion of her work. Angelica Garnett comments;

I was a witness to their feeling and admiration for Segonzac as well as for other French painters such as Pierre Clairin,

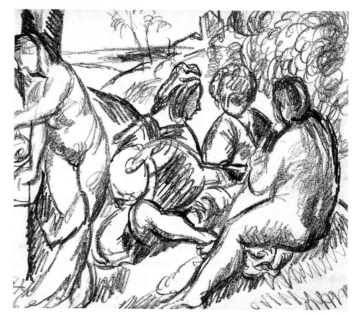

48 *Copy after Giorgione's Fête Champêtre* c.1921, pencil on paper, 7 × 8¼" (17.8 × 21 cms.), private collection

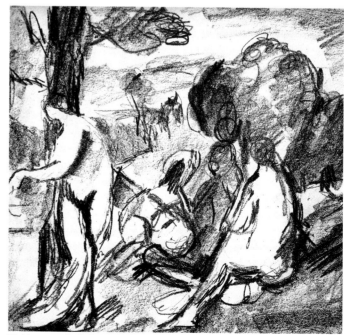

49 Vanessa Bell *Copy after Giorgione's Fête Champêtre* c.1921, pencil on paper, 7 × 7½" (17.8 × 19.2 cms.), private collection

whose artistic stature was far less than their own. It was a complex attitude, due in part to their utter unworldliness, but also to the fact that, although they criticized their contemporaries, sometimes dismissively, they did not, mentally, enter the lists themselves. Again, their feelings came from the shock of the Post Impressionist exhibitions, the initial impact the French had had on them. They did, after all, accept the 'fact' that English art was inferior, and the French had bowled them over in a heap, which had the effect of raising *all* French painters, regardless of merit, to a special, Parnassian elevation, as though they had received a mysterious *Légion d'Honneur* from God. (Zeus and not Jehovah). It was Vanessa Bell and Duncan Grant's conviction that painters and painting were taken more seriously on the other side of the Channel, and that they had hewed out a niche for themselves out of the social fabric, in which they could be completely themselves, in contrast to the English who, in order to be socially acceptable, had to forfeit their artistic integrity. (It seemed that they had never read about the Impressionists' and Cézanne's difficulty in being taken seriously).

This, I think, points to their class difference, to the fact that they could not disengage themselves from the upper echelons of English society, to which, in many ways, they belonged. They were uneasily balanced between the longing to be 'bohemian', and the social status for which they had been educated. But this was untrue of most of the French, who therefore had a far simpler problem. But it was also the personal, psychological impact of men such as Segonzac, Derain or Clairin, not to speak of that of Matisse and Picasso (and even Simon Bussy), that knocked them for six, as it were. Not for one moment could Duncan and Vanessa have competed in this field. The French never apologised for themselves; they were personally and socially confident, and their conviction that their art was a valid profession regardless of personal merit, gave them a strength lacked by Vanessa and Duncan. The French suffered neither from (false?) humility, or the temptation to be ironic. Vanessa and Duncan envied and admired this, without being able to apply it to themselves.[45]

Neither of them enjoyed the advantages of artists working in Paris or Berlin, who were supported by a gallery system which made far greater efforts than galleries in London to win over a substantial audience for contemporary painting.

Back in England Grant worked incessantly through

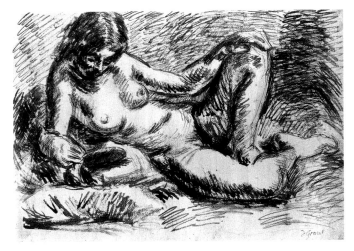

50 *Study for 'Reclining Nude' in the Royal Albert Memorial Museum, Exeter* c.1935, ink and wash on paper, 15½ × 22¾" (38.7 × 56.9 cms.), private collection

the inter-war period in a ceaseless routine of portraits, nudes, still lifes and decorative projects, all of which developed his new interests. As he remarked in 1923;

I am beginning to get more + more interested in painting + see that for me it becomes more + more a question of colour and consequently of colours – I shall have to get hold of those Munich colours.[46]

His *Self Portrait* of 1925 shows him wearing a familiar sun-hat, in front of a dazzling background of brilliantly coloured fabrics and a shawl, whilst his design work and smaller pictures such as *Four Dancers* of c. 1925 [43] have no equal in British painting from the period in their ambition to translate a tonal representation of three-dimensionality into the terms of pure colour.

This is most pronounced in a large number of magnificent paintings from the 1930's, including the *Reclining Female Nude* from the Royal Albert Museum, Exeter, the series of an Italian model, Tony Asseratti, [46] seen in the *Standing Male Nude* at Charleston, Grant's portraits of the model *Miss Holland* in 1932, and his [48] 1934 portrait of *Vanessa Bell*. One of the most remarkable of these is his c. 1931 *Venus*, an homage to Titian's [50] great *Venus Anadyomene* from the early 1520's, in the National Gallery of Scotland, given the facial features

attempting to give expression to his native inclinations, which derived from a study of the line from Poussin through Chardin to Cézanne. We decided to try to persuade him to give greater play to his essential gifts – and we agreed that for this to happen he would need to make a radical break with the Bloomsbury world . . . Duncan was offended and Vanessa annoyed.[47]

Whilst there was some grain of truth in their observation, it would be unwise to over-estimate the influence of Roger Fry on either Grant or Vanessa Bell, who were under no illusions concerning the consequences of Fry's art theory in his own work. It also overlooks the fact that Grant's mind was very unanalytical, as Angelica Garnett has remarked:

beyond a certain point, he was not interested, really, in ideas, and didn't want to talk about them. I think he had a distrust of words in that way, or of ideas that were stated . . . what he tried to do, especially in the 1920's . . . seems to me a very natural follow-on from Cézanne, but I don't know how much Duncan thought that. I mean, he didn't do it because he thought he ought to, he just did it because it somehow seemed to be the inevitable consequence of what he'd done before. And it was, in a way, a perfectly logical consequence of Post Impressionism.[48]

Nor did Medley and Doone perhaps appreciate at the time the profound continuities within Grant's work, and nowhere more so than in relation to this particular theme. For in a sense *The Bathers* is as much a picture that considers one figure (or two) from a variety of perspectives, as *Bathing* from 1911 had shown the movement of a single figure – diving, swimming, and climbing out of the water. Whilst there is a greater tonal unity to the version in Australia, the London version pushes its colour modulations to greater extremes, with almost surreal results. *The Bathers* should also be considered in the wider context of the convention to which it belongs. Whilst Cézanne sometimes painted male bathers as a result of his well-known shyness of female models, *The Bathers* constructs an erotic fantasy world that was strictly continuous with Grant's life at Charleston, just as it was also continuous with his more purely decorative work. It does not appear that he felt any division of

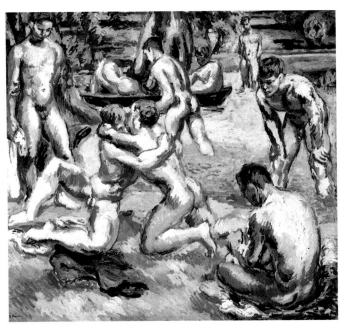

51 *The Bathers* 1933, oil on canvas, 54½ × 60¼″ (138.2 × 56.9 cms.), National Gallery of Victoria, Melbourne

of his daughter Angelica. Here the paint is extremely dense and closely factured and this style of painting could reach levels of high abstraction, which at times seems to anticipate the post-war work of Bomberg's followers in the School of London. He also produced at least one large 'Salon' picture, *The Bathers*, of which there are two fully finished versions worked on from 1927 until the version now in Melbourne was completed in 1934.

Robert Medley and his friend the dancer and choreographer Rupert Doone were the models who sat for the picture. At the time they were concerned that Grant's great talent,

for decorative invention – the quite un-English *esprit* that animated his best work – was being dulled by a misplaced seriousness. Under the influence of Roger Fry's rather puritan ideas of what serious painting should be, he was moving in the direction of a heavy, rather solemn, academic Post Impressionism. In *The Bathers* (so consciously – indeed conscientiously – a Cézanne subject) Duncan seemed to be

62

loyalties between easel painting, even on this scale, and his work as a designer. Furthermore, understanding of his decorative work suffers without the anchoring context of his work on canvas, just as the latter needs to be viewed constantly in relation to his work in other media. Yet for Medley, and many of his contemporaries, Grant was beginning to appear somewhat out of date by the mid Thirties. This was perhaps inevitable, since none of his generation – Wyndham Lewis, William Roberts, David Bomberg, or Vanessa Bell – survived the inter-war years with their previous reputations intact.

The greatest disappointment for Grant came in 1936, when the directors of the Cunard company decided to reject the decorative panels, and textile designs that had been commissioned from him for the *Queen Mary*. He was personally devastated, whilst Cunard threw away the opportunity to use one of the most startlingly beautiful design projects in the history of modern British art. In the meantime Roger Fry had died in 1934, and Vanessa Bell's elder son Julian had been tragically killed in the Spanish Civil War in July 1936, causing the breakdown of her health. In a brief catalogue note about Roger Fry for a 1942 exhibition of modern British painting, Grant argued that,

Analysis of a work of art might make us more aware of its significance but could hardly provide rules for producing another . . . His belief that there could be an infinite number of ways of expressing our aesthetic convictions made a collaboration an exciting event.[49]

It was precisely this sense of the diversity of creative artistic practice, and his refusal to toe a single stylistic 'party line' that must have required considerable courage for a painter in Britain between the two world wars. John Piper had written in 1931 that,

Grant is a painter for his own time, which means that in fundamentals he is ahead of it: not a preacher but a prophet. Indeed, no British artist has ever preached less or prophesised more.[50]

Grant and Bell made works and gave away others for auction in the cause of the anti-fascist Artists International Association, but neither of them could have been expected to subscribe either to the strong current of social realism in the British visual arts of the late 1930's, or to imbibe the powerful influence of Surrealism. Nor could they move backwards to the opposing extreme of non-figurative painting, however fashionable such a move might have appeared at the time. Nor did Grant enjoy the teaching that he was expected to undertake at the Euston Road School,[51] where, as W. H. Auden expressed in his Letter to William Coldstream in 1937, 'We'd scrapped Significant Form, and voted for Subject'.[52] As Virginia Woolf observed ruefully in one of her final letters to Julian Bell in Spain, a few months before his death, life in England in the late 1930's seemed, 'rather like sitting in a sick room, quite helpless'.[53] Duncan and Vanessa would doubtless have nodded in silent assent.

52 *Portrait of Julian Bell* c.1928, pencil on paper, 10 × 8¼″ (25.5 × 20.8 cms.), private collection

53 *The Labours of the Months* c.1942, oil on board, Berwick Church, Sussex

Isolation and Rediscovery

Anne Olivier Bell has described how, on a visit to Paris in 1937, she happened upon the three figures of Quentin Bell, Angelica Garnett, and Duncan Grant;

who appeared to form a protective bodyguard to the fourth, an infinitely sad, grey lady. She was Vanessa Bell, whose eldest son, as I knew from my then obligatory reading of the *New Statesman*, had recently been killed in Spain. [1]

Vanessa Bell explained something of her feelings to Duncan Grant in a letter;

One can't recover very quickly. But I expect I *shall*. It's difficult now to keep interested for long at a time and when one stops (painting) one feels as if that other existence were so remote – one forgets it somehow. You are the only person I can ever behave so stupidly to my dear. It's hard on you. [2]

Painting helped with the slow process of mourning, and provided her with a routine behind which she was very gradually able to recover something of her former self-confidence, now shrouded in an inviolable privacy. Their daughter Angelica Garnett was at Charleston on the day that the Second World War was declared, and they listened together to Neville Chamberlain's grim announcement on the radio in the garden, 'which was glowing with the reds and oranges of the dying autumn'. [3] In the Spring of the following year Angelica Garnett learned over the telephone of the suicide of her aunt, Virginia Woolf. Returning directly to Charleston she found,

a fragile but not overwhelmed Vanessa: it must have been an event she had expected for most of her life, and now that it had happened it had lost its power to shatter. Virginia's death merely confirmed the general pessimism and sense of futility which surrounded us. On Duncan's arrival from London she broke the news to him, and we all three clung together in the kitchen, in a shared moment of despair, feeling that the world we knew, and the civilization Virginia had loved, was rapidly distintegrating. [4]

In her autobiography, Angelica Garnett paints an extremely moving picture of her mother in the 1940's;

With age she had become thinner and more bent, dressing in clothes of grey and iron black. She had never dressed the

same way as other people; her clothes had always been defiant of convention and since middle age they had become increasingly unrelated to her own beauty ... Her movements were slow and tentative, her manner enquiring but impressive. In the Charleston dining-room she presided over the table painted by herself; it was round, but where she sat was the indubitable head of it. [5]

Duncan showed thirty-three pictures at the Wallace Collection in the early summer of 1940. These had been intended for the twenty-second Venice Biennale, but the war had made their display impossible in Italy, which must have been a considerable disappointment to him, since he had previously shown work in the British Pavilion at the Biennales of 1926 and 1932. However, in 1939 he and Vanessa Bell had been invited by the Bishop of Chichester to submit designs for the internal decoration of the sadly over-restored medieval parish church at Berwick, a mile or two to the east of Charleston, along the old coach road that skirts the foot of the Downs. After much ecclesiastical confabulation the scheme was approved by all the various parties involved, from the Diocesan Chancellory to the local parishioners, and the panels were painted at Charleston, which Vanessa Bell described as, 'all a dither with Christianity'. [6] Duncan Grant provided a central scene, above the chancel arch, of *Christ in Glory* with his hands stretched out in benediction. The Christ is seated on a low throne, surrounded by a mandorla, with four flying angels in attendance with garlands – muscular relations of the angels who swoop in a ring, that brings to mind Matisse's *La Dance*, above *The Mystic Nativity* by Botticelli in the National Gallery. On either side of the arch the landscape of the South Downs unfolds, behind figures representing the armed forces and the Church, personified by Bishop Bell of Chichester. On the inside of the west wall of the church Grant painted a large *Crucifixion*, and for the side of the chancel screen facing the nave he added four roundels of *The Four Seasons*. These were interpreted as scenes of Sussex farm life, possibly to reassure the anxious parishioners of Berwick, and they form the most charming of all the decorations in the church. [7]

54 *Portrait of Vanessa Bell* 1938, ink on paper, 10 × 8¼″
(25.5 × 20.8 cms.), private collection

The entire decorative scheme at Berwick shares with Charleston a sense of the intimate relationship between a building and its immediate surroundings, in this case the local Sussex landscape, which extends away behind Vanessa Bell's *Nativity* in the familiar form of Firle Beacon, as behind Grant's *Christ in Majesty*. The weakest part of the decoration is the coloured banding along the nave arcades, between the individual decorated scenes, which makes the overall interior appear unnecessarily boxed in, and counteracts the luminosity of Vanessa Bell's scenes. The large areas of scumbled marbling also seem out of scale with the rest of the interior, and act to dwarf the figures in both her *Nativity* and *Annunciation* which, though very beautiful,

appear as individual pictures, rather than as elements within an integrated interior.

In 1962 Grant added three small vertical decorative panels for the pulpit, painted to designs by Angelica Garnett, replacing three images of archangels by Vanessa Bell which had been damaged, beyond any hope of repair, by vandals. According to Angelica Garnett, Duncan Grant had thought it 'suitable' that she should produce something by way of designs. However, she found it 'impossible to step into VB's shoes. He took over and I doubt whether much of mine remains'.[8] The replacements belong to a decorative style that has its antecedents in the long *Embroidered Panel* in Grant's studio at Charleston, which was designed in the mid-1920's and worked in cross-stitch by his mother. He was evidently still profoundly drawn to the vertical format of his 1914 *The Scroll*, but its geometric forms have given way to a narrative of leaves and largely imaginary flowers, swirling from a bright blue vase, which is set upon a brilliantly coloured painted table-top. It is a motif to which he returned repeatedly throughout his career, and it allowed him to combine the most experimental and innovative aspects of his Post Impressionist work, with the looser brush work of the Twenties. Thus hand-painted paper flowers from the Omega survive amongst the bouncing arabesques of his *Queen Mary* decorations, and emerge once more in Berwick, as they were to continue to inform his decorative work in the Sixties and Seventies.

There were to be long years between the original designs for Berwick church, and the panels for its pulpit, perhaps the most difficult years of his life. Margaret Drabble was probably thinking of his magnificent 1942 *Portrait of Vanessa Bell*, in the Tate Gallery, when she wrote that,

there is something alarming about the serenity of Duncan Grant's later portraits of her, suggesting a formidable self-contained strength. She looks like the woman she was, a woman well accustomed to life, well learned in organizing herself in both easy and tragic times, a woman who relies on herself, first and foremost, and expects others to rely on her.[9]

It is an extraordinary painting, and one of Grant's finest portraits. She sits, cross-legged, with her arms folded across her lap, on a great straight-backed Victorian chair, upholstered in a brilliant Nile green. She wears a long, severe black dress framed by a sombre cape of apricot, its lining dusty pink – a colour that she specially loved. Behind her there is nothing but a blank screen, draped with stuffs of a rich, saturated purple, which splendidly enhance the imperial effect, at once infinitely remote, and unnervingly intimate. And in the subtlest visual pun that she must herself have much appreciated, her right foot in its black shoe points grandly downwards, exactly like the shoe in Gainsborough's greatest portrait, that of the imperious *Lady Howe* at Kenwood House.

In a letter of 1929 Grant had written to Roger Fry to let him know;

how good I thought your lecture was last night ... your hymn of praise for Gainsborough reduced one to tears. It is far the fairest and most complete thing we've ever heard on Gainsborough.[10]

In both temperament and sensibility, Grant had more in common with Thomas Gainsborough than with any other British artist. Indeed, it is almost too easy to hear Duncan Grant behind Gainsborough's question of his friend Jackson, if he thought,

that a regular Composition in the Lanskip way should ever be fill'd with History, or any figures but such as fill a place (I won't say stop a Gap) or to create a little business for the Eye to be drawn from the Trees in order to return to them with more glee.[11]

Grant's copy of Gainsborough's *Family Group* is now sadly missing from the pictures hanging at Charleston from the time he lived there.

There is much of Titian in the *Portrait of Vanessa Bell*, and one is reminded of the telling anecdote of how Vanessa fumed in silence when a guest at Charleston ventured the unwise opinion that Titian could not draw! One can also see something of Rembrandt, whom Grant had revered since his student days in Paris. He had made a loving copy of a detail of the Brunswick *Family Portrait* when it came to London in a temporary exhibition in the 1940's. Grant referred to Rembrandt's drawings only in his most intimate and personal work, as for example in his drawings of Vanessa Bell during her slow recovery from the death of her elder son, and in drawings of his mother. Like Picasso, Rembrandt was too vast and overwhelming for Grant ever fully to digest: he was content to take from Rembrandt only what he needed in moments of special intimacy, that would otherwise have run against the grain of his more optimistic nature, though one should recall that he had imagined his own appearance by reference to Rembrandt since at least 1909. The strange turbans and headgear that he frequently sported in self-portraits betray a fond acknowledgement of their shared fascination with disguise and fancy-dress, and the artist's capacity to construct an entire social world in miniature in the space of the studio.[12]

For some fifty years, he and Vanessa Bell had lived and worked in the image of John Donne's couple who,

> If they be two, they are two so
> As stiffe twin compasses are two,
> Thy soule the fixt foot, makes no show
> To move, but doth, if th'other doe
>
> And though it in the center sit,
> Yet when the other far doth rome,
> It leans, and hearkens after it,
> And grows erect, as that comes home.[13]

In the 1950's foreign travel proved one of the few guaranteed means to rouse Vanessa Bell from her melancholy. As Angelica Garnett recalls;

Anticipating what they called adventures, she and Duncan would pack up their painting things and go to Venice, Lucca, or Perugia in Italy, or to Auxerre or other small places in France where, installing themselves in some modest pension or auberge, they would immediately set out to find a subject. There was no nonsense about absorbing the atmosphere or taking time to settle down: they started a sketch at once by church or riverbank, afterwards enjoying a sedentary evening in a café and supper eaten on the terrace, recounting in amused and rather exclusive accents the events of the day.[14]

As British tourists they were that rare thing, genuinely cosmopolitan, polyglot, and culturally sensitive to the nuances of French and Italian society. In this context it is worth recalling the full significance of Bloomsbury's championing of Oriental and Third World art before the First World War, in a society which overwhelmingly believed itself innately superior to all other cultures and civilizations. Yet at this distance in time it is possible to detect that they were not so unlike such otherwise hostile contemporaries as Leon Underwood, or even D. H. Lawrence, who as,

exiles in the land of their birth were no less exiles in the land of their adoption. Their flight was from an England as it had become, and their hearts' desire remained England as it might have been.[15]

Grant and Bell were increasingly isolated in a climate of sexual puritanism, xenophobia, and a growing critical hostility to all things associated with the Bloomsbury Group that was spearheaded by the militantly provincial Dr and Mrs Leavis. The most recent survey exhibition of British art in the 1940's did not even mention them.[16] Charleston increasingly became a place of retreat, to which newcomers were rarely welcomed. Angelica Garnett has described how Duncan Grant was the only person who could persuade Vanessa Bell to,

live momentarily in the present, sensuously enjoying her rare cigarette or cup of coffee, and making those ironical jokes that lit up the recesses of her mind. Devoted and entirely suited to each other as they were it would hardly have been possible, after the time they spent in each other's company, not to have sometimes affected one another adversely, like sealing wax that runs a little too far and leaves a mark when none was intended.[17]

Grant responded to Bell's deepening dependency on his judgement of her work by drawing closer in his own work to hers. He faced the tremendous responsibility of constantly consoling and reassuring her, both as a person and as an artist. His distrust of critical theory as a motivation for artistic practice also prevented him from sustaining the type of dialogue with other artists and critics that had so nourished his earlier work. His own taste and interests were much more

55 *The Barn* c.1955

catholic than those of Vanessa, yet he increasingly deferred to her judgement, perhaps partly in response to her great need for encouragement. This only served to increase her dependency on him, and on his judgement.

Grant had always been far more outgoing than Vanessa Bell, in his life and in his art. He was gregarious by nature, even if his own self-confidence was largely dependent on her approval of his friends and his own work. In effect they became the sole arbiters of one another's careers, and this evidently had a limiting effect on them both. She made it clear that he was the only person in whom she could ever confide, and he alone was able to penetrate the thick carapace of irony and reticence with which she protected her innermost feelings. Hence the impression of Charleston in the 1950's is of a household under a powerful spell or enchantment, throwing a blight of melancholy over all its inhabitants, and their work. Much of Grant's post-war painting gives the impression of a still vital and immensely gifted painter, retreating into mannerisms that only echoed the inner artist. He and Vanessa Bell froze defensively into the

safety of the known and trusted in their art. The routine of painting every day guaranteed to some extent an over-production of pictures that was accompanied by a certain levelling off in quality, since there was little to encourage him to go beyond the tried and tested, especially in his painting of still lifes and landscapes. These never lack a sureness of touch, or a beauty of tone and drawing, but they none the less suggest a cumulative sense of déjà vu, that was only relieved in his figure paintings and his decorative work.

Grant's nudes from the 1950's are generally his most successful works, in which he responded in the most direct and spontaneous way to the sensual pleasures of seeing, and a social world from which he himself was largely cut off. The world of naked male bodies that he painted in these years found its acknowledgement in the work of Vanessa Bell, who responded in her own way with an extraordinary and greatly under-valued series of paintings of a parallel world of womens' bodies, often in the Sussex landscape, and also nude.

Throughout the later 1950's and 1960's Grant pro-
59 duced a considerable number of smaller works that returned to the themes that he had begun to develop at the end of the First World War in pictures such as *Venus and Adonis* and *Cupid and Psyche*. He created a world of Arcadian fantasy and reverie, which is a sort of Mediterranean England. Often using pastel or watercolour, he painted maidens with their hair frequently scraped back into the Grecian Knot that had been so fashionable in his own youth, together with young men and children, in a generalised erotic vision. Many of the pictures explore the themes of Ovid's *Metamorphoses*, interpreted by a sensibility which, as many have pointed out before, was strongly informed by an almost Elizabethan sensibility. Nymphs and youthful swains abound, and an elephant can cheerfully
60 convey a basket of flowers twice its own height. He returned repeatedly to the themes of *Leda and the*
59 *Swan*, and the figure of Jupiter carrying off Europa on his back, often depicted in the form of roundels, that had so inspired him as a teenager in the work of Burne-Jones. These are amongst his most unexpectedly

charming and successful work in any medium, with a delicacy of means that has no peer in modern British illustrative art. His lifelong gifts as a sensitive 'animalier' are equally apparent in a considerable number of studies of farmyard animals, a reminder that Charleston, then as now, stood closely alongside a working commercial farm, in farming country.

56 *Paul Roche* 1953, Charcoal on paper, 24 × 17½″ (60 × 43.5 cms.), private collection

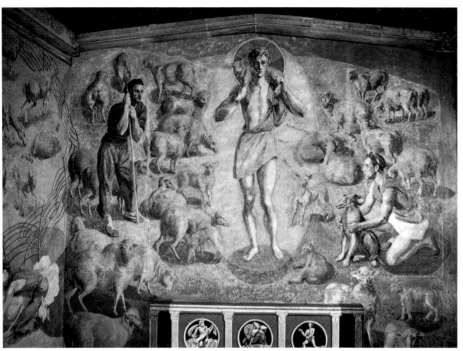

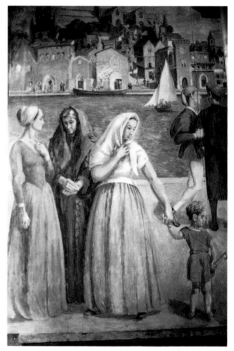

57 *The Good Shepherd* c.1958, oil on panel, The Russell Chantry, Lincoln Cathedral

58 *Women with Child* c.1958, oil on panel, The Russell Chantry, Lincoln Cathedral

He also produced a significant number of abstract designs in the last three decades of his life, which are more wholly in keeping with the highly sophisticated decorative style that he had developed by this stage in his career. This typically included abstracted leaves and flowers, or irregular geometrical designs in an extremely personal, calligraphic idiom, frequently employing the simultaneously rounded and pointed mouchette form that is found in early fourteenth-century British stone tracery. Indeed, Grant never felt bound to observe the familiar distinction in twentieth-century design history between artists whose work is either curvilinear or geometric. He was as much at home in the one as in the other. Indeed, the formal elements of his later decorative work could be reorganised into non-figurative paintings in much the same way that his Post Impressionist decorative work had informed his earliest non-figurative pictures. Throughout his career one finds 'pictures' which were

not necessarily executed with any particular purpose in mind, often done in pastel or gouache or watercolour, as if the medium itself were halfway between the practices of easel painting and design. These are frequently of the highest quality, thoughts out loud as it were, with a panache and directness that was sometimes lost in further elaboration to specific purposes.

In 1956 Grant designed the sets and costumes for the Aldeburgh Festival production of the seventeenth-century composer John Blow's opera, *Venus and Adonis*, a singularly appropriate subject for him, and one that provided him with a rare opportunity to extend his skills once more to work in the theatre. The production was well received, although there would seem to be no extant photographs. Grant's maquettes and other studies suggested that he worked hard to try to capture something of the spirit of an actual Baroque production, and his designs share a fantastical quality with the work of Inigo Jones, whom he much admired.

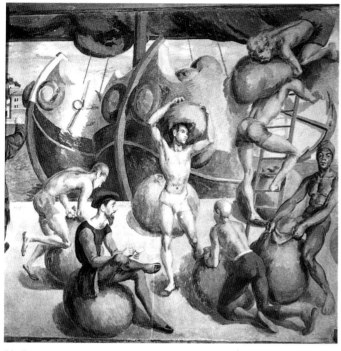

59 *Dockers* c.1958, oil on panel, The Russell Chantry,
Lincoln Cathedral

This was more than a decade before the more celebrated Glyndebourne productions of Cavalli and Monteverdi, which aimed at a similar kind of authenticity, with gods and heroes rising and descending on the wings and clouds of Baroque stage machinery.[18]

58 In 1956 a series of large-scale decorative panels by Grant was installed in the fifteenth-century Russell Chantry in Lincoln Cathedral, for which he worked in the same way that he had approached the designs for Berwick church, painting, at Charleston, the panels which were subsequently transferred to their intended destination. He described his choice of subject matter in a contemporary sketch book;

After some discussion . . . we decided that as the chapel was dedicated to St. Blaise, the patron saint of the wool industry, and as Lincoln had been a great centre of the wool trade in medieval times – that over the altar Christ should be represented as the Good Shepherd among mortal shepherds, and that among the subjects depicted on the other walls

should be sheep shearers at work, a portrait of St. Blaise, and finally facing the altar wall, a scene of the loading of bales of wool on ships in Lincoln harbour.[19]

It was typical of Grant that he should thus distinguish the Christian son of God from 'mortals' in such a pagan sense, for it is clear that he was by temperament unsympathetic to religious enthusiasm of any kind, and least of all to a Protestant theology rooted in the concept of original sin. The composition of the principal section showing Christ as the Good Shepherd derives directly from Raphael's *Sistine Madonna*, which he had seen more than thirty years previously in Dresden, whilst the iconography relates with equal directness to the image of the Good Shepherd in the mosaics of the churches of S. Vitale and S. Apollinare in Classe, at Ravenna, which he had visited with Vanessa Bell and Roger Fry in 1913. The painting of St. Blaise, leaning forward out of a roundel, also strongly recalls the very similar band of saints and patriarchs in roundels that runs along both sides of the basilica of S. Apollinare in Classe, above the supporting arches. Grant's likeness of Christ is however more in the style of Masaccio and Piero della Francesca, and is a serene yet powerful image of youthful male beauty. The sheep in their fold on the left wall are bright blue, and are evidently direct descendents of the flock that fills his *Blue Sheep Screen* from 1912. The wall on the right is energetically marbled around the portrait of St. Blaise, with a pair of ducks running furiously from the understandably startling blue sheep above the flat arch of Bishop Russell's tomb-chest.

Vanessa and Anne Olivier Bell stand in the foreground of the scene of Lincoln Harbour, whilst behind them a crew of beautiful, semi-naked youths load bales of wool into two delightfully improbable vessels. The shrouded, even anxious forms of the women contrast strongly with the exuberant, sensual world of the dockers, which suggests something of his subconscious awareness of the oppressive regime at Charleston – a division between two worlds that he had quietly tried for so long to reconcile.

Perhaps it was this element of frank sensuality that led to the closure of the Chantry in the 1960's, and

71

60 Departure from Charleston of Duncan Grant's decorations for the Russell Chantry in Lincoln Cathedral, 1959. Quentin Bell, Vanessa Bell, and Duncan Grant. Photograph by Mrs Anne Olivier Bell

character that he observed how, if the murals had been made in Spain,

the opportunity would most likely have been taken to paint with all possible horror the frightful death of St. Blaise, torn to pieces by the combs of the wool workers. Lincoln is a gloriously happy church, like Chartres, and I feel that I was right in thinking that anything so grim would have been completely out of place.[20]

Lincoln is extremely fortunate to possess this one last major decorative scheme by Duncan Grant, though its long neglect only serves to remind one of the lost opportunities in Grant's career, and the regrettable failure of the British art establishment to support his work throughout his lifetime.

Vanessa Bell died on the 7 April, 1961, and Grant drew her on her deathbed, downstairs in her bedroom, its French windows looking out onto the spring garden. Angelica Garnett has published a note, dated 3 June, in which Grant summarised his feelings;

After lunch I suddenly became aware that I am now 'on my own' for better or worse. Exactly what I mean? I can only guess by using the word 'deference' that is what I always felt with V. I do not mean the suggestion of flattery which the word has, but I always did defer to her opinions and feelings. Now henceforth I think I shall always defer to her *opinions*, I know or can guess so often what they would be – but her feelings no longer exist, so in that respect I feel I am alone. D.G.[21]

Mrs Garnett comments that,

The transparency of this small document is for me like a testimony to the quality of their relationship; its ingenuousness is touching, reminding me of an offering, not to Vanessa herself so much as to the Gods . . . Until Duncan regained his balance we all lived in suspension. No outward habits were changed, but the raison d'être of the old ones had vanished.[22]

Grant meanwhile assumed Vanessa's place at the dining table, whence he now presided over the life of the house, contre-jour against the side window of the room, facing the door. Showing guests around Charleston in subsequent years he would pause to explain, 'This picture is by Mrs. Bell', or 'That decoration was made by Mrs. Bell'. He never drew

its conversion to a store-room, where the murals languished unseen behind heaps of clerical detritus. Fortunately the chapel has recently been restored and, though little known, now provides a marvellous opportunity to see Grant's later decorative work at its most charming and voluptuous. It was wholly in

attention to his own work, and this too was infinitely touching.

In his mid-eighties Grant once compared the lives of artists to those of dancers. Whilst a dancer's life is circumscribed by age, he explained, the artist's is enlarged. The painter's problem becomes a question of how to distance oneself from life. This, he told me, became easier as he got older, and was hardest in middle age. His inability to remember dates, and his general distaste for retrospection, both proceeded from his discipline as a painter. Like Vanessa Bell, he subscribed, when questioned, to the view that subject matter in art is entirely secondary to formal issues. This was a typical example of Bloomsbury's tendency to set up a fixed distinction between art and life. Yet in both their work one may fairly detect an intense engagement with their own richly complex lives. At the end of his life, Roger Fry had noted that;

Each generation has to recreate the meaning of our Old Masters by critical appreciation: it is only by that means that they are kept alive. Indiscriminate worship would kill them.[23]

This seems close to Grant's more intuitive response to the art of the past, which he continued to sustain in old age. In 1976 he recommended one to,

explore the ultimate cracks in the Via Margutta. They contain many ghosts: Quentin, Vanessa, self, Maynard Keynes – That accounts for 3 studios, all bigger than London. I am as you know a square and have never got it out of my head that all budding painters should go to the Vatican City to finish their studies. A thing of the past I find. I hope you may have something to say from the opposite side?[24]

For many years the large canvas of *The Entry of the Italian Comedians* that he had painted for the Festival of Britain in 1951 dominated his studio, and its over-worked voulu quality bore witness to his nervousness about competitive public exhibition in the 1940's. Yet the many pictures that he made in the 1950's of Chinese dancers and acrobats are among his most subtly painted and effective later works. Grant loved the theatre, and opera, and Chinese variety theatre

added the quality of athleticism to which he always responded.

Throughout the 1950's and 1960's he continued to produce decorative work of the finest order, refining the swirling style that he had developed in the 1920's to its most sophisticated potential for colourful abstraction. Yet his oil paintings became increasingly uneven in these years as a result of over-production and a tendency to overwork individual pictures. Attempting to do everything with colour, he developed a formula approach in many of his landscapes and garden scenes that led to a technical impasse in the form of repeated pools of purple shadow that draw attention to his own inability, or refusal, to recognise the limitations of modelling entirely with colour.

Grant was fortunate to live long enough to witness the beginnings of a revival of serious interest in his work, which initially resulted from the tremendous retrospective Duncan Grant and His World, at Wildenstein's in 1964. This was selected and hung with much greater care than his Tate Gallery retrospective of 1959. Richard Shone's Arts Council exhibition of Portraits by Duncan Grant in 1969 also made a number of his finest early and Post Impressionist works available to a wider audience for the first time, and he was taken up by the successful and eminent London dealer Anthony d'Offay, whose stable of artists came to include such contemporaries as Francesco Clemente and Gilbert and George. None the less, British art critics remained indifferent when not overtly hostile, and the failure of British art criticism even to try to

61 *Design* 1950's, pencil on paper, 3 × 6½″ (7.7 × 16.5 cms.), private collection

take his work seriously has had a seriously detrimental effect on his reputation throughout recent decades. However, he continued to paint and to travel, frequently in the company of his close friend and long term model, the writer Paul Roche.[25] He appeared in several television programmes, and was the subject of a highly praised documentary film by Christopher Mason, which permitted the beginnings of a new appreciation of the significance of Charleston. In 1967 the art historian Richard Morphet also published an important re-evaluation of Grant's work, and of Charleston.[26] The revival of interest in the cultural politics of the Bloomsbury Group also helped to draw him back into the limelight. This new celebrity could have unexpected results, and there is a certain pathos in his 1975 comment;

After all that has happened, what does it mean for example when a middle aged gentleman tells me that my pictures have been a spiritual experience for him? He seemed completely sincere.[27]

Scholars arrived to bombard him with questions that he often could not answer, though it was entirely to his credit that he should have insisted on complete candour concerning his early sexual relationship with Lytton Strachey, in Michael Holroyd's highly praised two volume biography, published in 1967 and 1968. He was also fortunate to have lived long enough to witness and experience the widespread assault on British cultural parochialism and philistinism in the 1960's, a decade who's optimistic values he cheerfully welcomed.

Grant's late paintings reveal an often moving return to his highest form, even as his physical strength ebbed. Staying in Cyprus with the writer John Haylock in 1970 he reported how much he enjoyed being taken around the sites of the island. 'It really makes me very lazy and I do precious little painting, so my morale is not very good'.[28] He was greatly inspired by his visit to the Rembrandt exhibition at the Rijksmuseum in Amsterdam in 1969, and his still lifes began to take on a new dimension of brilliance. In his late eighties it seems as if he was half consciously revisiting the themes and styles of his youth in a late flourish of passion for his craft.

In particular his *Still Life with Photograph of Nijinsky* of 1972, together with his *Still Life with Sharaku Scarf*, and the *Still Life with Matisse* constitute a glorious coda to his remarkable career. The former shows a horizontal photograph of Nijinsky in his costume as a Siamese dancer in Fokine's 1910 ballet, *Les Orientales*. Grant had kept two of Druet's contemporary photographs in his studio, though one of these disappeared one day

62 *Still Life, The Sharaku Scarf* 1972, oil on canvas, 36 × 26″ (90 × 65 cms.), private collection

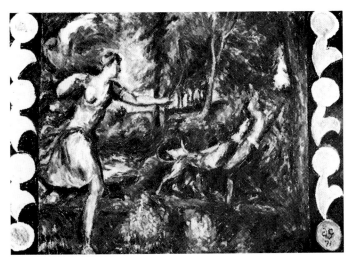

63 *Copy after Titian's 'Death of Actaeon'* 1971, size and present whereabouts unknown

with an American visitor who, Duncan explained simply, had 'wanted it'. The image of Nijinsky lies at a most complex and difficult angle both to the picture plane, and to the wall against which it rests, with a detail below of one of the legs of the caryatids on either side of his studio fireplace. The photograph is propped up on an old cabinet gramophone, decorated by Angelica Garnett, with an urn painted by Vanessa.

The *Still Life with Sharaku Scarf* similarly shows a hanging fabric after the great Japanese wood-cut artist, Sharaku, which he had been given by John Haylock, with its echo of his work as a schoolboy at Hillbrow. The *Still Life with Matisse* reveals the back of a stretched canvas behind a poster reproduction of Matisse's *Blue Nude 1* papier collé of 1952, with a small jug of roses before it, flanked by a whelk shell and a deep lapis lazuli bowl. These objects rest on the top of a table covered by a magnificent chequered red and white Italian scarf, permitting a most intense and exhilarating relation of colour tones.

All three pictures quietly betray Grant's profound awareness of the art of his contemporaries, yet register also his own determination to go his own way regardless. How could he not have been aware of the very different paths that Matisse and Picasso had carved for

themselves, and it would be a great mistake to imagine that he did not continue to measure his own work, for all its differences to theirs, against the two artists who had so inspired him since at least 1908.

Yet inspiration can mean many things, and in Grant's case it never meant imitation, at least in any simple sense. For the art of Simon Bussy also still informs these late still lifes, together with a spirit of serious, decorative naturalism that was all Grant's own. Nor is it perhaps coincidence that it was in Nijinsky's role in *Les Orientales* that Jacques-Emile Blanche had painted the dancer, in his celebrated yet excessively showy portrait of 1911. In Grant's picture of 1972 the photograph dissolves into a shadowy image of mauve and the deepest imaginable lilac, the figure monochrome, in the subtlest drama of contrast to the brilliant orange leg of Grant's own painted fireplace figure from the 1920's. These pictures have a depth of personal reference, and a resonance of colour hues, that recall his most breathtaking colour painting between the two world wars, whilst they are painted with a delicacy of touch that recalls his lightest and most exquisite Post Impressionist handling of paint. They resonate with all the accumulated wisdom of a lifetime.

It was wholly fitting that in 1971 he contributed to Richard Buckle's great campaign to save Titian's *Death of Actaeon* for the National Gallery. For it was in the National Gallery, in his teens, that Grant had first studied the work of Titian, together with Masaccio, Piero della Francesca, Botticelli, Zurburan, and Gainsborough, and had begun to establish that grand dialogue with the art of the past that nourished him throughout his long career. Buckle had invited a great array of British artists to make copies of the Titian including David Hockney, Keith Vaughan, Robert Medley, and Patrick Procktor. Grant's copy was largely faithful to its original, translating Titian's gravely disturbing image of the impassive goddess's revenge upon her mortal, voyeuristic admirer into his own idiom, gently obliging the viewer to consider Titian through the eyes of that early twentieth-century generation which had rethought the possibilities of painting under the equally

27 grave intellectual influence of Cézanne. Furthermore, Grant surrounded this most terrifying of Titian's later images – a mere boy, being torn to shreds by Diana's hounds – with a glorious, broad decorative frame, which holds the Titian in the greatest respect, whilst returning to the abstract, sensuous movement of forms and colours that had never ceased to fascinate him since his 1914 *The Scroll*. He honoured Titian's great design with all the formal richness and invention of the modern movement, in which he had played a not insignificant role. Here, side by side, we find the figurative and the non-figurative, reconciled in Bloomsbury painting as nowhere else in modern British art.

When Duncan Grant died at the great age of 93, on 9 May, 1978, he had but recently returned from the great retrospective of Cézanne's late works at the Grand Palais in Paris. More than any other British painter, Grant had helped to cleanse our understanding of the legacy of European art of the contagion of snobbery and pomposity that had all but smothered popular appreciation of its great aesthetic vitality. In some deep, unfathomable way, painting from the life sustained him, and he continued to draw from the life, and to invent, until he was physically no longer able, and died within days.

37 Charleston is the finest monument to his art. It embodied his ideal of the work of art apprehended in movement – and over time. His finest work always derived from the life he led at Charleston, and the social and aesthetic vision that it embodied, as if pictures were at the same time fragments of that world, and outgoing missionaries on its behalf. Charleston reaches out to the great centres of Western civilization, from Paris to Rome to Berlin. It also reaches out, forlornly now, to the many lost interiors in which he and his friends had lived before their destruction during the Second World War. It was the headquarters and, as it were, the front-line of a virtual revolution in British taste and decorative style.

Grant was in a profound sense both British and European. He belonged to a particular, brief moment at the turn of the century at which it became possible

64 Duncan Grant, 1977, photograph by Simon Watney

to think of British culture as part of a wider European project, within which Purcell and Gainsborough might be considered alongside Palestrina and Goya. That vision was pulverised in the trenches of Flanders, and it belongs to the late twentieth century to recognise and celebrate his vision in the light of a later moment of pan-European cultural optimism.

In one of his most baffling and intuitive aphorisms, Picasso once remarked that art is a lie that helps us know the truth. For all the sophistication of his work, Grant remained an essentially simple and direct man, and the vigour and beauty of his art, and his personality, were never more apparent than in a casual comment recorded by Paul Roche in 1973;

I don't think it's true that children are great liars. It's simply that they don't have the words to express the truth, so they invent things.[29]

This seems to me to speak directly from the sympathetic human heart of a great artist who never lost the courage to invent in order to tell the truth as he perceived it.

Conclusion

In 1927 Clive Bell described the social order into which he and Duncan Grant had grown up. With considerable insight and not a little disdain he pictured the way in which;

An English boy with fine sensibility, a peculiar feeling for art, or an absolutely first-rate intelligence, finds himself from the outset at loggerheads with the world in which he is to live. For him there can be no question of accepting those national conventions which express what is meanest in a distasteful society . . . all his fine feelings will be constantly outraged; and he will live a truculent, shamefaced misfit, with John Bull under his nose and Punch around the corner . . . As a result of all this England is not a pleasant country to live in for anyone who has a sense of beauty or humour, a taste for social amenities, and a thin skin.[1]

Sadly the familiar British vices of snobbery, philistinism, hypocrisy, and sanctimonious moralism have only marginally abated in the sixty or so years since Bell's *anathema* on his homeland. At the end of the twentieth century it is easy to trace the lineage of Bloomsbury from the traditions of Utilitarianism and the Clapham Sect, Cambridge rationalism, and an intellectually founded hostility to nationalism in all its hydra-like manifestations, to a Bloomsbury European in taste and outlook, yet deeply English in its ascetic individualism and its intense Anglophobia. None of this however will help us to understand the art of Duncan Grant, though it may fill in something of the context in which his work was received. If the subject of Bloomsbury has been lately revived by a liberal intelligentsia as a form of compensatory fantasy to paper over the disappointments of modern British history, it can serve only to falsify Grant's reputation, and to obscure his achievements as an artist. For whilst he indeed shared much of the general outlook of his friends, his work should not be made to shoulder the heavy load of illustrating a later generation's fantasy of wish-fulfilment projected onto the Bloomsbury Group, understood as a rare idyll of civilized social relations and values.

Grant was a conventionally good son to his parents, and sustained close relations with his mother and her sisters Daisy and Violet throughout their lives. By no stretch of the imagination can he be seen to have been at loggerheads with the world, and this was doubtless due to his unwavering discipline as an artist. He found a deep sense of belonging in his work, and in his lifelong relationship with Vanessa Bell, focussed upon Charleston, which was his only real home, and the indispensable condition of his identity as a painter. The silence of the artist that Virginia Woolf frequently noted and analysed may be largely understood as a path of least resistance taken by both her sister and Duncan Grant, who could only retreat away from the babble of Bloomsbury and into their brushes.

It would never have entered Duncan Grant's head to enquire about the social world from which his friends came. However, he undoubtedly shared their inability to imagine worldly success as an end in itself, 'perhaps partly because it seemed out of the question'.[2] As his obituarist in *The Times* noted, he was, 'never a theorist, accepted no doctrine and indeed always regarded the "party politics" of doctrinal art with unfeigned distaste'.[3] That is not to say he was entirely untouched by the intellectual ferment of early twentieth-century modernism, in which he was literally steeped; but it is to note that the process by which he assimilated ideas was not susceptible to the type of dialogue sustained and cherished by his friends. His chosen Bloomsbury persona as a kind of Holy Fool fitted him well, but must have required considerable reserves of humility and forbearance at times. He respected and learned much from the utterly unselfconscious intellectualism of his friends, especially Maynard Keynes in his youth. He loved Keynes dearly for the fact that he never made Grant feel in the least inferior to himself, and because he respected his opinions precisely as those of an artist. Old Bloomsbury tended to think of artists as failed rationalists, to be tolerated rather like children, because it could not easily appreciate that other forms of communication are equally as valid as the written or spoken word. Keynes helped Grant to develop a sense of self-respect as an artist, and that never failed him. This was recognised by Vanessa Bell, who was perhaps rather more intimidated by her sister and her Bloomsbury colleagues than is usually acknowledged.

Early in his life Grant seems to have learned that strong emotions threatened his equilibrium in ways that he was not well equipped to control. He recognised that love has many faces, and after an unhappy unreciprocated experience with David Garnett during the First World War, he seems to have gone out of his way to avoid situations in which he would be plagued by jealousy. As he grew older, he increasingly aspired to an ideal condition of amorous lightness with his lovers, and rarely showed bitterness to anyone. He had mastered the demanding art of taking people as they come, without straining to judge them, or to mould them into the likeness of his own wishes. It was a discipline that he taught himself, like painting daily, and is not to be despised. Grant was devoid of self-pity, and taught himself to make the most of life as he found it. If that sometimes involved 'settling for less', then it was his choice and was more than compensated for by the relative serenity it afforded him, and the absence of emotional distraction from his work. He was not ashamed of his homosexuality, which he took entirely for granted, and was not running away from it in his relationship with Vanessa Bell. She in turn recognised this, and respected it. They recognised the inevitable cost to them both that resulted from their mutual commitment, and both appear to have accepted very early on that the gains far outweighed any possible losses. Duncan Grant did not expect anyone to behave like a saint, least of all himself. For this reason, he seemed genuinely saintly.

As anyone who knew him well will testify, he was the least conceited of men, which is not to deny that he was a shrewd judge of character and worth, including his own. He knew what he did not want in life rather more clearly than what he did want, apart from the conditions to pursue his art freely. He did not particularly want prams in the hall, or the distraction of commercial work, or the bother of dealing with the mortgage and the life insurance salesman. He was not a very practical man, and he was sufficiently wise to avoid getting involved in situations in which he would be expected to do more than he knew to be feasible.[4] Throughout his life he would accept advice about his

pictures from almost anyone, which was his own way of not having to get involved in debates which he found useless. If he had one hero it was Picasso, of whom he once noted in a sketch book;

In admiring Picasso a sense of contest is nearly always to be taken into account.[5]

Picasso was one of the very few people he quoted, and dreamed about, and wrote of. For example, he once described how,

Picasso after being brought by Jean Cocteau to see his decorations of the chapel at Antibes said: 'Jean, je ne t'ai jamais demandé ce que tu pense de mes poèmes.'[6]

This is a telling anecdote, for it suggests Grant's awareness of the sheer pointlessness of misplaced judgements concerning works of art, expressed gently, with wit. He found in Picasso a complete artist, like himself. In the final analysis Matisse was too cerebral for him. Only Picasso and Vanessa Bell lived up to his high self-imposed standards concerning what it means to be a true artist. Yet Picasso was also a dangerous figure, who possessed a far more dominating personality than Grant, and whose influence might easily have overwhelmed him, as it annexed so many others.

Grant seems to have recognised that his unbridled admiration for Picasso's work involved an element of competition, and this to some extent explains why he deliberately steered his own work in an opposite direction from that of Picasso. This must have been difficult for an artist to whom emulation and creative commentary were second nature. In this sense he was perhaps actually protected by his Britishness or, to be more precise, his education under Simon Bussy. He recognised his need for the complementary, self-contained gravitas of Vanessa Bell, just as she recognised her need for his aesthetic and personal fluidity and responsiveness.

As a young man Grant had been unable to deal with emotional complexities of any kind, for reasons that only a biographer may discern. Anecdotes of his throwing down his brushes in tears when a picture or decoration was not going as well as he wanted are revealing. He recognised his need to be managed and

65 *Still Life with Photograph of Nijinsky* 1972, oil on canvas, 20 × 16″ (50 × 40 cms.), private collection

organised, as he recognised Vanessa's needs to control those around her, in a way that she had learned from her earliest years. It would be quite wrong to blame Duncan Grant for Vanessa Bell's being as she was. They were doubtless complex, vulnerable people, and it is entirely to their credit that they identified mutual emotional needs in one another, together with their shared and complementary need to paint. It is therefore preposterous and insulting nonsense to claim that Grant reduced Vanessa Bell to the status of a skivvy, exploiting her vulnerability, so that, 'until her death, at the age of eighty-one, Vanessa continued to run an elaborate household for him and a succession of his male lovers and to paint side by side with him in the studio at Charleston'.[7] It is still more preposterous to argue that Vanessa Bell, 'justified her self-sacrifices and Duncan's selfishness by declaring him a genius'.[8]

It was against precisely this kind of vulgar philistinism that both Duncan Grant and Vanessa Bell strove to protect themselves and each other. She ran Charleston as she did for many reasons, including her own convenience as an artist and a mother, on her own terms, and this was not the least of her considerable achievements. Besides, there is an ugly double-standard at work in retrospective comments such as the one above, revealing a stubborn and recalcitrant strain of homophobia. Doubtless they both suffered in their different ways. This was to some extent inevitable, given their different sexualities. Yet to dwell primarily or exclusively on their suffering entirely overlooks the remarkable, positive achievement of their relationship which, after all is said and done, survived for more than half a century. They did not fail one another: England's art establishment failed them, and Vanessa Bell was entirely spared the usually grim fate of the artist's wife.

Alongside Vanessa, Duncan made great art on a domestic scale and in a domestic setting, and for this reason his work can never be entirely accommodated to the requirements of a museum aesthetic. He made art to live with, intimately, and if this has tended to be held against him in the past, it now seems likely to be appreciated as a positive value in its own right. He would have been the first to remark on the peculiar irony by which his fabric designs from the 1930's, which represented a high ideal of applied modernist art, should have ended up as mass reproductions in the Laura Ashley catalogue in order to raise funds for the conservation of Charleston. His work implies the hand of the artist, responding to a particular environment, although he himself was never given the opportunity to explore his potential to reach wider audiences. His finest work represents a world of unusual yet unostentatious domestic values, including a profound respect for privacy, and a refusal to accept the general

distinction between work and the home. Amongst these values, the aesthetic has a central and privileged place. It embodies domesticity in the sense described so well by Witold Rybczynski as,

a set of felt emotions, not a single attribute. Domesticity has to do with family, intimacy, and a devotion to the home, as well as with a sense of the house as embodying – not only harboring – these sentiments.[9]

In his fabrics and ceramics, his paintings, designs and interiors, Grant fashioned a sophisticated yet accessible artistic vision of great beauty, folding together a modest rented Sussex farmhouse and its walled garden, with the surrounding countryside, and the wider world of family, friends, and London life, as well as a vital sense of European culture, felt in a concrete, neighbourly way, unthreatening, and as taken for granted as the taste of salt on a Sussex breeze, blowing in from the nearby English Channel.

Charleston exemplifies this sensible fusion of the mundane with the fantastical; of memory with aspiration. Here Grant pioneered a version of modernism that was neither aristocratic nor industrialised, a modernism that reintegrated the artist into the
37 quotidian. Grant's studio at Charleston was an intensely social space, where personal experience accreted around his own preferred themes and techniques – a space in which the many overlapping relations between artist and models, artist and loved ones, and the artist and his own history, were lived intensely, as indispensable and inseparable aspects of a lifelong process of artistic vision and design. It was where he was most himself. Towards the end of his life he was interviewed by a sympathetic art historian who none the less understood comparatively little about him. The best way to conclude this introduction to the art of Duncan Grant is with his own characteristically reticent, modest, and doubtless wryly amused conclusions on himself:

– *Do any of your paintings include an element of conscious symbolism?*
– No. I am not that sort of painter.
– *Well, what sort of painter are you?*
– I must leave that to others to decide.[10]

66 *The South Downs* 1969, charcoal on paper, 19½ × 23¾″ (49 × 59.5 cms.), The Charleston Trust

67 Duncan Grant, 1970, photograph by Simon Watney

APPENDIX A

Professor Quentin Bell in Conversation with Duncan Grant

This conversation took place at Charleston in the summer of 1969, during the making of Christopher Mason's film, Duncan Grant at Charleston. *It has been transcribed and edited from a tape held in the Library of the University of Sussex (Reference Number R 727), and is published here with Professor Bell's kind permission. The first section consists of Duncan Grant reading from a manuscript concerning his early years that he had prepared for the occasion. The second part consists of a discussion.*

My father, a poor major, and more gifted as a musician than as a soldier, organised musical comedies wherever he went. The last time he saw active service was in the war in Afghanistan. At five or six years old it seemed a pleasant enough life. At nine years of age it was customary to send English children back home to school. Being an only child, I had been indulgent in yielding to my childish dreams without any interference. I went to an English private school. It was only when I got there that the dangers and sorrows of life became apparent. However, there were happy interludes. My master at the Great School at Rugby was a genuine painter and a pleasant man, who made me understand that he thought I had some talent, and gave our class delightful things to do, such as copying Japanese prints. Then there was the Headmaster's wife, a sister of Horatia Ewing, who on Sundays read scenes from Dickens and lent me a large volume of reproductions of the work of Burne-Jones. This was a revelation to me, I suppose of a purely aesthetic nature. I had always hitherto pored over the yearly books of the Academicians, but Burne-Jones was different. I couldn't explain this to myself, but for years I would ask God on my knees at prayers to allow me to become as good a painter as he. I am still very doubtful if God has answered my prayers.

During my first years in England I lived with my grandmother at Chiswick Knell, and benefited very much from her society. Totally without self-consciousness, she would talk about her pictures and experiences in Italy. She was a beautiful old lady, directly a relic of the Byronic age. She possessed a slender foot painted on a piece of marble, and another of a lustrous eye. Alas she died when I was about eleven years old, when my parents came back from Burma, and I went to live with them in London and went to St. Paul's School when I was fifteen years old.[1] By this time I was determined to become a painter, not very much encouraged by my poverty stricken parents, very naturally. But I had within my reach a certain income, and later on a pension, if I were to become a member of the Bibbet Brothers – I think they were called – whose headquarters had been in Rangoon, who offered my parents a position for me in the firm, with a pension for me at the age of forty, on retirement. My father thought that I ought to become a soldier. My mother I think was rather uncertain as to how much I wished to become a rice merchant. But the question at one moment became urgent, for at the age of twenty I had to go to the City of London and either sign on as it were, or scratch my name off the list. I had no doubt in my mind what I must do, so it was with a sort of horrid pleasure that I went to the City of London to accomplish this task of scratching out my name.

My Aunt Jane, who was Lady Strachey and mother of Lytton Strachey, was a very sensible woman, and when my parents were away from England she thought that I'd better be taken away from school, where I was doing no good at all at my lessons, and go straight to an art school. So I went to the Westminster School, then under Mr. Loudan's teaching. Brown had been there before, but it was not his teaching that I benefited from, but that of my fellow students, from whom I learned much.[2] They were an intellectual lot. I remember the name of Ballard, and Urquart, but not the others. But they were extremely intelligent and my favourite companion was Forestier, a charming French boy, the son of the well-known illustrator on the *Illustrated London News*. They all admired Degas and Whistler enormously, and despised much of the contemporary painting in England. It was not a provincial atmosphere at all.

I remember at this time, and even earlier, when I was at school, very much admiring the work of Aubrey Beardsley. My father used to take in *The*

Yellow Book. About this time my parents again went abroad, to Malta. My father had been called back to his Regiment during the Boer War. I then went to live with my cousins the Stracheys where, with great good luck, a Frenchman – the painter Simon Bussy – was staying, come to England to make his fortune by painting portraits. He did paint a good many portraits, but they never had the success they should have had. Perhaps they had no touch of sentimentality, or perhaps his vision was too acutely observed, I don't know, but luckily many remain and I hope one day they will meet the admiration they deserve.

On the way to Paris, where I went at the age of 21 because an aunt had left me £100, I had a letter from Simon Bussy to pay a visit to Matisse, who was then living outside Paris with his family. He was very kind to me, but it was impossible for me at that age to think of anything to say on seeing his pictures, which were in another idiom to anything I'd ever seen before. However, he let me sit in the corner of his studio whilst he prepared an enormous canvas, on which I think that afterwards *La Ronde* was painted.[3]

Q.B. Do you have memories of Burma?
D.G. Oh, I remember Burma very distinctly. That was the last place I was in at the age of nine, and I do remember scenes in India before that, but mostly Burma, mostly the look of things. I do seem to remember the entrance to Rangoon Harbour was a great event because it was a lovely morning and we got there about six in the morning I should think, and there was that great pagoda that was covered with gold and quite near the port. It really was an astonishing sight. Well, that sort of thing I remember very distinctly. And other scenes in Burma ... bananas, and the colours. They had wonderfully brilliant silk things they wound round themselves ... I do remember people. I suppose people say one's earliest memory of the look of things is important, and it may be, but I wouldn't know compared to other people's experiences. Being there was a great event I think.

Q.B. Burne-Jones? Do you still admire him?
D.G. Very much!

68 *Four Male Nudes* c.1904, 4½ × 4½″ (11.5 × 11.5 cms.), private collection

69 *Female Nude* (Vanessa Bell), c.1911, pencil on envelope, (18.5 × 12.5 cms.) (irregular), private collection

Q.B. You don't find the sentiment too much?
D.G. I don't mind the sentiment.

Q.B. Even the complete Burne-Jones?
D.G. I like some of his pictures much better than others, but I mean I don't mind the sort of thing that people say of for instance: 'Oh! How frightful!', and then: 'Sentimentality!'. I see it is there, but I can ignore that, because of the design.

Q.B. I sometimes find there is a repressed sexual feeling that gets in the way.
D.G. Well, it's very suppressed, isn't it . . . I think it was a new, utterly unknown experience for me, to see something which was done from the aesthetic point of view, and not just a story, or something in the Academy pictures, which were wildly exciting – battle pieces and things of that sort – which I thought were the best things going, until I saw Burne-Jones. [4]

Q.B. Were there things in your parents' house?
D.G. Nothing. Two watercolours by an uncle, but nothing surprisingly new.

Q.B. And at Lancaster Gate also?
D.G. Well, that was later wasn't it. I was thinking of very early days, before Lancaster Gate.

Q.B. What about the Japanese prints?
D.G. Well, that was a good idea. They excited me very much when I was made to copy them.

Q.B. Did that remain an enthusiasm?
D.G. Yes, I always liked them very much. I bought an Utamaro years later in a tray and unfortunately lost it. It was a beauty.

Q.B. It will probably turn up.
D.G. No. Too long ago.

Q.B. Simon Bussy? He actually taught you?
D.G. Yes, he always gave me advice when I was doing anything at home, and once a week I used to go to the National Gallery, and he made me copy a bit of a Piero della Francesca. Wonderful he was, as a teacher. He never allowed any – what's the phrase he used – 'à peu près' – the thing he said – 'Never à peu près'. He was very strict, and yet very encouraging. He often took up a brush and did it himself, on my little picture.

He'd take up a head, and then do it, and that was more of a lesson than you could get by word of mouth really. He may have said some interesting things too.

Q.B. Did being made to copy encourage a love of Piero?
D.G. Oh, very much so. I always loved that particular picture, and afterwards in Italy had an immense admiration for his frescoes. I went when I was about seventeen, with my mother, to spend the winter in Florence, and it was from there that I went to Arezzo to see them. They were an eye-opener to me. I copied the one in the Uffizi, that used to be in the dining room here. [5]

Q.B. Would it be true to say that Piero had really been one of the great influences on you?
D.G. I think it would, really. I mean, I've never varied or altered my opinion of him. I went again the other day to Arezzo: better than ever I thought.

Q.B. Did that give you the idea of painting on walls that you've done a great deal of?
D.G. I don't think that gave me the idea. I always thought I'd like to paint frescoes, but not necessarily from him. I mean, in Florence what struck me first of all was the art of the fresco painters. It had such a different quality to oil painting, and was in the position it was meant to be. All that struck me very much. I think it did seem to me important when I got to Florence (that) very often the pictures were painted for particular places, . . . now often removed. But I think that probably that had some effect on the painter, to be told he had to paint an altarpiece in this particular light, and church.

Q.B. Did you meet any other painters besides Matisse when you were in Paris?
D.G. Well, shortly after I did, because I was introduced – I can't remember how – to Gertrude Stein, who had a weekly party in the evening at the studio she had on the Rue de Fleurus, and there I met Picasso and often saw him there, and other painters used to come.

Q.B. Did you see much of their work?
D.G. Only in her studio. I mean, I was just thinking how difficult it was in those days to see what was

being done at the time. You could see the Impression-ists to some extent, but it was very difficult to see the early work of Picasso, or Braque, or any of those people, unless you happened to know someone who possessed them. I do remember on one occasion an amusing incident though. In my hotel, which was called the Hôtel de l'Univers et du Portugal, it was a very old fashioned hotel just near the Palais Royal, and in the cupboard I found rolls of a very old Victorian wallpaper, and I knew by that time – I had seen some of Picasso's collages – and thought: 'Oh *this* is the place for him to come!'. So I took a roll round to Miss Stein, and gave it to him, and he was really delighted. Only I was rather interested that he seemed to be shocked that I might have stolen them. It did seem to me really rather ridiculous to think that I should ever have been found out . . . I was very much surprised.

Q.B. Did you know any of the older generation?
D.G. I was promised by a mutual friend of Simon's, a man called Breal, to go to see Degas one day, but it never came off, much to my disappointment.

Q.B. None of the great Impressionists?
D.G. No, never. But of course Blanche, who was my teacher at La Palette, had known them all intimately, because his father was a great friend of Manet, and he used to talk of them sometimes to me, and having known Manet it was rather a link I felt. He was a very intelligent man, although many people object to his paintings. As a teacher I found him very sincere and very interesting indeed. He always allowed his pupils to go along their own lines, rather than paint as he painted.

Q.B. What about your work at the Borough Polytechnic?
D.G. I can't tell you much about it, except that Roger got hold of somebody who agreed to allow Roger to decorate the whole of the Dining Room at the Borough Polytechnic, which is a very big room, and Roger, as Roger always did, got us all ahead with it without knowing much about it. I mean, we were told we must decorate this large room, and were given our panels, and I'm trying to think, they were supposed to be the Pleasures of London, or the Pleasures of Life,

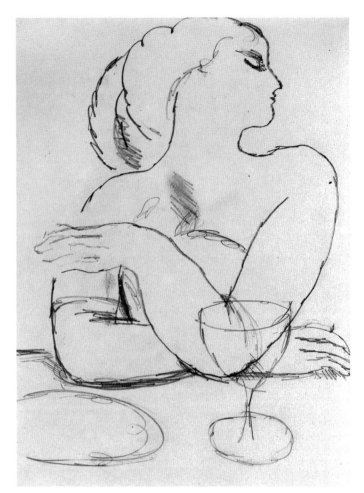

70 *Jeune Fille à Table* c.1919, pencil on paper, 12 × 9″ (30 × 22.4 cms.), private collection

and I remember Etchells was one. He did the best thing I think, and then there was Gill, the brother of the sculptor, and Rothenstein, Albert I think, me and Roger, and Adeney. I think that was all. They were finished and rather well received on the whole. It made rather an event. Then the building was destroyed, or altered, and somebody bought the whole lot and gave them to the Tate Gallery, where they are still, I think. I was commissioned by Cambridge – Newnham wanted a picture for this newly built cloister. Jane Harrison wanted me to do something, and she chose

the subject of *The Queen of Sheba*, which I did a large sketch for, which does exist, in the Tate now I think, but it didn't come off in the College. Some people were against it, but I suppose that was a commission, I don't know, before or after the Borough Polytechnic.

Q.B. The Queen of Sheba was painted in a pointilliste manner?

D.G. When I was in Brunswick Square I had a period of it.

Q.B. Had you been looking at Seurat?

D.G. Certainly, I must have been. I think it was experimenting along the same lines, though no doubt ideas were put in my head by Seurat.

Q.B. And what of the Omega?

D.G. That was a brilliant idea of Roger's ... the original idea was a place where you could go and work if you were hard-up, for a day, and you were paid seven shillings and sixpence, and if you wanted to make more you went every day, and so on. There were no rules otherwise at all. It was to help painters make a little money for themselves to paint. But it was very inspiring to be given special jobs to do, for definite purposes, and all sorts of ideas I think came out of doing decorative things, if one didn't have the opportunity of doing otherwise. I found it a very inspiring institution myself, and I think others did too. It came to an undue, early end, mostly I think due to the war, and it was a great misfortune. Wyndham Lewis's quarrel with Roger, taking away people like Etchells from working there – in fact all that was very disappointing, but in itself, I think it did a great deal of good for the short period it lived.

Q.B. You've always wanted to do decorative work?

D.G. Well, I think I may have begun to realise when I was working there what opportunities it gave one. I don't know that I did before that particularly.

Q.B. And you've gone on really ever since?

D.G. Yes, I found it a great relief, after painting, to do something of that sort.

Q.B. A light relief as it were, less emotionally exhausting?

D.G. Much less exhausting in some ways. I don't

know exactly why I feel that. It's another part of one at work ... one did designs for all those things. One didn't make the furniture oneself. One had people one employed round about for doing that sort of thing.

Q.B. Did you feel the same sense of relief with mural decorations?

D.G. Well sometimes of course it's much more in the nature of a picture.

Q.B. One has the impression that you and Vanessa couldn't really live happily in a house without covering the walls, to some extent at Wissett, even at Canonbury Square. Almost before one could turn round something had happened over the fireplace.

D.G. I often think, if I go to a house of a friend who hasn't anything, I think of myself almost unconsciously decorating the space over the fireplace, or something like that. I remember Sickert coming to see Vanessa in Gordon Square once, when we had painted the end of the wall, and he was *furious*. 'You might be painting pictures!' He was also furious because Virginia had given Vanessa a new sort of chair, a modern chair which was comfortable enough, but he railed against that. 'How *can* you have this appalling sort of stuff when you might get a decent old chair?' I see it wouldn't do for his pictures at all. I mean, he was always on the look-out really for some sort of ... half-made beds, rickety chairs, and all sorts of oddities.

Q.B. He didn't really want I suppose to have a work of art ready made?

D.G. No. I like things to happen. I wouldn't clear this studio up for anything, until it makes itself necessary, which won't be soon.

Q.B. When did you first meet Roger Fry?

D.G. I met Roger first of all about 1910, and immediately very much liked him, and was interested in what he had to say about everything. But he hadn't by then come across the Post Impressionist painters in France at all.[6] He didn't altogether like a painter like Renoir – something or other he didn't like, I forget what, and I had not long been able to look at *their* pictures, but he didn't approve of Impressionism, in theory either at that time, and I thought his ideas rather got in the way

of the pleasure of looking at their pictures. But then of course, when he discovered Post Impressionism, that fitted in entirely with his aesthetic ideas, and it was a great revelation to everyone in England when he got up the first Show, when was it, I think in 1911 or 1912?[7] And after that one couldn't stop talking about painting whenever any of us met, there was so much to be said . . . There were very angry people about the place. Tonks was *furious*, gibbering with fury, and a good many others too . . . Cézanne was the person he most hated.

Q.B. And what did Sickert think of Cézanne?

D.G. He wasn't appreciative. He knew all about Cézanne. He'd made up his mind what he thought of him, as I gather his generation in France had done so. They thought him a very gifted man, but totally inadequate *technically*. He couldn't *draw*, or anything! (laughter). He had a very great gift for painting, which they admired, but he didn't alter his opinion about that – that it was rather sad that people should worry about him so late in the day.

Q.B. And over-estimate him in Sickert's view?

D.G. Yes. Of course, I don't know what he thought later, of the next show, of Matisse. I never heard his opinion about him.

Q.B. Did you witness the explosions of rage of ordinary members of the public?

D.G. One couldn't help it, oh yes.

Q.B. Can you tell me something about your work in the theatre?

D.G. The first time I think anything I did was produced was for Copeau, at the Vieux Colombier theatre in Paris, where I did the costumes for *Twelfth Night*. I found him easy to work with, very pleasant indeed, a very nice man. But the theatre was *tiny*, and the clothes were the only thing that mattered really. There was this little empty stage with a few painted screens about the place, but no decor. Segonzac told me he's seen some drawings about at the Biblioteque Nationale – I don't know how they got there. I used to give the actors their drawings after I'd done them, so I never have collected many.

71 *Composition with Coffee Pot* 1914, charcoal on paper, 13 × 8¼", private collection

Q.B. Did you find people in the Ballet difficult to work with?

D.G. Not on the whole. Occasionally there were differences of opinion. Lytton (Strachey) was furious at *The Son of Heaven* being made into a Russian Ballet,[8] and left London in order not to see it. (He) thought Matisse vulgar, which is to me rather hard, but from the literary point of view perhaps he is. I mean, he lets out a lot of things that Lytton might not want to know about.

Q.B. Could I come back to teaching? Have you taught?

D.G. Yes, I have. I always find it very exhausting and not at all pleasurable, for myself. I had to take over for an artist who had a holiday for a term at a boy's school in Islington. I took on the task of artmaster and I found that very exhausting . . . trying to sympathise with the artist's wishes . . . not putting myself in the position of saying, 'That's wrong', or, 'That's right', but trying to find out what they were up to. I found that very exhausting – Mr Cholmondley's school. And then I used to go occasionally to the Slade to give one lesson to students who were picked out for me by people like Claude Rogers, and so on, perhaps six people in a room, with their pictures. I found that very exhausting too. I used to come out drenched with effort. And again, when the Euston Road School started, Vanessa and I both went round I think for a day a week, when the School started, to criticise. That was bad enough . . . interest there was, but not pleasure. And I used to hear stories of other teachers who simply did go round saying, 'That's all wrong. You must do this. You know perfectly well you ought not to draw like this'. And that didn't fatigue them. There are two methods, and I got hold of the wrong method.

Q.B. *You were too sympathetic in fact.*
D.G. Yes. I thought that was necessary, but apparently it isn't. It is exhausting trying to see from the perspective of another artist, another person.

Q.B. *How do you think one can teach?*
D.G. Well, I think that if I'd had more time it wouldn't have been so awful.

Q.B. *What do you think of contemporary painters?*
D.G. I think Jackson Pollock interests me. De Stael for instance was the first painter I came across after the War and I thought; Well, here is a great painter again, the first great painter I've seen since I was in Paris before the War. And I still like his things very much, but he is now an Old Master. I find Rothko a bit difficult. I don't personally see anything else in it, but just what meets the eye. The way to look at Magritte is to go to sleep, wake up, and find that there are reproductions in your lap, and they become dreams, at once. My first vision of him, I thought; This is

deplorable, because it's not my idea of *painting* at all. But if you haven't got your critical ideas to the fore, I think you can accept them as a dream, to be seen half asleep. But I don't know that you can ask people to go to the Tate Gallery in that condition.

Q.B. *What is your opinion of Virginia Woolf's writings on art?*
D.G. I thought very well of what she wrote about Sickert . . . I always think that Virginia was very jealous about painting, that is . . . I think it irritated her at one period. It didn't amount to making her *not* interested in painting, but she thought the talk was a nuisance. She couldn't very well join in.

Q.B. *And the business of the Degas sale?*
D.G. We found a catalogue of the Degas sale before Maynard (Keynes) went (to Paris) and were wildly excited by the reproductions.[9] I think I did say, 'Why on earth don't you get money to buy things for the National Gallery?', and he went off to The Treasury and said, 'I want £20,000', and they said, 'Of course. Have it at once'. Holmes had to go too, and didn't spend the whole amount – left about £10,000 unspent, which always seems to me rather silly.[10] . . . Vanessa and I advised Maynard to buy Seurat's *Grand Jatte*, which he could have had for £5000, and took us to see it, at the studio, and they couldn't find the money. Vanessa and I found a Seurat sketch, which was purchased by Maynard, propped up on a chair in Chelsea. It had come from Germany, when Germans sold things very cheaply.

APPENDIX B

The Lincoln Murals: Duncan Grant's Notes

The following is a short note written by Duncan Grant in a black A4 sketch book that was at Charleston in the early 1970's. It is entitled 'Lincoln BBC '62', though I have been unable to trace any record of a BBC radio or television programme from this period concerned with the decoration of the Russell Chantry.

I am sorry to say that I am very ignorant of the iconography of Christian art, and the fact that I chose to represent Christ as a youth was due to the whole spirit of the subject, chosen to combine scenes of every-day life in the sheep country with the issue of the Good Shepherd (though I have of course seen examples in the painting of the Roman catacombs).

The foundation of the Edwin Abbey Fund for the encouragement or mural painting in England was due to Edwin Abbey, the American artist who lived in England and became an R.A., who left a sum of money for the purpose. This is now administered by a committee chosen every few years, (and) a permanent chairman and secretary. This Society suggested that I should undertake the decoration of the Russell Chantry with the approval of the Dean of Lincoln and his advisors. After some discussion as to a suitable subject we decided that as the chapel was dedicated to St. Blaise, the patron saint of the wool industry, and as Lincoln had been a great centre of the wool trade in medieval times – that over the altar Christ should be represented as the Good Shepherd among mortal shepherds, and that among the subjects depicted on the other walls should be sheep shearers at work, a portrait of St. Blaise, and finally, facing the altar wall, a scene of the loading of bales of wool in Lincoln harbour.

58 The whole scheme needed the making of many cartoons and studies of figures and sheep, which I carried out in my studio in Sussex and finished there the final work, on plaster boards which were finally fixed up over the stone walls of the chapel and skilfully contrived to leave a space between the boards and the wall to prevent damp from damaging the paint. Mr Higgins the surveyor of the cathedral was of the greatest assistance in helping to carry out the work.

I have recently been in Spain. There the opportunity

72 Quentin Bell, Duncan Grant and Vanessa Bell on the occasion of the departure of the decorations for the Russell Chantry, 1959. Photograph by Mrs Anne Olivier Bell

would most likely have been taken to paint with all possible horror the frightful death of St. Blaise, torn to pieces by the combs of the wool workers. Lincoln is a gloriously happy church, like Chartres. I wished to express the happiness of the surroundings and I feel I was right in thinking that anything so grim would have been completely out of place.

Notes

Introduction

1. Raymond Mortimer, 'The Arts', *The Sunday Times*, 19 January, 1975, p. 35.
2. Anne Olivier Bell (ed.), *The Diary of Virginia Woolf, Volume 5 1936–1941*, London, The Hogarth Press, 1984, p. 331.
3. 'Artist Who Belongs to a Period Now in Disfavour', *The Times*, 12 May, 1959.
4. Eric Newton, 'Duncan Grant's Paintings', *Manchester Guardian*, 12 May, 1959.
5. Quentin Bell, *Virginia Woolf, A Biography, Volume 1, Virginia Stephen*, London, The Hogarth Press, 1972, pp. 128/129.
6. Carl Van Vechten, *The Blind Bow-Boy*, London, Grant Richards Ltd, 1923, p. 134.
7. Quentin Bell comments, 'This happened alright, but by the mid Twenties there was a distinct change of feeling, a much more hopeful outlook for internationalists. Symptoms: the two Labour governments, for all their failures; the Locarno Treaty; the entry of Germany into The League of Nations; the publication of Remarque's book *All Quiet on the Western Front*, and of many English books equally pacifist. This tendency continued through the late Twenties and the very early Thirties. In fact we had got to love the Germans by the time they became quite horrible. The left wing movement in the arts starts about 1934.' Private communication. See also, Lynda Morris and Robert Radford, eds. *The Story of the Artists International Association 1933–1953*, The Museum of Modern Art, Oxford, 1983.
8. Angelica Garnett, 'Charleston Remembered', *The Antique Collector*, Vol. 57, No. 5, May 1986, p. 68.
9. Ibid., p. 71.
10. Christopher Reed, *Bloomsbury Art: Re-imagining the Domestic*, unpublished thesis, 1988.
11. Ibid.
12. Ibid.
13. Lisa Tickner, *The Spectacle of Women: Imagery of the Suffrage Campaign 1907–14*, London, Chatto & Windus, 1987, p. 16.
14. Roger Fry, *Architectural Heresies of a Painter*, London, Chatto, 1921, p. 19.
15. Leonard Woolf, *Barbarians at the Gate*, London, Gollancz, 1939, p. 143.
16. Christopher Reed, op. cit. (10).
17. Personal communication.
18. Duncan Grant to Virginia Woolf, March 1917, University of Sussex Library.
19. Duncan Grant to Virginia Woolf, May 1927, University of Sussex Library.
20. Sketch-book at Charleston in 1970's.
21. Angelica Garnett, op. cit. (7), p. 68.
22. Angelica Garnett, *Duncan Grant*, London Anthony d'Offay Gallery, 1981, n.p.
23. Dorothy Todd & Raymond Mortimer, *The New Interior Decoration: An Introduction to its Principles, and International Survey of its Methods*, London, Batsford, 1929.
24. Ibid., p. 28.
25. Angelica Garnett, op. cit. (22).
26. Quentin Bell, unpublished memoir.
27. Francis Haskell, *Rediscoveries in Art: Some Aspects of taste, fashion and collecting in England and France*, London, Phaidon, 1980, p. 7.

Chapter 1

1. David Garnett, *The Flowers of the Forest*, London, Chatto & Windus, 1955, p. 27.
2. Duncan Grant, note in black Rowney No. 1 drawing book at Charleston, dated 5 January, 1960.
3. David Brown, *Duncan Grant to 1920: The Basic Outline*, 1972, The Tate Gallery Archive, 7241.1, p. 1.
4. Duncan Grant to Vanessa Bell, 31 July, 1923, The Charleston Papers, Folder VI, 143–177 (157).
5. Quentin Bell, *Interview with Duncan Grant*, 1969, University of Sussex Library, tape no. R 727 (transcribed as Appendix A to this book).
6. Ibid.
7. Ibid.
8. Ibid.
9. Quentin Bell, personal communication.
10. Richard Shone, *Bloomsbury Portraits*, London, Phaidon, 1976, p. 51.
11. Quentin Bell, personal communication.
12. David Brown, op. cit. (3), p. 2.
13. Quentin Bell, op. cit. (5).
14. Peggy Angus, personal communication.
15. Duncan Grant to Virginia Woolf, March 1917, University of Sussex Library.
16. David Garnett, op. cit. (1), p. 30.
17. Ibid., pp. 30–31.
18. Michael Holroyd, *Lytton Strachey: A Critical Biography*, 2 vols., p. 261.

19. David Garnett, op. cit. (1), p. 28.
20. Duncan Grant, *Memoir of Paris*, n.d., The Tate Gallery Archive, 8010.9.3.
21. Ibid.
22. Ibid.
23. Ibid.
24. David Brown, op. cit. (3), p. 2.
25. Duncan Grant, *Memoir of Paris*, op. cit. (20).
26. Duncan Grant, *M. Simon Bussy's Pastels*, n.d. The Spectator, 1908.
27. Tate Gallery Archive.
28. Duncan Grant, op. cit. (20).
29. Quentin Bell, op. cit. (5).
30. Duncan Grant, op. cit. (20).
31. Ibid.
32. Ibid.
33. Duncan Grant to Lytton Strachey, February 1907, British Museum.
34. Duncan Grant to Lytton Strachey, 4 February, 1907, British Museum.
35. Duncan Grant to Lytton Strachey, March 1907, British Museum. At the age of ninety he was asked on the BBC radio programme *Desert Island Discs* what luxury he would take with him, and he opted for a picture by Rembrandt.
36. Paul Roche, *With Duncan Grant in Southern Turkey*, Renfrew, Honeyglen Publications, 1982, pp. 74–75.
37. Quentin Bell, op. cit. (5).
38. See Alfred H. Barr, *Matisse: His Art and His Public*, London, Secker & Warburg, 1975.
39. *Four Americans in Paris*, New York, Museum of Modern Art, 1970.
40. Nigel Nicolson ed., *The Flight of the Mind: The Letters of Virginia Woolf 1888–1912*, London, The Hogarth Press, 1975, p. 377.
41. Personal communication, 1976.
42. Ibid.
43. Quentin Bell, op. cit. (5). Picasso used hand-printed Victorian wallpaper as the ground in at least two still-lives in the autumn of 1912; see William Rubin, *Picasso and Braque: Pioneering Cubism*, New York, Museum of Modern Art, 1989, p. 205.
44. Pierre Daix and Joan Rosselet, *Picasso: The Cubist Years: 1907–1916*, London, Thames & Hudson, 1979, p. 204.
45. Ibid., p. 205.
46. Frances Spalding, *Vanessa Bell*, London, Weidenfeld and Nicolson, 1983, p. 86.
47. Quentin Bell, op. cit. (5).
48. For example, Burne-Jones's *The Garden of the Hesperides*, 1870–73, private collection, illustrated in Martin Harrison and Bill Waters, *Burne-Jones*, London, Barrie & Jenkins, 1973, plate 17.

Chapter 2

1. Vanessa Bell, *Memories of Roger Fry*, 1934.
2. Ibid.
3. Simon Watney, *English Post Impressionism*, London, Studio Vista, 1980, p. 8.
4. Richard Le Gallienne, *The Romantic '90's*, London, Putnam & Co., 1951, pp. 77–78.
5. *Four Americans In Paris*, New York, The Museum of Modern Art, 1972, Plate 11.
6. For example, *The Lady in Blue*, c. 1894, in John Russell, *Vuillard*, London, Thames & Hudson, 1971, Plate V. Modigliani's work c. 1914 is also relevant. See also *Interior with a Birdcage*, by Jacques-Emile Blanche, n.d., (c.1900?), illustrated in The Fine Art Society Catalogue, Spring 1989, London, p. 35.
7. Personal communication, 1976.
8. For example, *Titans in the Forge of Vulcan*, Roman mosaic in the Bardo Museum, Tunis.
9. See Frances Spalding, *Roger Fry: Art and Life*, London, Paul Elek/Granada, 1980, pp. 149–50.
10. For example, the type of illusionistic decoration typified by Roger Fry's own 1893 painted chimney-breast, illustrated in *The Omega Workshops 1913–19: Decorative Arts of Bloomsbury*, London, Crafts Council, 1984, p. 10.
11. Duncan Grant to Virginia Woolf, 23 September, 1912, University of Sussex Library. Grant possibly also had in mind the fate of the Victorian artist, Richard Dadd, who had worked from the Bethlem Hospital after his confinement.
12. Judith Collins, *The Omega Workshops 1913–19: Decorative Arts of Bloomsbury*, London, Crafts Council, 1984, catalogue note D2, p. 77.
13. This is also characteristic of many of his paintings and drawings of Vanessa Bell in this period, for example, *Vanessa Bell in a Sunhat, Asheham*, 1914.
14. Robert Ross, *The Morning Post*, 1911.
15. Personal communication.
16. David Brown, *Duncan Grant to 1920: The Basic Outline*, The Tate Gallery Archive, 7241.1, p. 5.

17. Quentin Bell, 'The Omega Revisited', *The Listener*, 30 January, 1964, p. 201.
18. Ibid., pp. 200–201.
19. I have discussed this point at greater length in *English Post Impressionism*, op. cit. (3).
20. See Roger Fry, *Architectural Heresies of a Painter*, London, Chatto, 1921.
21. See Judith Collins, *The Omega Workshops*, Secker and Warburg, 1983.
22. David Brown, op. cit. (16).
23. Quentin Bell, *Interview with Duncan Grant*, 1969, University of Sussex Library, tape no. R 727. (See Appendix A.)
24. The *Abstract Kinetic Collage Painting With Sound* is extremely fragile and the Tate Gallery prepared a film with the artist's agreement in 1974, showing it in continuous sequence, to the accompaniment of the adagio from Bach's first Brandenburg Concerto. It is likely that Grant had much more contemporary music in mind in 1914.
25. Gabrielle Buffet, *Musique d'Aujourd'hui*, Les Soirées de Paris, 15 Mars, 1914.
26. A. Wallace Rimington, *Colour-Music: The Art of Mobile Colour*, London, 1911.
27. G. Apollinaire, *Survage*, Paris-Journal, 15 July, 1914.
28. See Gail Levin, *Synchronism and American Color Abstraction 1910–1925*, New York, George Brazier/The Whitney Museum, 1978, illustration 99.
29. Illustrated in Collins, op. cit. (21), plate 35.
30. S. D. Lawder, *The Cubist Cinema*, New York, 1975.
31. John Rudlin, *Jacques Copeau*, Cambridge University Press, 1986, p. 16.
32. Ibid., p. 23.
33. Quentin Bell, op. cit. (23).
34. Rose Macaulay, *Non-Combatants and Others* (1916), Methuen, 1986, p. 21.
35. Ibid., p. 45.
36. John Golding, *Cubism: a history & an analysis 1907–1914*, Faber, 1968, p. 109. The foil was removed in a regrettable over-restoration of the picture after the artist's death.
37. David Brown, op. cit. (16).
38. David Brown (ed.), *Duncan Grant*, Scottish National Gallery of Modern Art, Edinburgh, 1975, p. 7.
39. Linda Parry, *Textiles of the Arts and Craft Movement*, London, Thames & Hudson, 1988, pp. 113–114.
40. Rybczynski Witold, *Home: A Short History of an Idea*, Heinemann, London, 1988, p. 198.
41. Duncan Grant to Roger Fry, 20 October, 1913, Tate Gallery Archive, 8.455.
42. Ibid.
43. Duncan Thomson, *Eye to Eye*, Scottish National Portrait Gallery, Edinburgh, 1980, p. 38.
44. Illustrated in Simon Watney, *English Post Impressionism*, op. cit. (3), plate 12.
45. Duncan Grant to Virginia Woolf, March, 1917, University of Sussex Library.
46. Ibid. *Framley Parsonage* is a novel by Trollope.
47. Duncan Grant to Vanessa Bell, n.d. (late 1917), Charleston Papers, File 1, no. 27, The Tate Gallery Archive.
48. At Charleston in the 1970's, present whereabouts unknown.
49. Duncan Grant to Vanessa Bell, 7 June, 1919, Charleston Papers, File 2, no. 62, Tate Gallery Archive.
50. Duncan Grant to Vanessa Bell, n.d. October (?) 1919, Charleston Papers, File 2, no. 75, The Tate Gallery Archive.
51. See David Garnett, *The Flowers of the Forest*, London, Chatto & Windus, 1955, p. 36.
52. Another work from this series is *The Baptism of Christ*, c. 1918, formerly at Charleston, which combines elements from Cézanne and Piero della Francesca in particular. It is unlikely that Grant was encouraged by Cézanne's writings.
53. Duncan Grant to Vanessa Bell, 30 March, 1917, Charleston Papers, File 1, no. 19, The Tate Gallery Archive.
54. Illustrated in Richard Shone, *Bloomsbury Portraits*, London, Phaidon, 1976, illustration 14, p. 42.

Chapter 3

1. Quentin Bell, *Clive Bell at Charleston*, London, Edward Harvane Gallery, 1972, n.p.
2. Ibid.
3. E. M. Forster, *A Room With a View* (1908), Harmondsworth, Penguin, 1955, p. 163.
4. In a BBC radio interview in 1986, Frances Spalding spoke of the 'cost' to Vanessa Bell of accepting Grant's homosexuality. This seems to me to overlook the possible 'cost' to Duncan Grant of accepting Vanessa Bell's heterosexuality, though 'cost' is too simple a term

in either case. More recently, Professor Louise DeSalvo has advanced the hypothesis that Vanessa Bell suffered in her relationship with Grant because he was, 'a committed homosexual' (Louise DeSalvo, *Virginia Woolf: The Impact of Childhood Sexual Abuse on her Life and Work*, Boston, Beacon Press, 1989, p. 74–76). Furthermore, she argues that Vanessa could only have made her commitment to a gay man as a result of sexual abuse in childhood. Kennedy Fraser has written of Vanessa Bell as a representative of an entire class of women who are 'afraid, entranced', and sacrifice themselves to 'childish men' (Kennedy Fraser, 'Ornament and Silence', New York, *The New Yorker*, 6 November 1989). This even outdoes the grossly reductive line pursued by Professor DeSalvo. There are double-standards at work here, and they profoundly distort our understanding of both Vanessa Bell and Duncan Grant, whilst demeaning the integrity of their relationship.

5. David Garnett, *The Flowers of the Forest*, London, Chatto & Windus, 1955, p. 46.

6. In September 1920 Grant sent Vanessa Bell, 'a sample of nature's marbling', in the form of some autumn leaves. Duncan Grant to Vanessa Bell, The Charleston Papers, File 2, No. 82.

7. Picasso's *Vase of Flowers, Wineglass, and Spoon* is reproduced in colour in William Rubin, *Picasso and Braque: Pioneering Cubism*, New York, Museum of Modern Art, 1989, p. 97. It is also worth pointing out that this particular painting also features a transparent glass, with a long stem and flat base, outlined in white, of the type that Grant adopted c. 1913 as a form of signature device.

8. Roger Fry, *Cézanne: a study of his development*, London, The Hogarth Press, 1927, p. 28. This had first appeared in French in the previous year, in a special edition of December 1926 of *L'Amour de l'Art*, to which Fry and Clive Bell both subscribed. It was an important source of information about the mainland European art world of the 1920's for Vanessa Bell and Duncan Grant.

9. Bettelheim, Bruno, *The Uses of Enchantment: The Meaning and Importance of Fairy Tales*, Penguin, Harmondsworth, 1978, p. 295.

10. Frances Spalding, *Vanessa Bell*, London, Weidenfeld and Nicolson, 1983, p. 187.

11. Duncan Grant to Vanessa Bell, July 1920, The Charleston Papers, File 3.

12. Robert Medley, *Drawn from the Life: A Memoir*, London, Faber & Faber, 1983, p. 53.

13. Ibid., pp. 54–55. Medley had a walk-on part as a eunuch in *The Son of Heaven*.

14. Stephen Spender, *Duncan Grant*, London, d'Offay Couper Gallery, 1972, n.p.

15. Duncan Grant to Vanessa Bell, 27 April 1924, The Charleston Papers, File 7, No. 189.

16. Quentin Bell, *Conversation with Duncan Grant*, 1969, University of Sussex Library, tape No. R 727. (See Appendix A.)

17. Ibid.

18. Several panels are in private collections, whilst others are in the collection of the City of Southampton Art Gallery. The entire decorative scheme went unsold at auction in the mid 1970's for less than £1000.

19. Duncan Grant to Vanessa Bell, 13 July, 1923, The Charleston Papers, File 6, No. 154.

20. Robert Skidelsky, *John Maynard Keynes, Hopes Betrayed 1883–1920*, London, Macmillan, 1983, p. 394.

21. Memorandum in a drawing book at Charleston in the 1970's.

22. For example, Leonard Woolf thought that the Cavatina from Beethoven's B-flat Quartet, Opus 130, should be played at Virginia Woolf's cremation; 'but when the time came to make arrangements for the funeral, he could not bring himself to discuss Beethoven's cavatina. When the doors of the crematorium opened and the coffin slid forward. Leonard heard, to his surprise, the music of the Blessed Spirits from Gluck's *Orpheo*'. Phyllis Rose, *Woman of Letters: A Life of Virginia Woolf*, London, Routledge & Kegan Paul, 1978, pp. 246–247.

23. Roger Fry, op. cit. (8), p. 42.

24. Ibid.

25. Roger Fry, *Reflections on British Painting*, London, Faber & Faber, 1934, p. 27.

26. This distinction was elaborated in 'Some Questions In Aesthetics', in *Transformations*, London, Chatto & Windus, 1927.

27. Lawrence Gowing, *Painting from Nature*, The Arts Council of Great Britain, 1981, p. 9.

28. Margaret Drabble, *The Radiant Way*, Harmondsworth, (1988), p. 92.

29. Duncan Grant to Vanessa Bell, 5 February, 1921, The Charleston Papers, File 4, No. 100.

30. Duncan Grant to Vanessa Bell, 7 February, 1921, The Charleston Papers, File 4, No. 101.
31. Duncan Grant to Vanessa Bell, 13 January, 1922, The Charleston Papers, File 5, No. 118.
32. Duncan Grant to Vanessa Bell, 15 January, 1922, The Charleston Papers, File 5, No. 119.
33. Duncan Grant to Vanessa Bell, 30 January, 1922, The Charleston Papers, File 5, No. 132.
34. Duncan Grant to Vanessa Bell, 28 January, 1922, The Charleston Papers, File 5, No. 129.
35. Duncan Grant to Vanessa Bell, 15 June, 1924, The Charleston Papers, File 7, No. 194.
36. Duncan Grant to Vanessa Bell, 16 June, 1924, The Charleston Papers, File 7, No. 195.
37. Ibid.
38. Duncan Grant to Vanessa Bell, 18 June, 1924, The Charleston Papers, File 7, No. 197.
39. Ibid.
40. Duncan Grant to Vanessa Bell, 19 June, 1924, The Charleston Papers, File 7, No. 198.
41. The *Sistine Madonna* by Raphael.
42. Duncan Grant to Vanessa Bell, 22 June, 1924, The Charleston Papers, File 7, No. 200.
43. Angelica Garnett notes; 'A reproduction of the upper half of the *Sistine Madonna* hung on the walls of Charleston at least until Vanessa Bell's death. It came, I think, from Julia Stephen. It was alluded to with ribaldry, chiefly I think by Quentin and Julian, but it remained, striking an unusual note in the prevailing decor'. Personal communication.
44. Duncan Grant to Vanessa Bell, op. cit. (42).
45. Personal communication.
46. Duncan Grant to Vanessa Bell, 29 September, 1923, The Charleston Papers, File 6, No. 163. Robert Medley suspects that Grant got the name of the paints he wanted wrong, and that he was referring to the increasingly popular *Mars* range of paints, manufactured in Belgium.
47. Robert Medley, op. cit. (11), pp. 99–100.
48. Personal communication. It should also be pointed out that Roger Fry had little sympathy for Cézanne's *Bathers*, and dismissed their theme as, 'recrudescent romantic emotion', *Cézanne: a study of his development*, London, The Hogarth Press, 1927, p. 81. He found in them, 'the effect of dryness and wilfulness which so deliberate a formula arouses', ibid. This is a good example of the way in which Fry could dismiss those aspects of an artist's work that did not tally with his theoretical position. In the case of Cézanne this amounted to almost everything painted before 1860, as well as the *Bathers* series, about which Grant was hugely enthusiastic. See footnote (21). Much of Grant's own work was similarly unsympathetic to Roger Fry.
49. Duncan Grant, 'Roger Fry', in *Seventeen Contemporary British Painters* 1912–1942, London, Council for the Encouragement of Music and the Arts, 1942, n.p.
50. John Piper, *The Listener*, 24 June, 1931.
51. Quentin Bell comments: 'I think it is only fair to Duncan and Vanessa to say that although they saw in the Euston Road School a counter revolution against most of what they believed in (Graham Bell had been obsessed by Duncan Grant and was reacting sharply) they had sufficient magnanimity to welcome the revolt, to respect its leaders and to help them in every way possible, not only by teaching but by going round with a begging bowl and raising the funds with which the school was started. In consequence they remained always on very good terms with William Coldstream and Claude Rogers, and arranged a Claude Rogers exhibition in Lewes during the war. There was affection and some respect on both sides.' Personal communication.
52. W. H. Auden, 'Letter to William Coldstream' in *Letters from Iceland*, 1937, quoted in Lynda Morris and Robert Redford (eds) *The Story of the Artists International Association: 1933–1953*, Oxford, The Museum of Modern Art, 1983, p. 44.
53. Virginia Woolf to Julian Bell, 2 May, 1936, in Nigel Nicolson (ed.) *Leave the Letters Till We're Dead: The Letters of Virginia Woolf 1936–1941*, London, The Hogarth Press, 1980, No. 3126, p. 33.

Chapter 4

1. Anne Olivier Bell, 'Towards Charleston', *Charleston Newsletter*, No. 14, March, 1986, p. 12.
2. Frances Spalding, *Vanessa Bell*, Weidenfeld and Nicolson, 1983, p. 299.
3. Angelica Garnett, *Deceived with Kindness: A Bloomsbury Childhood*, The Hogarth Press, 1984, p. 149.
4. Ibid., p. 151.
5. Ibid., p. 167.
6. Frances Spalding, op. cit. (2), p. 319.
7. Properly speaking, these are Labours of the Months, of which for example a fine fifteenth-century series of

stained glass roundels from the School of Norwich are to be found at Brandiston Hall, Norfolk. Another series survives at Norbury Manor, Derbyshire.

8. Personal communication.
9. Margaret Drabble, 'Vanessa Bell', *Charleston Newsletter*, No. 17, June, 1988, p. 22.
10. Duncan Grant to Roger Fry, n.d. (1929?), The Tate Gallery Archive, no. 8, 456.
11. John Hayes, *Thomas Gainsborough*, London, The Tate Gallery, 1981, p. 37.
12. Scholarship and intelligent speculation concerning Rembrandt's use of costumes, and his studio practices are combined in Svetlana Alpers, *Rembrandt's Enterprise: The Studio and the Market*, Chicago, University of Chicago Press, 1988.
13. John Donne, *A Valediction: Forbidding Mourning*.
14. Angelica Garnett, op. cit. (3), p. 168.
15. John Premble, *The Mediterranean Passion: Victorians and Edwardians in the South*, Oxford, Oxford University Press, 1988, p. 268.
16. The Arts Council of Great Britain, *Decade: Painting, Sculpture and Drawing 1940–1949*, London, 1972.
17. Angelica Garnett, *Duncan Grant*, Anthony D'Offay Gallery, 1981, n.p.
18. Shortly after his ninetieth birthday Duncan Grant recorded an edition of the popular long-running BBC radio programme, *Desert Island Discs*, in which he stated that he: 'simply bathed in music'. Among the eight choices of records which he selected, was Kirsten Flagstad's recording of the aria 'Remember Me' from Purcell's *Dido and Aeneas*. It is difficult to think of a more suitable artist who might have designed a production of this short opera, originally written for children to perform.
19. Duncan Grant, *The Lincoln Murals 1958–1959*, Appendix B.
20. Ibid.
21. Angelica Garnett, op. cit. (3), 1984, p. 172.
22. Ibid.
23. Roger Fry, *Reflections on British Painting*, London, Faber & Faber, 1934, p. 18.
24. Personal communication, 20 June, 1976.
25. See Paul Roche, *With Duncan Grant in Southern Turkey*, Renfrew, Honeyglen Publishing, 1982.
26. Richard Morphet, 'The Significance of Charleston', *Apollo*, November 1967, pp. 342–345.
27. Personal communication, 1 August, 1975.
28. Personal communication, 24 April, 1970.
29. Paul Roche, op. cit. (24), p. 90.

Conclusion

1. Clive Bell, *Civilization*, London, Chatto & Windus, 1927, pp. 84–86.
2. Duncan Grant, 'Virginia Woolf' (1941), in S. P. Rosenbaum, ed., *The Bloomsbury Group*, London, Croom Helm, 1975, p. 68.
3. *The Times*, Wednesday 10 May, 1978, p. 18.
4. See Angelica Garnett, *Duncan Grant*, Anthony D'Offay Gallery, 1981.
5. Duncan Grant, sketch book note, no date.
6. Ibid.
7. Kennedy Fraser, 'Ornament and Silence', *The New Yorker*, 6 November, 1989, p. 162.
8. Ibid.
9. Rybczynski, Witold, *Home: A Short History of an Idea*, Heinemann, London, 1988, p. 75.
10. David Brown, *Duncan Grant to 1920: The Basic Outline*, The Tate Gallery Archive, No. 7241.1.

Appendix A

1. Grant was fourteen years old when he first attended St. Paul's School.
2. Frederick Brown had taught Beardsley and Henry Tonks at the Westminster School of Art, before taking over from Alphonse Legros as Professor at the Slade School of Fine Art, in University College, London.
3. Grant's visit to Matisse at his home in Issy-les-Moulineaux took place in 1909 rather than 1905, when he left England to study in Paris. By *La Ronde* he presumably meant *La Dance*, the second version of which was painted at Issy-les-Moulineaux in 1910. The first, less resolved version of *La Dance* was shown at the Second Post Impressionist Exhibition in 1911. See Chapter Two.
4. The pictures exhibited at the Royal Academy's annual Summer Exhibition were published in book form each year. Several volumes from the 1890's are in the library at Charleston.
5. Grant's copy of Piero's portrait of *Federico da Montefeltro* hung in the Dining Room at Charleston until his death. It is now in a private collection.
6. Fry had first become enthusiastic about the work of Cezanne in 1906. See Frances Spalding, *Roger Fry: Art and Life*, London, Paul Elek/Granada, 1980, pp. 116–117.

7. The First Post Impressionist Exhibition, 'Manet and the post Impressionists' ran from 8 November 1910, until 15 January, 1911, at the Grafton Gallery, London.
8. *The Son of Heaven* had been written by Lytton Strachey in 1912, and was given two public performances in July 1925, at the Scala Theatre, London, with sets and costumes designed by Duncan Grant. Vanessa Bell assisted in the painting of some of the costumes.
9. Grant had recommended Keynes to raise government money to buy pictures for the National Gallery at the auction of the contents of Degas' studio, which he duly attended on 26–27 March, 1918, whilst in Paris for a meeting of the Inter-Ally Council. See Robert Skidelsky, *John Maynard Keynes: Hopes Betrayed 1883–1920*, London, Macmillan, 1983, p. 349.
10. Sir Charles Holmes, the Keeper of the National Gallery.

Bibliography

Alpers, Svetlana, *Rembrandt's Enterprise: The Studio and the Market,* University of Chicago Press, Chicago, 1988.

Anscombe, Isabelle. *Omega and After: Bloomsbury and the Decorative Arts,* Thames & Hudson, London, 1981.

Aslin, Elizabeth. *The Aesthetic Movement: Prelude to Art Nouveau,* Ferndale Editions, London, 1981.

Baron, Wendy. *The Camden Town Group,* Scolar Press, London, 1979.

Barr, Alfred H. Jr. *Matisse: His Art and his Public,* Secker & Warburg, London, 1975.

Bell, Clive. *Civilization,* Chatto and Windus, London, 1928.

Bell, Quentin. 'The Omega Revisited', *The Listener,* 30 January, 1964, pp. 201–204.

Bell, Quentin. *Roger Fry,* Leeds University Press, 1964.

Bell, Quentin. *Bloomsbury,* Weidenfeld & Nicolson, London, 1968.

Bell, Quentin. *Clive Bell at Charleston,* Gallery Edward Harvane, London, 1972.

Bell, Quentin. 'Vanessa Bell and Duncan Grant', *Crafts,* No. 42, January/February, 1980, pp. 26–34.

Bell, Quentin. 'Who's Afraid for Virgina Woolf', *The New York Review of Books,* Vol. xxxvii, no. 4, March 15, 1990.

Bell, Quentin. *Elders and Betters,* John Murray Ltd., London, 1995.

Bettelheim, Bruno. *The Uses of Enchantment: The Meaning and Importance of Fairy Tales,* Penguin, Harmondsworth, 1978.

Blanche, Jacques-Emile. *Portraits of a Lifetime,* J. M. Dent, London, 1937.

Blanche, Jacques-Emile. *More Portraits of a Lifetime,* J. M. Dent, London, 1939.

Bowness, Alan. *Decade: 1910–1920,* Arts Council of Great Britain, 1967.

Bowness, Alan. *Decade: 1920–1930,* Arts Council of Great Britain, 1970.

Bowness, Alan. *Decade: 1940–1949,* Arts Council of Great Britain, 1973.

Brown, David. *Duncan Grant,* Scottish National Gallery Of Modern Art, Edinburgh, 1975.

Buckle, Richard. *Nijinsky,* Weidenfeld & Nicolson, London, 1971.

Bullen, J. B. ed. *Post-Impressionists in England: The Critical Reception,* Routledge, London, 1988.

Carrington, Noel ed. *Mark Gertler: Selected Letters,* Rupert Hart-Davis, London, 1965.

Collins, Judith. *The Omega Workshops.* Secker & Warburg, London, 1983.

Crafts Council. *The Omega Workshops 1913–19: Decorative Arts of Bloomsbury,* London, 1984.

Daix, Pierre & Rosselet, Joan. *Picasso: The Cubist Years 1907–1916,* Thames & Hudson, London, 1979.

Drabble, Margaret. 'Vanessa Bell', *Charleston Newsletter,* No. 21, June 1988, pp. 17–23.

Elderfield, John. *Fauvism and its Affinities,* The Museum of Modern Art, New York, 1976.

Elderfield, John. *Matisse in the Collection of The Museum of Modern Art,* The Museum of Modern Art, New York, 1978.

Fry, Roger. *Duncan Grant,* Hogarth Press, London, 1923.

Fry, Roger. *Cezanne, a study of his development,* Hogarth Press, London, 1927.

Fry, Roger. *Reflections on British Painting,* Faber & Faber, London, 1934.

Garnett, Angelica. 'Duncan Grant', Anthony D'Offay Gallery, London, 1980.

Garnett, Angelica. *Deceived with Kindness: A Bloomsbury Childhood,* Chatto & Windus, London, 1984.

Garnett, Angelica. 'Charleston Remembered', *The Antique Collector,* May 1986, pp. 67–71.

Garnett, Angelica. 'The Restoration of Charleston – A Talk', *Charleston Newsletter,* No. 23, June 1989, pp. 14–19.

Garnett, Angelica. *The Eternal Moment: Essays and a Short Story,* Puckerbrush Press. Orono Maine, 1998.

Garnett, David. *The Flowers of the Forest,* Chatto & Windus, London, 1955.

Garnett, David. *The Familiar Faces,* Chatto & Windus, London, 1962.

Golding, John. *Cubism: a history & an analysis 1907–1914,* Faber and Faber, London, 1968.

Harrison, Martin & Waters, Bill. *Burne-Jones,* Barrie & Jenkins, London, 1979.

Haskell, Francis. *Rediscoveries in Art,* Phaidon, London, 1976.

Hewison, Robert. *The Heritage Industry: Britain in a Climate of Decline,* Methuen, London, 1987.

Hayes, John. *Thomas Gainsborough,* The Tate Gallery, London, 1981.

Hirschl & Adler Galleries. *British Modernist Art 1905–1930,* New York, 1988.

Holroyd, Michael. *Lytton Strachey: The Years of Achievement 1910–1932,* Heinemann, London, 1968.

Levin, Gail. *Synchronism and American Color Abstraction 1910–1925,* George Braziller, New York, 1978.

Marler, Regina (ed.). *The Letters of Vanessa Bell,* Bloomsbury, London, 1994.

Medley, Robert. *Drawn from the Life: A Memoir*, Faber and Faber, London, 1983.

Morphet, Richard. 'The Significance Of Charleston', *Apollo*, November 1967, pp. 342–345.

Morris, Lynda and Radford, Robert. *The Story of the Artists International Association 1933–1953*, The Museum of Modern Art, Oxford, 1983.

Mortimer, Raymond. *Duncan Grant*, Penguin Modern Painters, 1948.

Mortimer, Raymond. 'Duncan Grant', *The Sunday Times*, January 19, 1975, p. 35.

Mortimer, Raymond and Todd, Dorothy. *The New Interior Decoration*, Batsford, London, 1929.

Musée D'Art Moderne De La Ville De Paris. *Modigliani*, Paris, 1981.

Orangerie des Tuileries. *A. Dunoyer de Segonzac*, Éditions des Musées Nationaux, Paris, 1976.

Parry, Linda. *Textiles of the Arts and Crafts Movement*, Thames and Hudson, London, 1988.

Pemble, John. *The Mediterranean Passion: Victorians and Edwardians in the South*, Oxford University Press, Oxford, 1987.

Percival, John. *The World of Diaghilev*, Studio Vista, London, 1971.

Read, Christopher (ed.). *A Roger Fry Reader*, University of Chicago Press, 1996.

Robins, Anna Greutzner. *Modern Art in Britain 1910–1914*, Merrell Holberton/Barbican Art Gallery, London, 1997.

Roche, Paul. *With Duncan Grant in Southern Turkey*. Honeyglen, Renfrew, 1982.

Rose, Phyllis. *Woman Of Letters: A Life of Virginia Woolf*, Routledge & Kegan Paul, London, 1978.

Rosenbaum, S. P. ed. *The Bloomsbury Group*, Croom Helm, London, 1975.

Rubin, William, ed. *Cézanne: The Late Work*, Thames and Hudson, London, 1978.

Rubin, William. *Picasso and Braque: Pioneering Cubism*, The Museum of Modern Art, New York, 1989.

Rudin, John. *Jacques Copeau*, Cambridge University Press, Cambridge, 1986.

Shone, Richard. *Bloomsbury Portraits*, Phaidon, London, 1976.

Shone, Richard. *Duncan Grant designer*, Bluecoat Gallery, Liverpool, 1980.

Shone, Richard. *The Charleston Artists: Vanessa Bell, Duncan Grant and their Friends*, Meadows Museum and Gallery, Dallas, Texas, 1984.

Shone, Richard. *The Berwick Church Paintings*, Towner Art Gallery, Eastbourne (1969), 1986.

Shone, Richard. 'Duncan Grant's Poussin', *Charleston Newsletter* No. 17, December 1986, pp. 20–21.

Shone, Richard. 'Works by Vanessa Bell and Duncan Grant in Public Collections', *Charleston Newsletter*, No. 24, December 1989, pp. 38–48.

Shone, Richard. ". . . Decorations domestic ecclesiastical theatrical . . .", in *Duncan Grant & Vanessa Bell: Design and Decoration 1910–1960*, Spink, London, 1991.

Skidelsky, Robert. *John Maynard Keynes: Hopes Betrayed 1883–1920*, Macmillan, London, 1983.

Smart, Alastair. *The Dawn of Italian Painting 1250–1400*, Phaidon, London, 1978.

Spalding, Frances. *Roger Fry: Art and Life*, Paul Elek/Granada, London, 1980.

Spalding, Frances. *Vanessa Bell*, Weidenfeld & Nicolson, London, 1983.

Spalding, Frances. *100 Years of Art in Britain*, Leeds City Art Gallery, 1989.

Spalding, Frances. *Duncan Grant: A Biography*, Chatto & Windus, London, 1997.

Spender, Stephen. 'Duncan Grant', Anthony d'Offay Gallery, London, 1972.

Stamp, Gavin ed. *Britain in the Thirties*, Architectural Design, Profile 24, n.d.

Taylor, Hilary. *James McNeil Whistler*, Studio Vista, London, 1978.

Tickner, Lisa. *The Spectacle of Women: Imagery of the Suffrage Campaign 1907–1914*, Chatto & Windus, London, 1997.

Trumble, Angus. *Bohemian London: Camden Town and Bloomsbury Paintings in Adelaide*, Art Gallery Board of South Australia, Adelaide, 1997.

Turnbaugh, Douglas Blair. *Duncan Grant and the Bloomsbury Group*, Lyle Stuart, Secausus, N.J., 1987.

Watney, Simon. *English Post Impressionism*, Studio Vista, London, 1980.

Watney, Simon. 'Critics and Cults', *Charleston Newsletter*, No. 17, December 1986, pp. 25–30.

Williams, Raymond. 'The Significance of "Bloomsbury" as a Social and Cultural Group', in Crabtree, Derek and Thirlwall, A. P. eds. *Keynes and the Bloomsbury Group*, Macmillan, London, 1980, pp. 40–68.

Woodeson, John. *Mark Gertler*, Sidgwick and Jackson, London, 1972.

Woolf, Virginia. *Roger Fry: A Biography*, Hogarth Press, London, 1940.

Acknowledgements

I am extremely grateful to the many individuals and institutions who have helped in the preparation of this book. Previous scholarly publications by Dr David Brown, Dr Judith Collins, Dr Frances Spalding, and Mr Richard Shone were of invaluable aid. I should also like to thank the staff of the British Library, King's College Cambridge Library, the University of Sussex Library, and the Tate Gallery Archive. The following provided a wealth of ideas and information, for which I am greatly in their debt:

Mr Charles A. Barber, Professor and Mrs Quentin Bell, Mr Richard Buckle, Dr Judith Collins, Mr Emmanuel Cooper, Mrs Angelica Garnett, Mrs Henrietta Garnett, the late Mr Duncan Grant, the late Mrs Grace Higgens, Mrs Sandra Lummis, Mr Robert Medley, Mrs Frances Partridge, Mr Christopher Reed, Mrs Clarissa Roche, Mr Paul Roche, and the late Mr Edward Wolfe.

Unpublished and copyright material is published by kind permission of Professor Quentin Bell, Mrs Angelica Garnett, Mrs Henrietta Garnett, and Mr Christopher Reed.

Finally I must thank my editors Miss Ariane Goodman and Mr John Stidolph for their patience and support, and, last but far from least, my partner Mr John-Paul Philippé, who has been my mainstay throughout the research, writing and production of the book.

PHOTO CREDITS

(Illustrations in bold are colour plates)

John Baily: 57, 58, 59
Anne Olivier Bell: 60, 72
Helen Bergen: 46
The Bloomsbury Workshop: **51**
The Charleston Trust: 11, 38, 42, **37**
The Courtauld Institute: 29, **12**
Anthony d'Offay Gallery: Frontispiece, 33, 34, 35, 39, 43, 50, 65, 70, 71, **2**, **13**, **16**, **17**, **20**, **21**, **22**, **26**, **31**, **34**, **35**, **36**, **40**, **43**, **52**, **54**
Ferens Art Gallery, Kingston upon Hull: 24
Howard Grey: **39**
Nicholas Hirst: **23**
Mary-Anne Kennedy: 2, 9, 10, 28, 30, 48, 49, 52, 54, 69
Stephen Keynes: 17
Sandra Lummis: **28**
Manchester City Art Gallery: **44**
Kirsty McLaren: 3, 5, 6, 7, 9, 11, 14, 15, 19, 22, 23, 26, 31, 32, 36, 37, 61, 66, 68, **1**, **6**, **8**, **9**, **15**, **23**, **25**, **27**, **30**, **33**, **38**, **42**, **45**, **46**, **47**, **48**, **49**, **50**, **53**, **55**, **57**, **58**, **59**, **60**
Sydney W. Newbery: 53
Phillips, London: 40, 53, **5**, **29**
Portsmouth City Museum and Art Gallery: **41**
Richard Shone: **61**, **62**
Southampton City Art Gallery: 44
The Tate Gallery, London: 13, 14, 16, 18, 20, 21, 25, 45, **4**, **7**, **14**, **32**, **56**
National Gallery of Victoria, Melbourne: 51
Simon Watney: 4, 56, 64, 67

Colour Plates

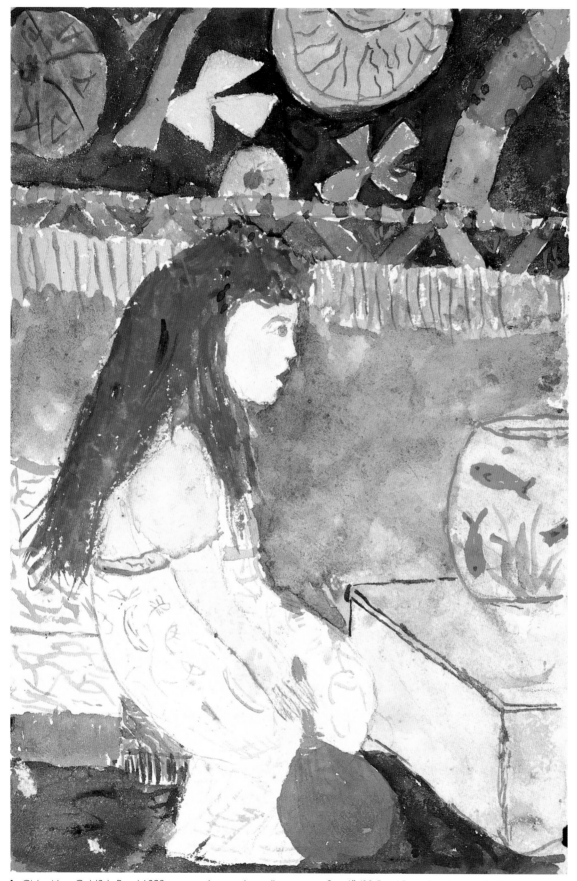

1 *Girl with a Goldfish Bowl* 1893, watercolour and pencil on paper, 9 × 6" (22.5 × 15 cms.), private collection

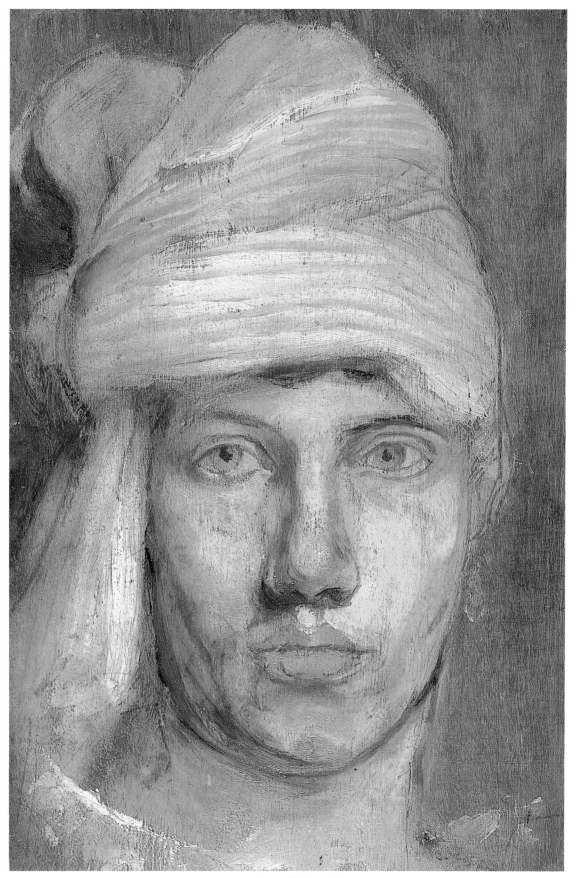

2 *Self-Portrait with Turban* c.1909, oil on board, 10¾ × 7¾″ (27 × 19.5 cms.), private collection

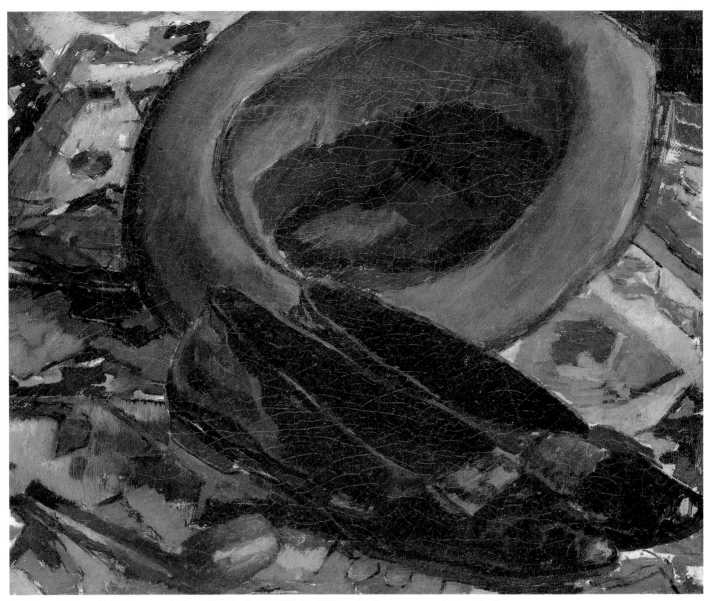

3 *Maynard Keynes' Hat, Shoes and Pipe* 1908/09, 9 × 11″ (22.5 × 27.5 cms.), oil on canvas, private collection

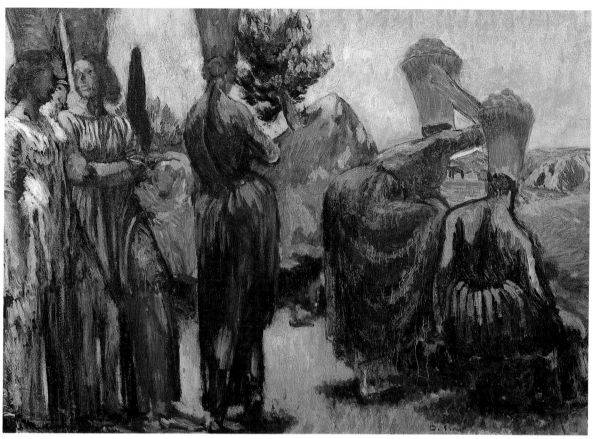

4 *The Lemon Gatherers* 1910, 22¾ × 32″ (57 × 80 cms.), The Tate Gallery, London

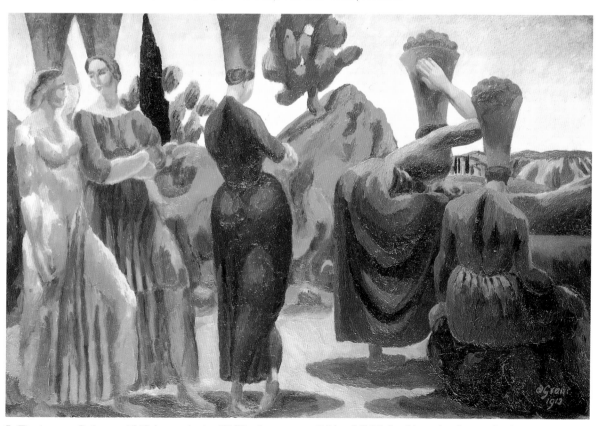

5 *The Lemon Gatherers* 1912 (re-worked c.1919?), oil on canvas, 24¼ × 36″ (61.5 × 91 cms.), private collection

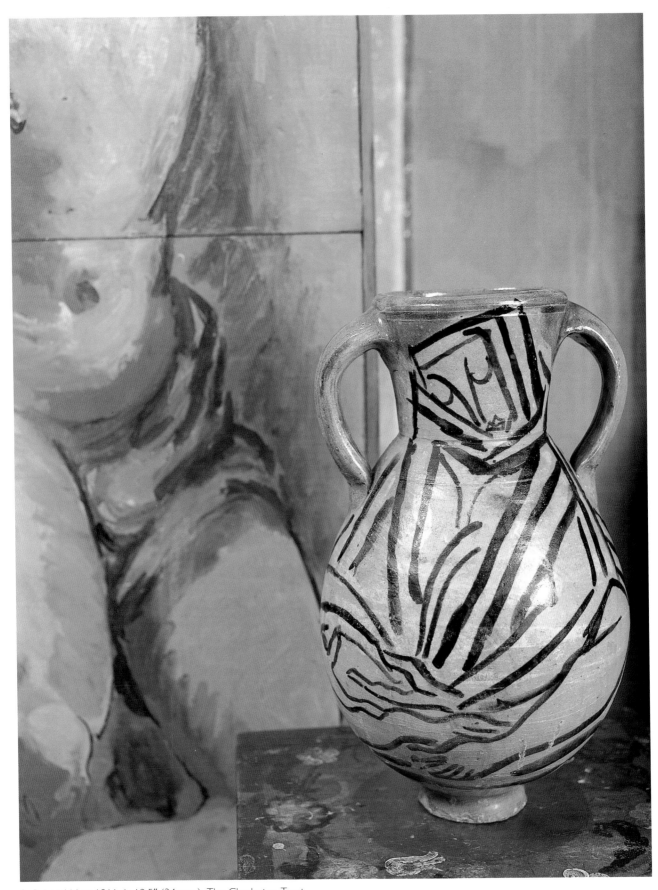

6 *Painted Vase* 1911, h. 13.5″ (34 cms.), The Charleston Trust

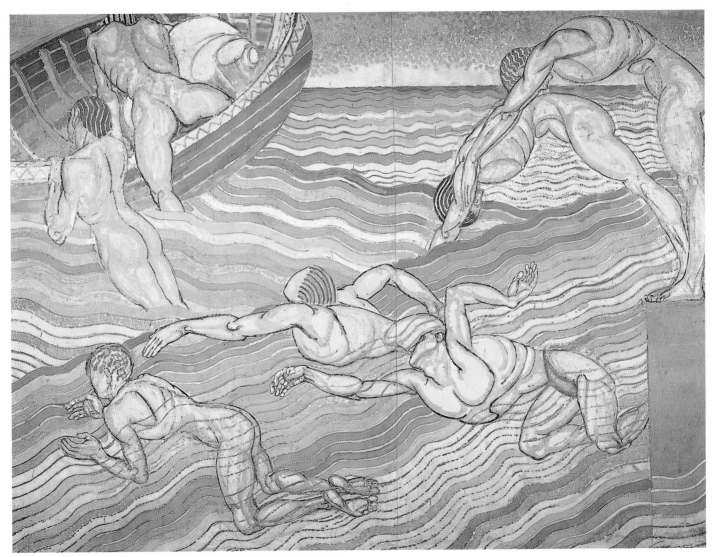

7 *Bathing* 1911, oil on board, 90 × 120½″ (225 × 301 cms.), The Tate Gallery, London

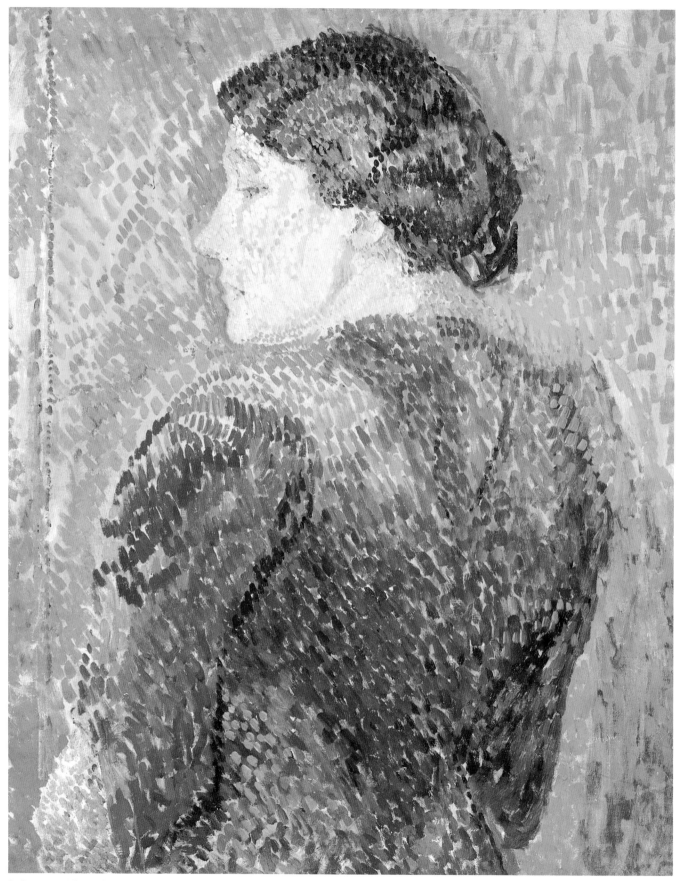

8 *Portrait of Ethel Grant* c.1910, oil on canvas, 30 × 25″ (76.5 × 63.6 cms.), private collection

9 *Design for Painted Chest, Swimmer with Goldfish* 1912/13, gouache on paper, 20½ × 37½" (51 × 94 cms.), collection Stephen Keynes

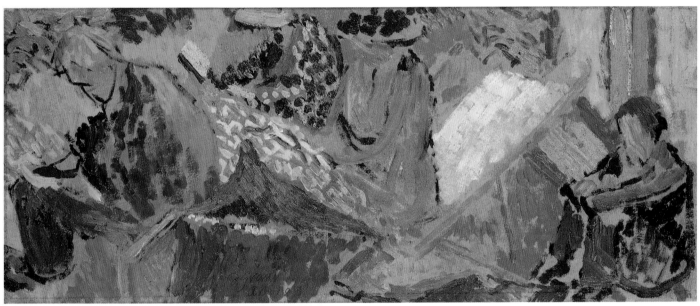

10 *Group at Asheham: Adrian Stephen, Virginia Woolf, Vanessa Bell and Henri Doucet* 1913,
oil on board, 10½ × 25" (26 × 62 cms.), private collection

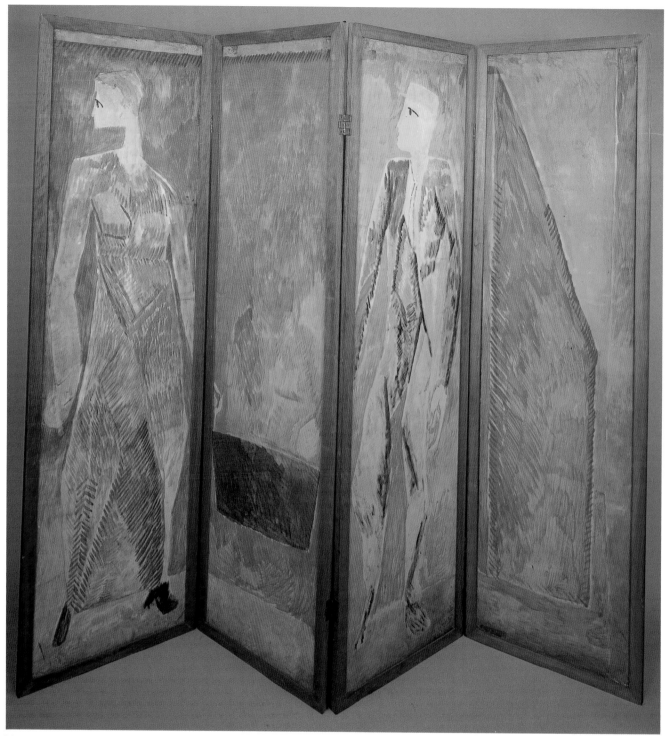

11 *Screen* 1913, oil on wood, each panel 70 × 20¼″ (174.7 × 50.8 cms.), The Charleston Trust

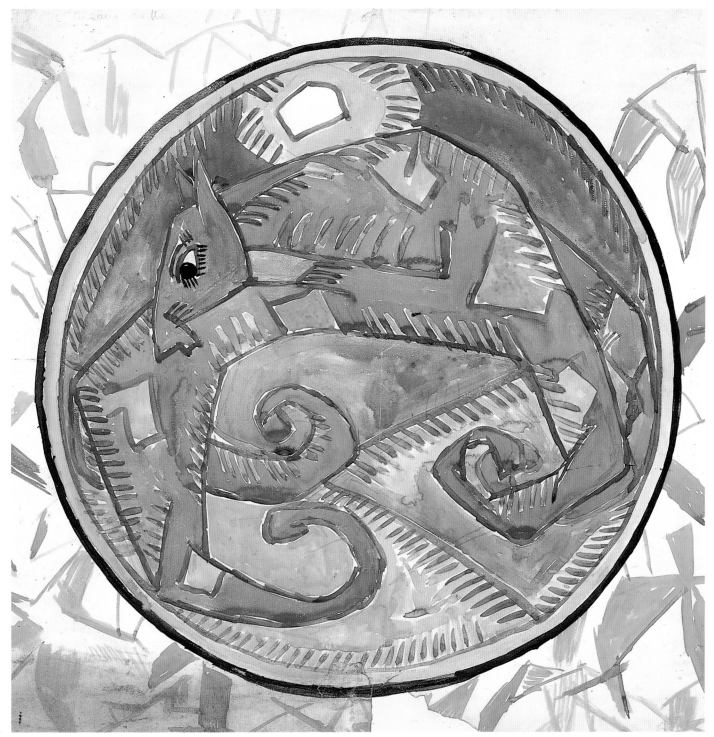

12 *Design with a Giraffe* c.1913, gouache on paper, The Courtauld Institute

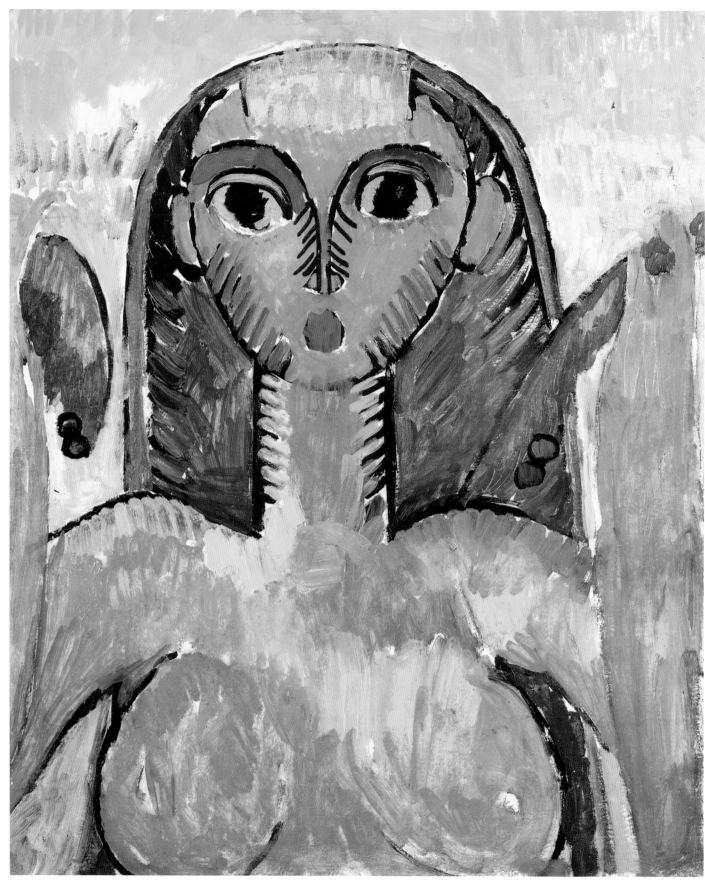

13 *Head of Eve* 1913, oil on board, 29¾ × 25″ (75.6 × 63.5 cms.), The Tate Gallery

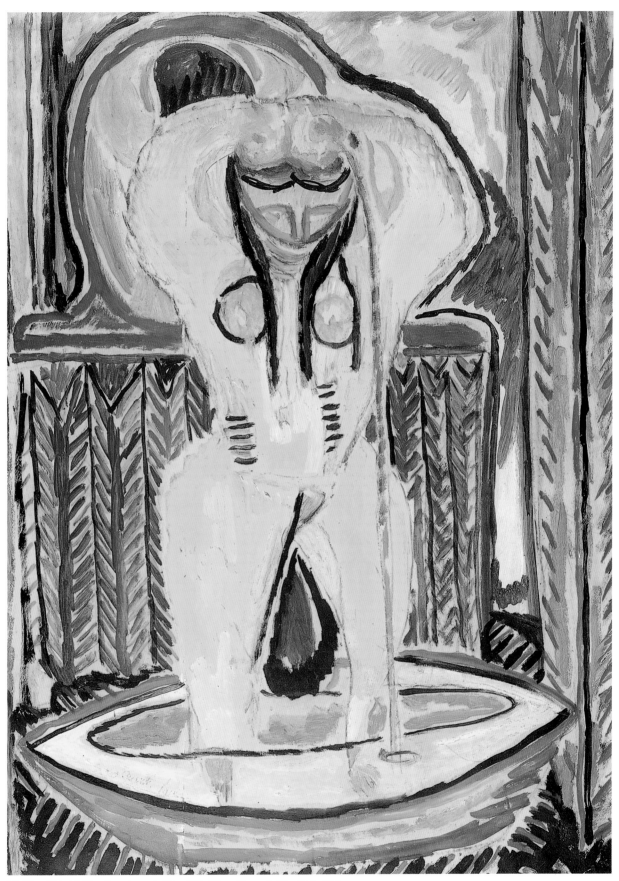

14 *The Tub* 1912, oil on board, 30 × 22" (75 × 55 cms.), The Tate Gallery

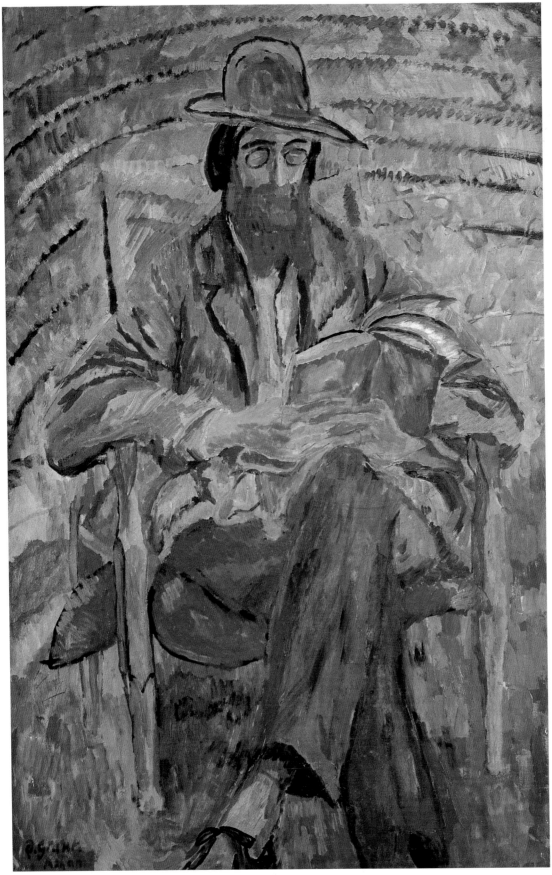

15 *Portrait of Lytton Strachey* 1913, oil on canvas, 35¾ × 23½″ (91 × 59 cms.), The Charleston Trust

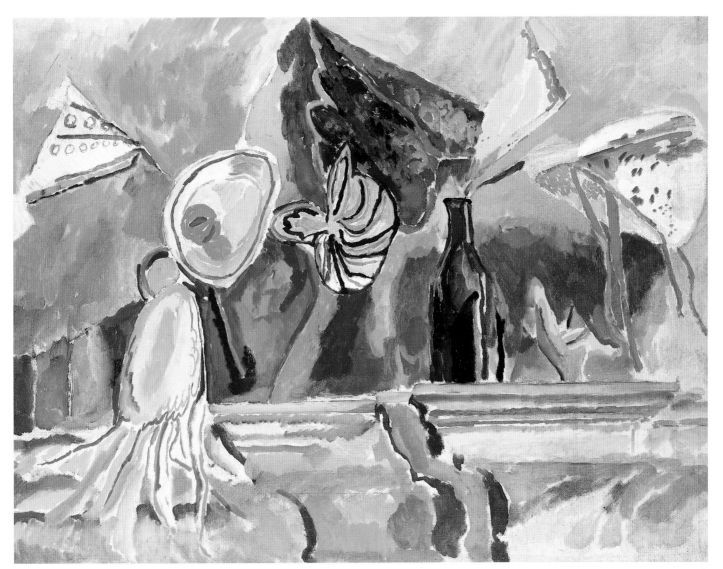

16 *On the Mantlepiece: Still Life with Omega Paper Flowers* 1914/15, oil on canvas, 21¾ × 29½″ (55.2 × 74.9 cms.), private collection

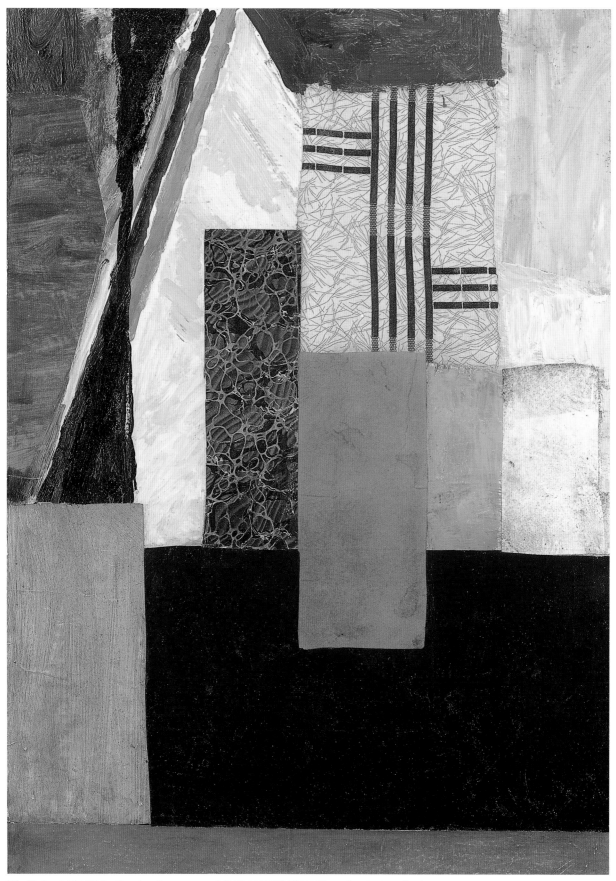

17 *Abstract* 1914/15, oil and collage on panel, 24¾ × 17¾″ (63 × 45 cms.), private collection

18/19 *Abstract Kinetic Scroll* 1914, (detail left), gouache, watercolour, ink and painted paper on canvas, 11 × 177¼" (28 × 450 cms.), The Tate Gallery

20 *The Modelling Stand* 1914, oil and collage on board, 29¾ × 24″ (75.6 × 61 cms.), private collection

21 *Blue Nude with Flute (Marjorie Strachey)* 1914, oil on board, 24½ × 72″ (61.2 × 180 cms.), private collection

22 *Nude with a Flute (Marjorie Strachey)* 1914, oil on panel, 24½ × 72″ (61.2 × 180 cms.), private collection

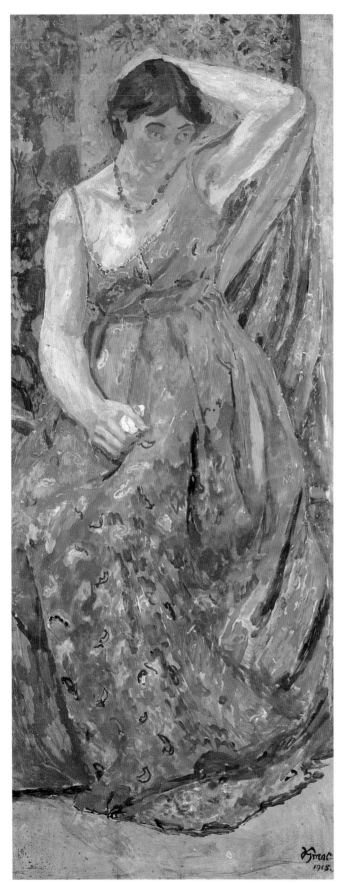

23 *Portrait of Vanessa Bell* 1915, oil and collage on wood,
60¾ × 24½" (152 × 61 cms.), private collection

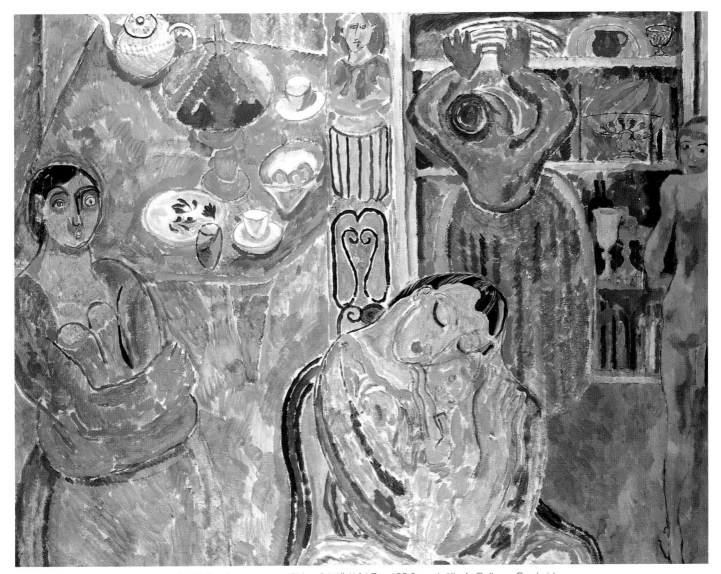

24 *The Kitchen* 1914 (reworked 1916/17), oil on canvas, 42½ × 54½″ (106.7 × 135.9 cms.), King's College, Cambridge

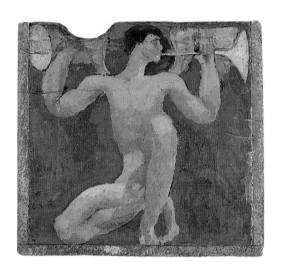
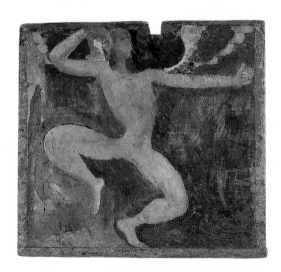

25 *Log-box* 1917, oil on wood, 13¾ × 13¾ × 12¾″ (34.3 × 34.3 × 31.8 cms.), The Charleston Trust

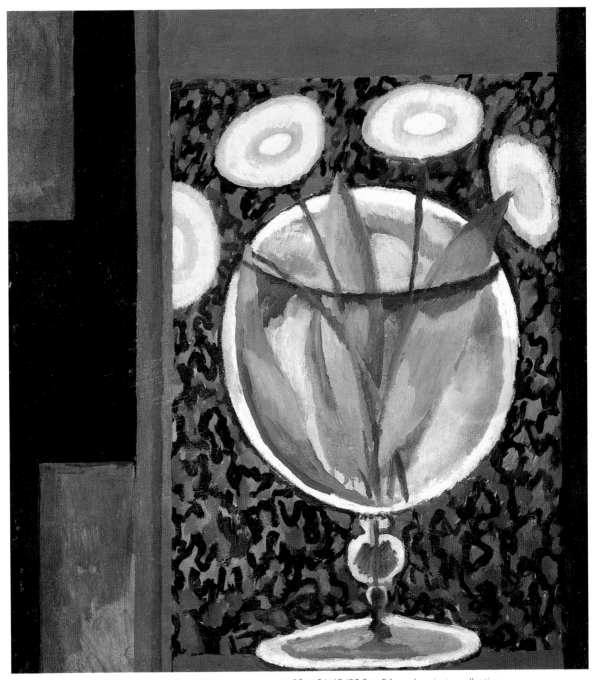

26 *Double-sided Decorative Panel* c.1917/18, oil on wood, 23 × 21½″ (58.5 × 54 cms.), private collection

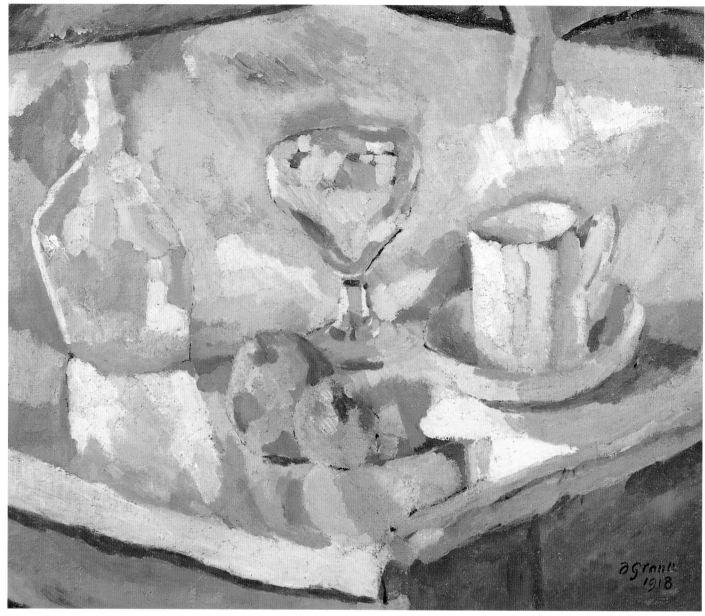

27 *The Table Top* 1918, oil on canvas, 18 × 22″ (45 × 55 cms.), collection Sandra Lummis

28 *Design for a Bedhead* c.1917/18, pencil and wash on paper, 9 × 12″ (22.5 × 31.2 cms.), collection Sandra Lummis

29 *Venus and the Duck* c.1917/18, oil on board, 11½ × 34″ (29 × 86.5 cms.), private collection

30 *Still Life with Plaster Torso* 1918, oil on canvas, 39 × 25½″ (97.5 × 63.7 cms.), collection Sandra Lummis

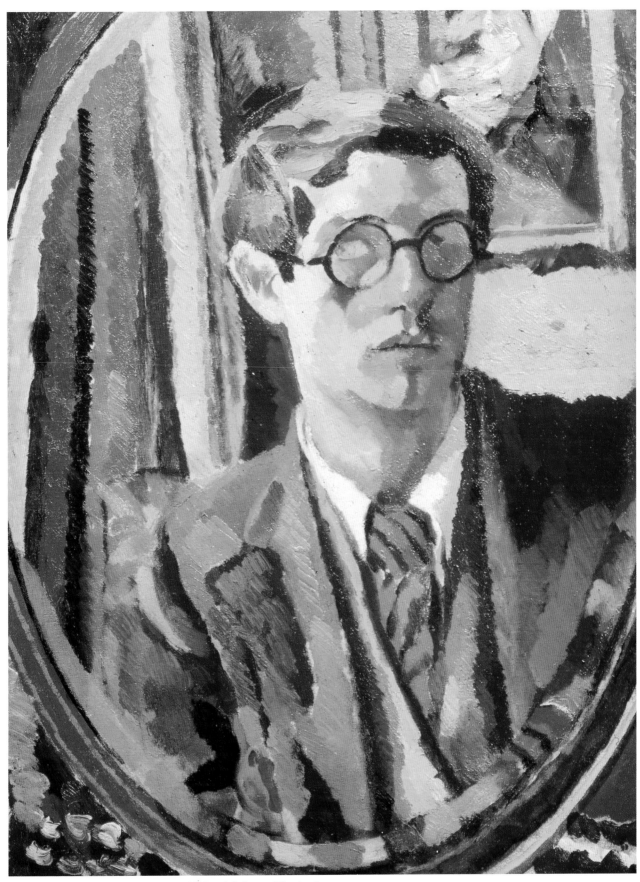

31 *Self Portrait* c.1918, oil on canvas, National Gallery of Scotland

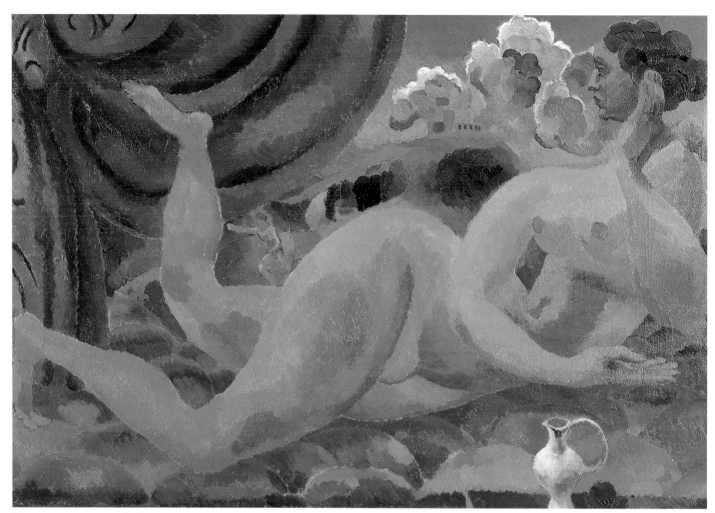

32 *Venus and Adonis* 1919, oil on canvas, 25½ × 37½″ (63.7 × 93.5 cms.), The Tate Gallery, London

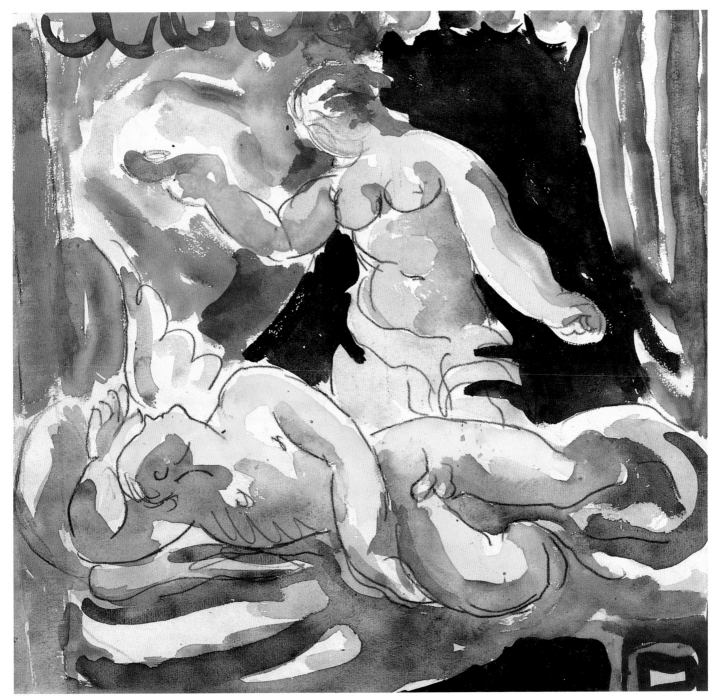

33 *Cupid and Psyche* c.1920, pencil and watercolour on paper, 14½ × 15″ (36.5 × 37.5 cms.), private collection

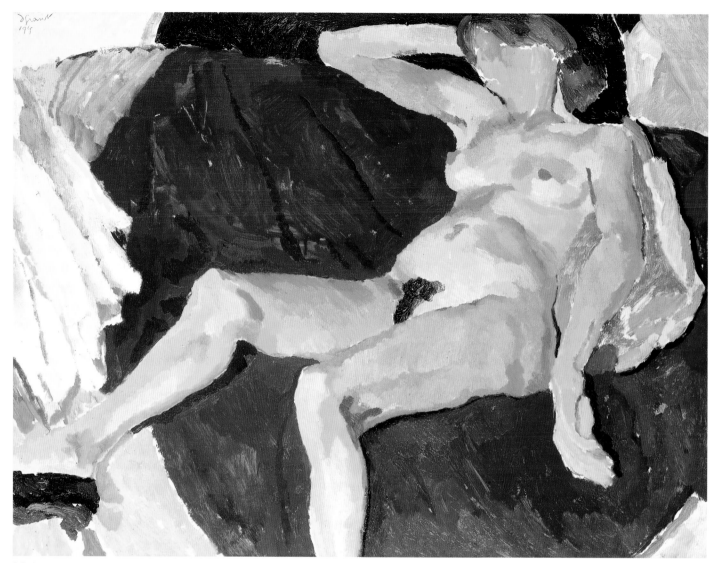

34 *Female Nude (Vanessa Bell)* c.1918, oil on canvas, 24¼ × 32¼" (61.6 × 81.9 cms.), private collection

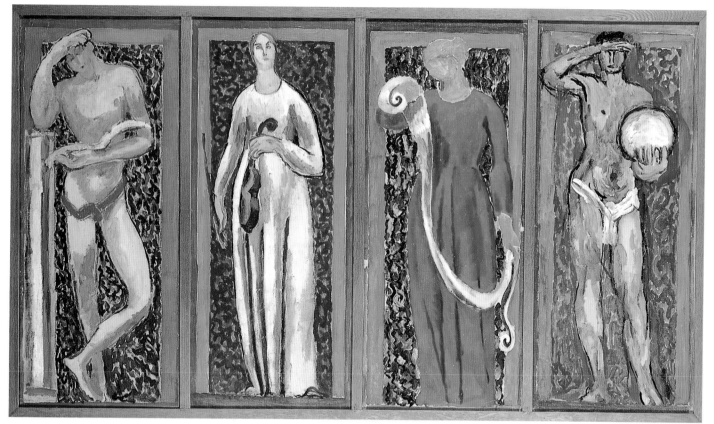

35 *Studies for Murals in J. M. Keynes' Rooms, Webbs Court, King's College, Cambridge* 1919, oil on canvas, each panel 33 × 14½″ (84 × 36.8 cms.), private collection

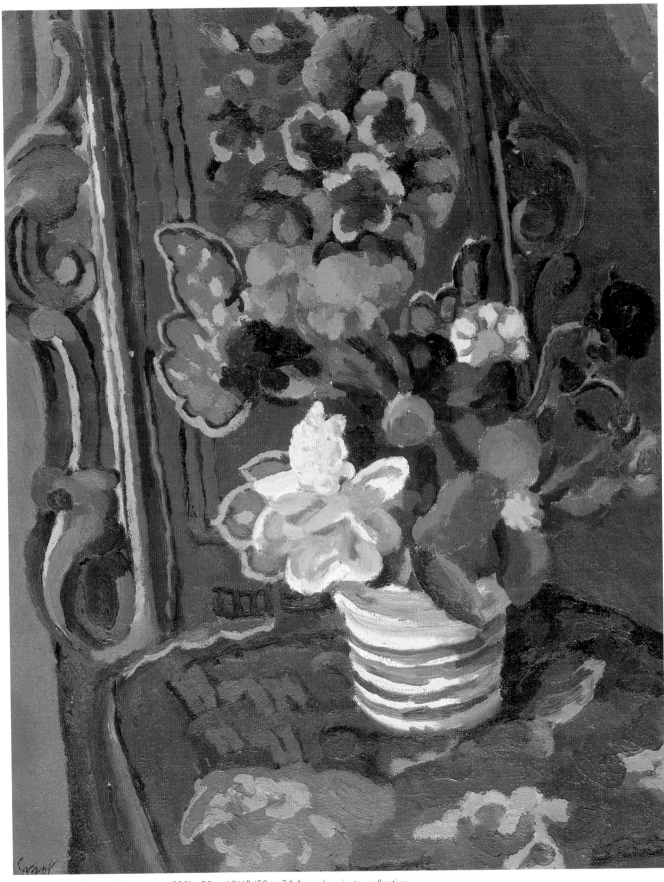

36 *Still Life with Prie-Dieu* early 1920's, 20 × 15¾″ (50 × 34.4 cms.), private collection

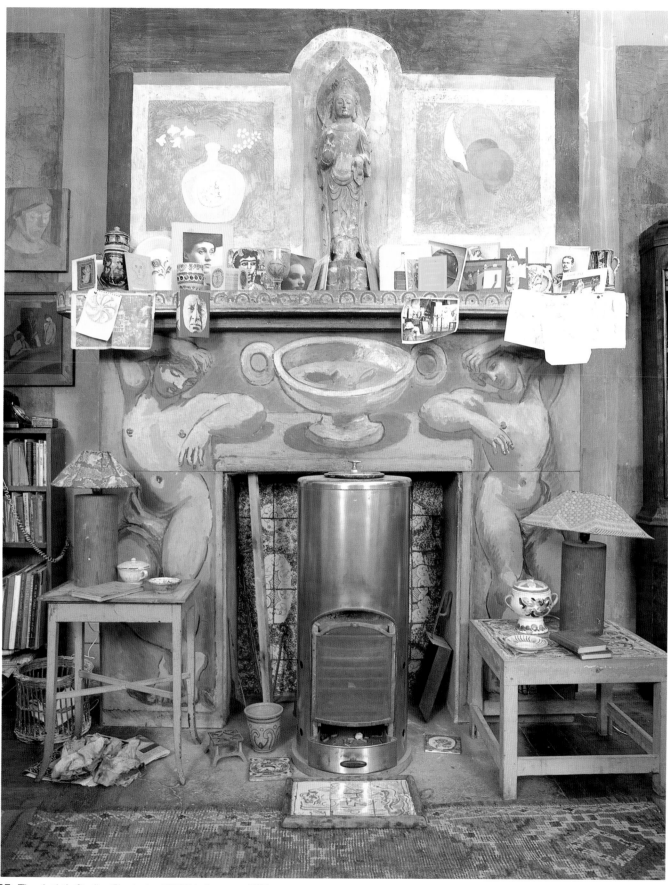

37 *The Artist's Studio, Charleston* 1925/26, figures c.1932.

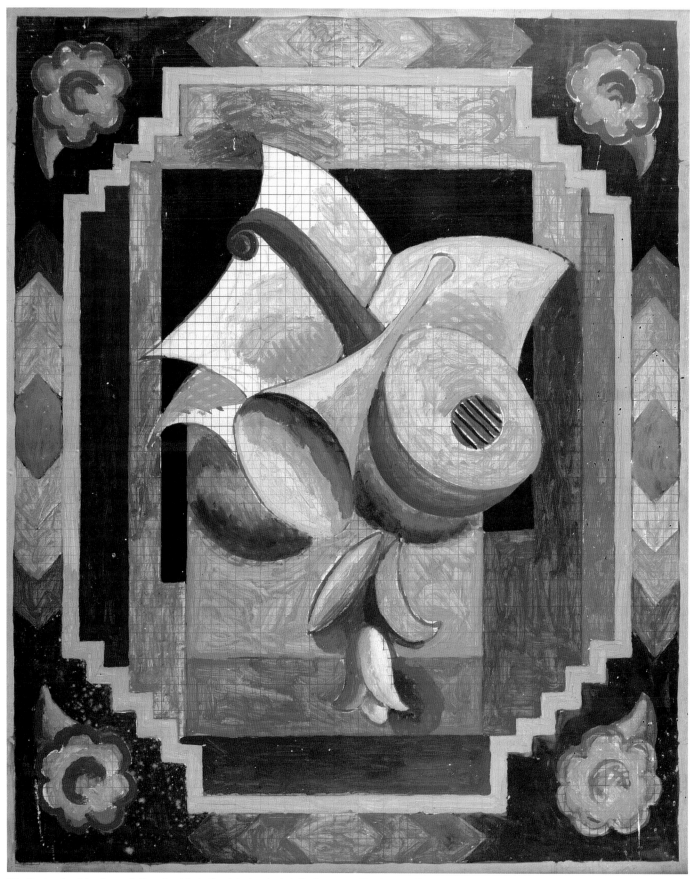

38 *Design for Needlework Seat for Music Stool in the Artist's Bedroom at Charleston* 1925,
oil on squared paper on wood, 28½ × 34½" (58 × 72.5 cms.), private collection

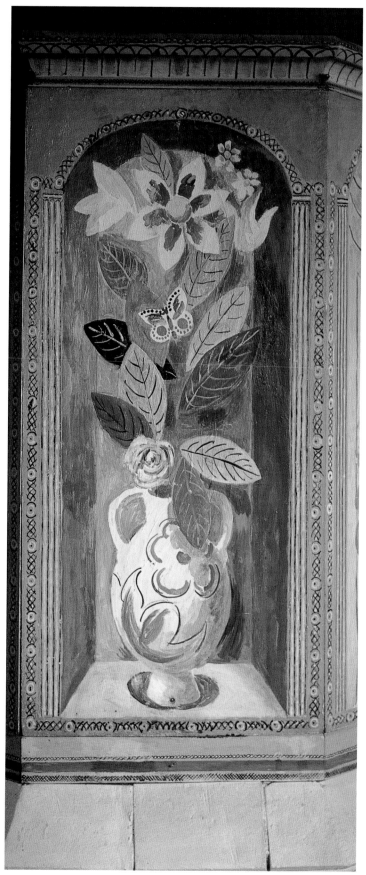

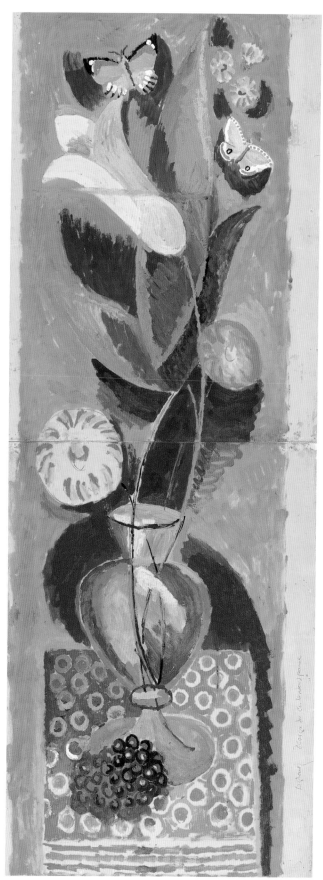

39 *Font Decoration* 1961, oil on board, Berwick Church, Sussex

40 *Design for Embroidered Panel* c.1926, oil on paper,
60 × 18″ (150 × 45 cms.), private collection

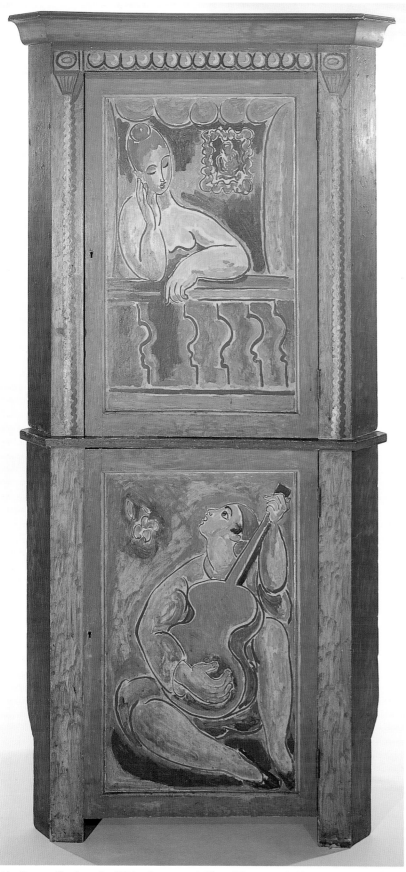

41 *Corner Cupboard* c.1924, oil on wood, City of Portsmouth Museum and Art Gallery

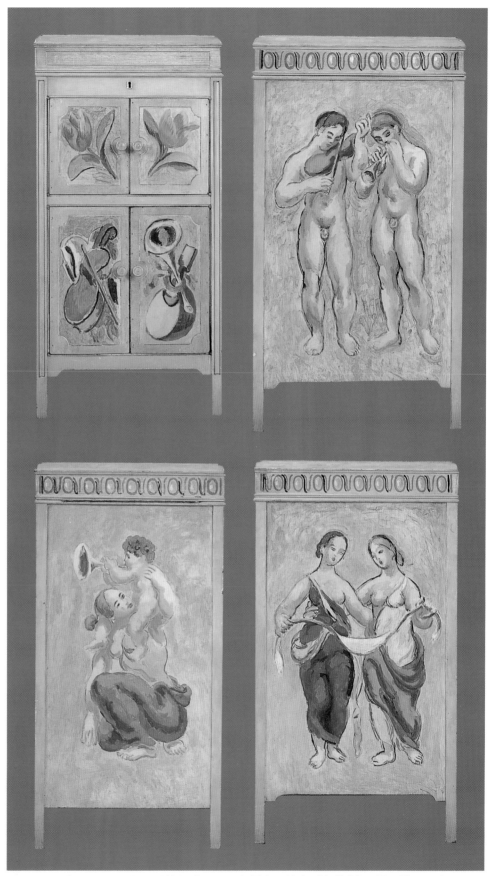

42 *Painted Gramophone Box* c.1926, oil on wood, 37¼ × 18¾ × 20¾″ (93 × 47 × 52.1 cms.), collection Stephen Keynes

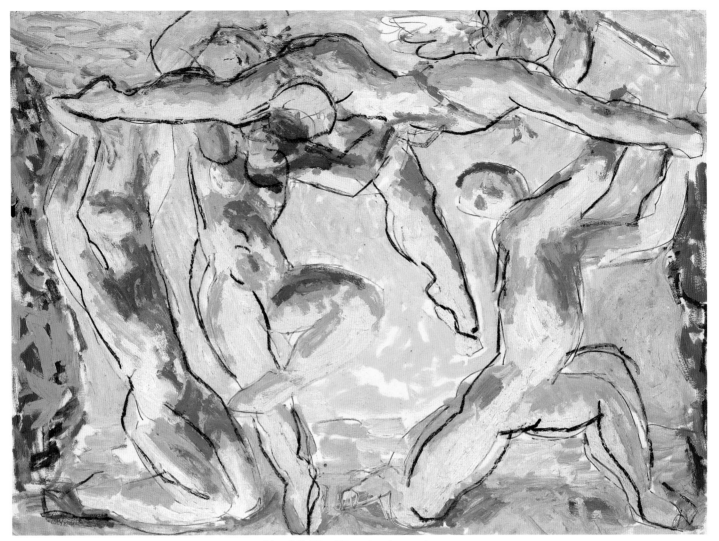

43 *Dancers* c.1925, charcoal, pastel and oil on paper, 22 × 30″ (55 × 75 cms.), private collection

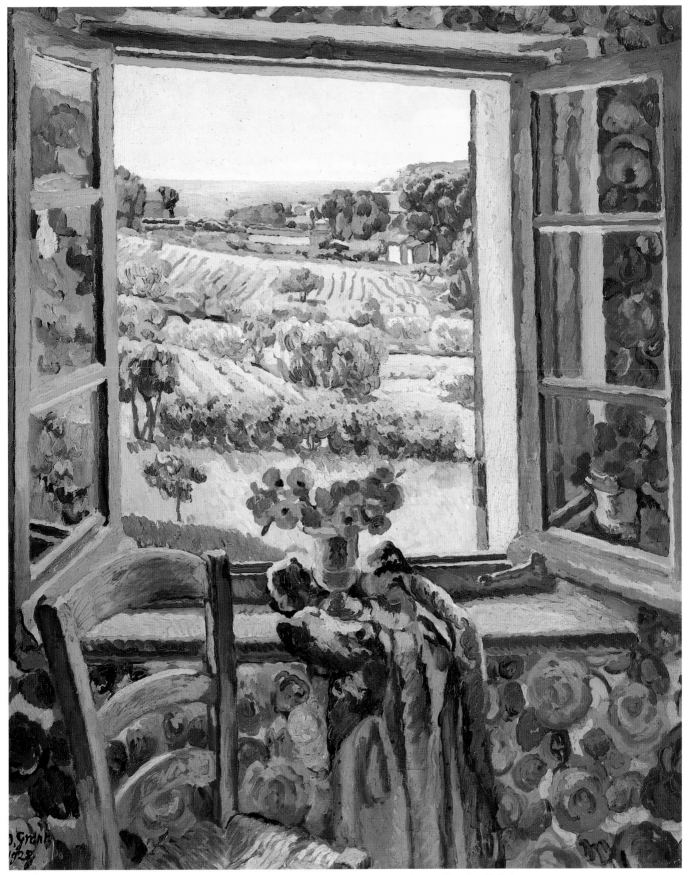

44 *Window, South of France* 1928, oil on canvas, 39 × 31¼" (97.5 × 78.1 cms.), Manchester City Art Galleries

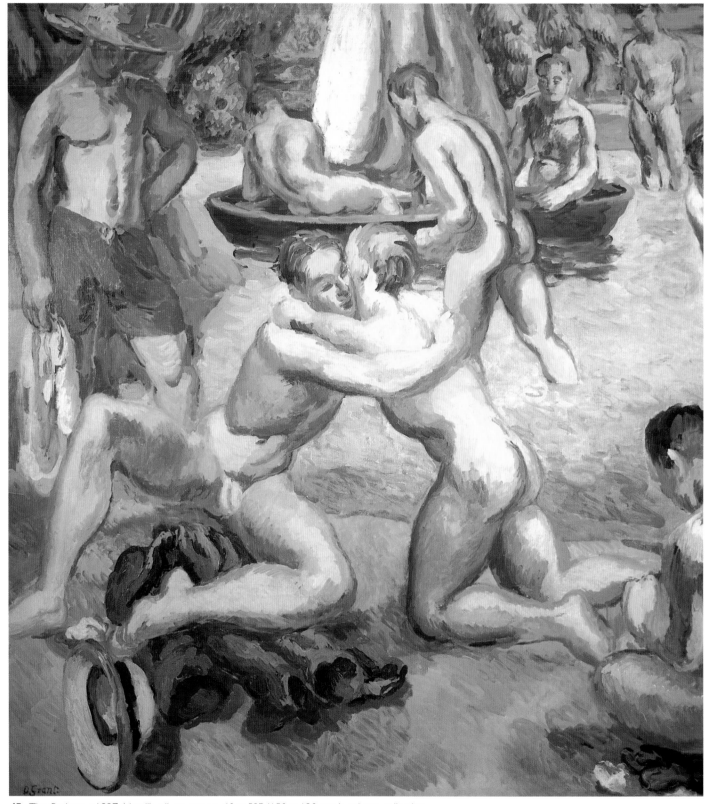

45 *The Bathers* c.1927 (detail), oil on canvas, 60 × 52″ (150 × 130 cms.), private collection

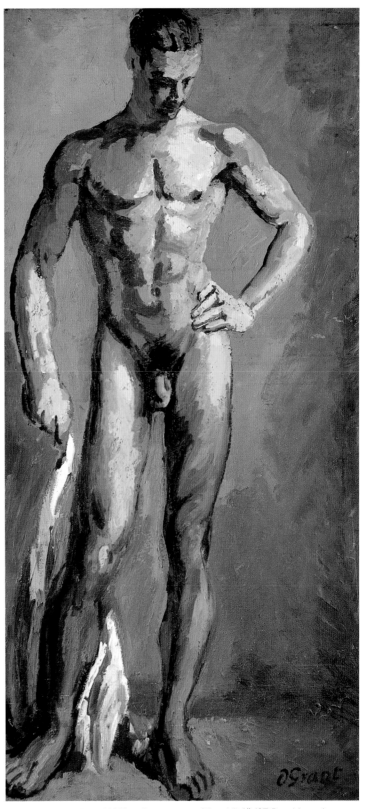

46 *Male Nude* late 1920's, oil on canvas, 39 × 18½" (97.5 × 46 cms.),
The Charleston Trust

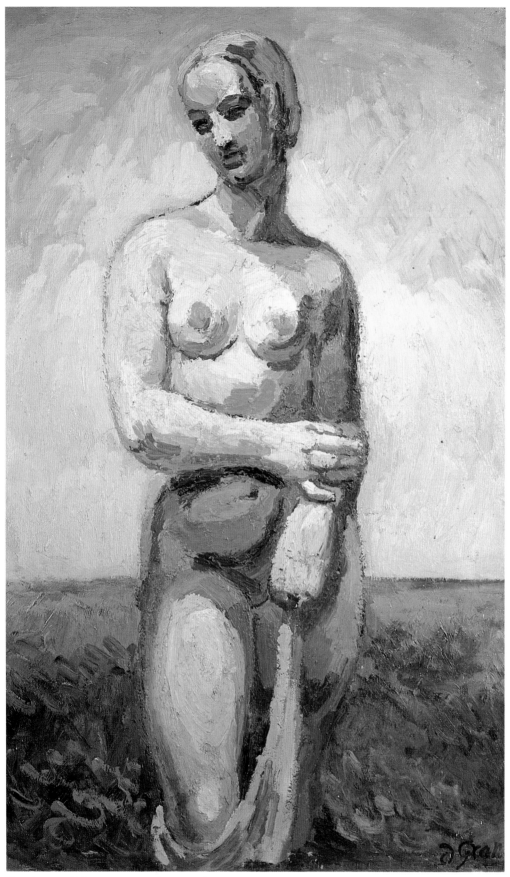

47 *Venus* c.1932, oil on canvas, 36 × 22½″ (90 × 56.2 cms.), collection Sandra Lummis

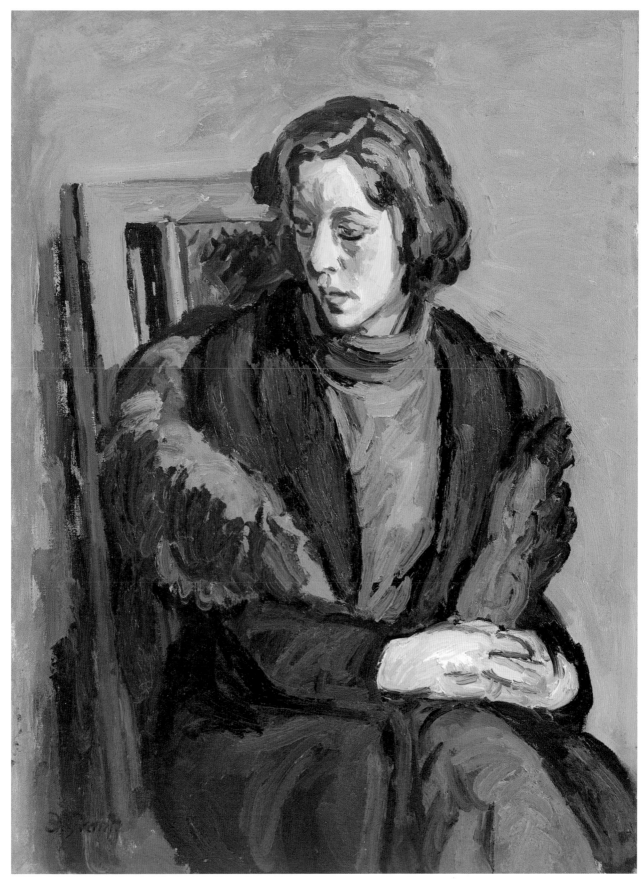

48 *Miss Holland* 1934, oil on board, 30 × 22″ (75 × 55 cms.), private collection

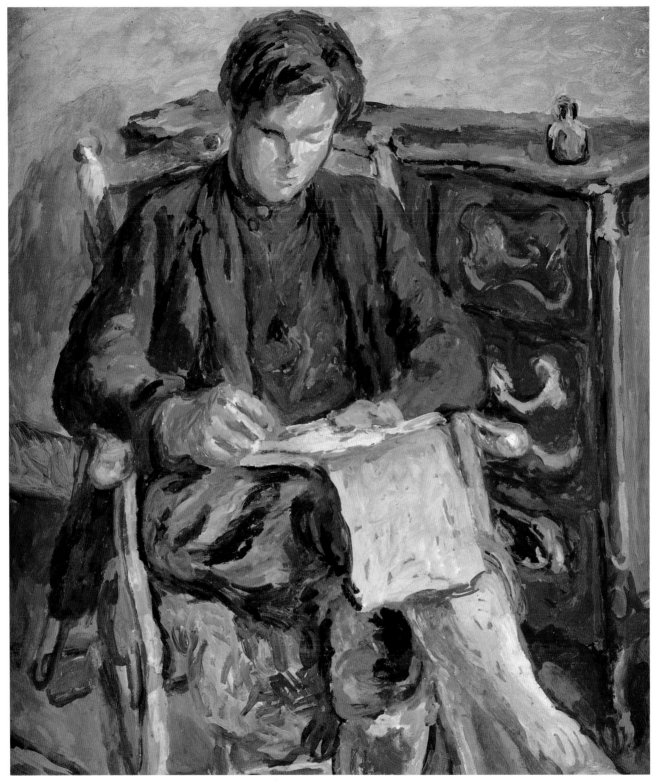

49 *Portrait of Julian Bell* c.1928, oil on canvas, 29¼ × 25¼" (74.2 × 64.2 cms.), The Charleston Trust

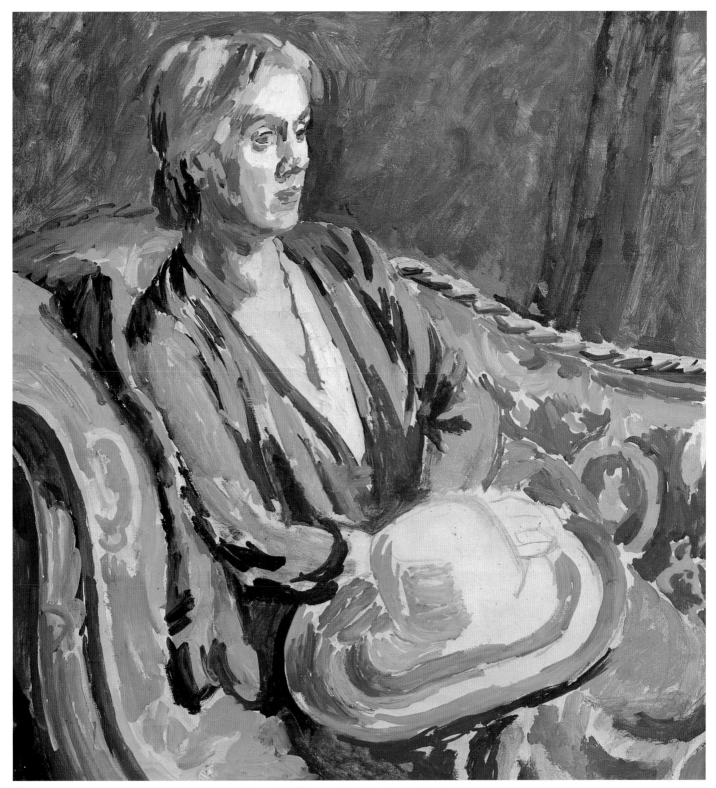

50 *Portrait of Vanessa Bell* c.1934, oil on canvas, 25.6 × 23½″ (64 × 59 cms.), private collection

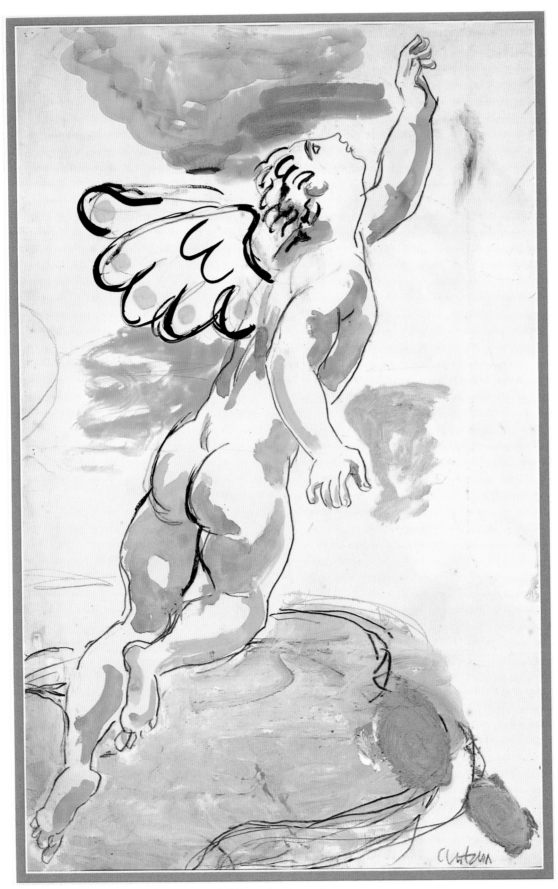

51 *Design for Fabric 'Apollo and Daphne'* c.1936, pencil and gouache on paper, 29¼ × 18½" (74.5 × 47 cms.), private collection

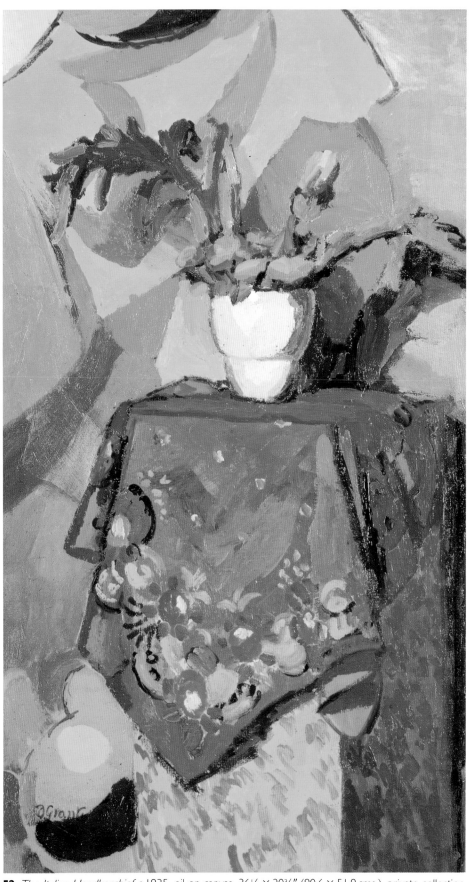

52 *The Italian Handkerchief* c.1935, oil on canvas, 36¼ × 20¾″ (90.6 × 51.9 cms.), private collection

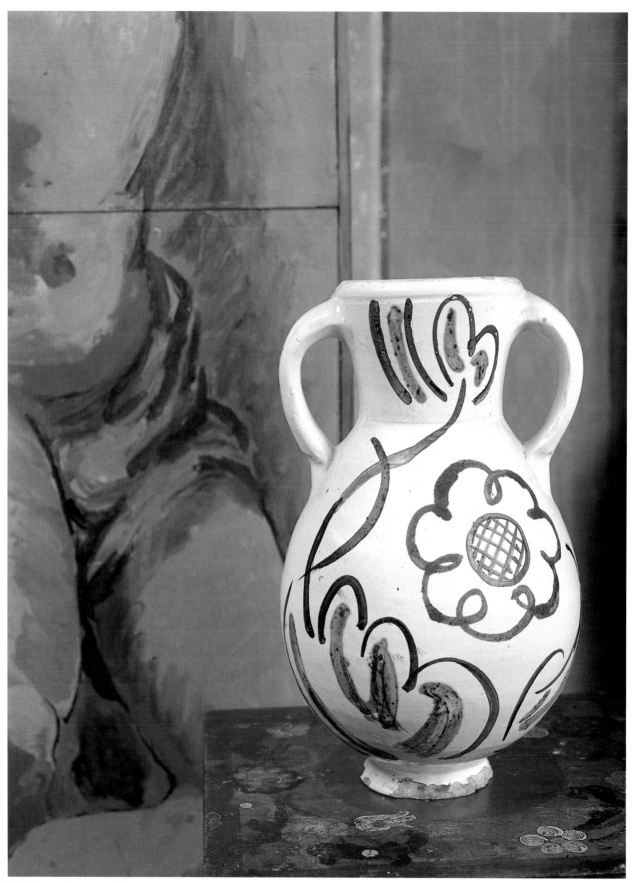

53 *Painted Vase* mid 1930's (cast by Phyllis Keyes from Tunisian vase decorated in 1911, see colour plate 6)
h. 13½″ (34 cms.), The Charleston Trust

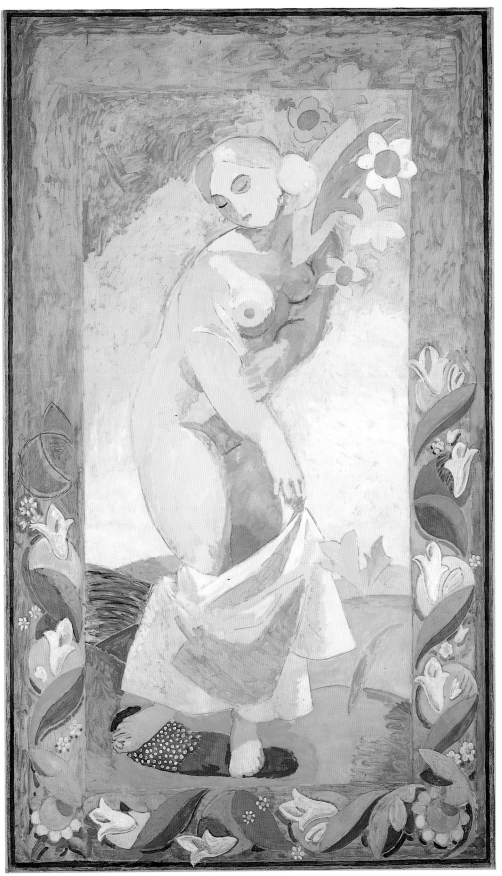

54 *Design for The Queen Mary* 1936, oil on board, 94 × 55″ (235 × 137.5 cms.), private collection

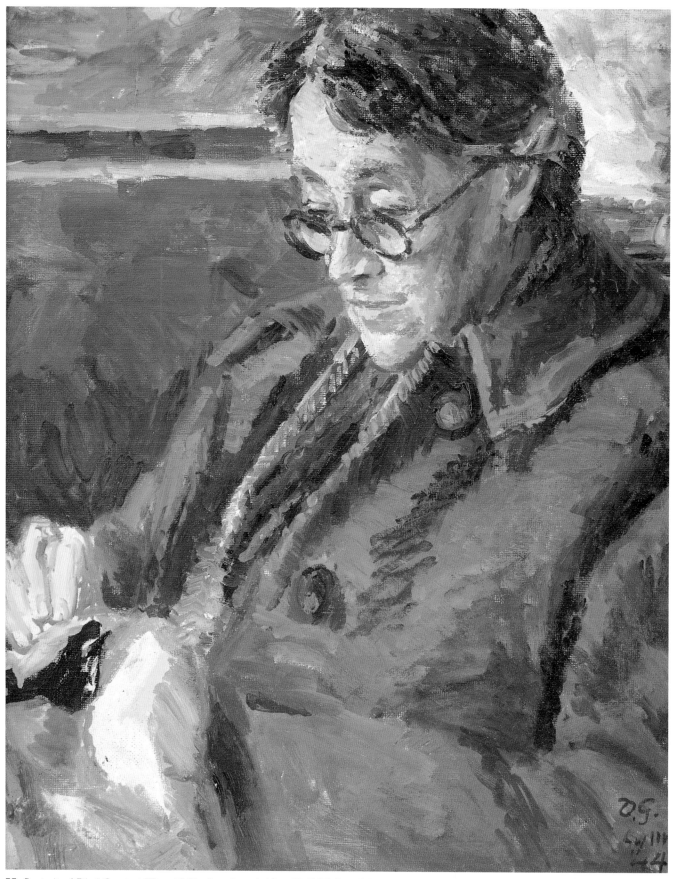

55 *Portrait of Ethel Grant at Tilton* 1942, oil on board, 18 × 15½" (76.5 × 63.5 cms.), private collection

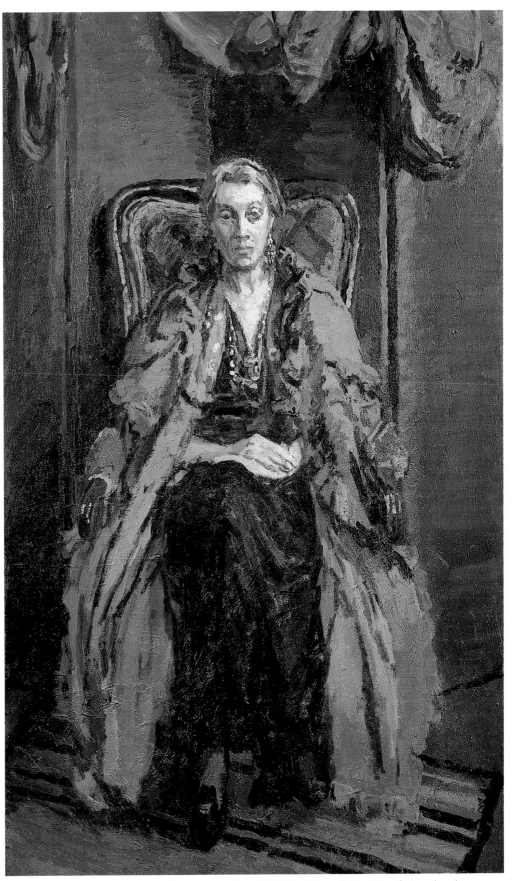

56 *Portrait of Vanessa Bell* 1942, oil on canvas, 40 × 24″ (100 × 60 cms.), The Tate Gallery, London

57 *The Salute, Venice* 1948, oil on board, 21½ × 14¾" (53.5 × 37 cms.), private collection

58 *Design for Mural at Lincoln Cathedral* c.1955, pencil and watercolour on paper, 28 × 37″ (70 × 92.5 cms.), private collection

59 *Leda and the Swan* 1950, oil and gouache on paper, 18 × 19½″ (45 × 48.8 cms.), private collection

60 *Design; Elephant with Basket of Flowers* c.1960, pastel on paper, 15½ × 14½" (39.5 × 37 cms.), private collection

61 *Still Life with Matisse* 1971, oil on paper on board, 22 × 14¾″ (55 × 36.9 cms.), reproduced
by gracious permission of Her Majesty Queen Elizabeth the Queen Mother

62 *Mantelpiece Still Life* c.1972, size and present whereabouts unknown